The Idea of Rococo

The Idea of Rococo

WILLIAM PARK

DELAWARE

Newark: University of Delaware Press
London and Toronto: Associated University Presses

Associated University Presses
440 Forsgate Drive
Cranbury, NJ 08512

Associated University Presses
25 Sicilian Avenue
London WC1A 2QH, England

Associated University Presses
P.O. Box 39, Clarkson Pstl. Stn.
Mississauga, Ontario,
L5J 3X9 Canada

The paper used in this publication meets the requirements of the American National Standard for Permanence of Paper for Printed Library Materials Z39.48-1984.

Library of Congress Cataloging-in-Publication Data

Park, William, 1930–
 The idea of Rococo / William Park.
 p. cm.
 Includes bibliographical references and index.
 ISBN 0-87413-434-X
 1. Arts, Rococo. 2. Arts, Modern—18th century. I. Title.
NX452.5.R6P37 1992
700'.9'033—dc20
 90-51017
 CIP

To Marlene

Contents

Preface

ALL PREFACES OF PUBLISHED BOOKS CONTAIN providential narratives and describe the good fortune of the author. And mine is no different. I am greatly indebted to a number of superb teachers—even to list their names is a form of boasting. James Thorpe first introduced me to eighteenth-century literature; John Weld to the poetry of Pope and the fictions of romanticism. Alan Downer taught me about structure and conventions. James Clifford guided me through graduate school and infected me with his enthusiasm for the eighteenth century. Douglas Bush-Brown and then Rudolph Wittkower opened my eyes to architectural history. My colleagues at Sarah Lawrence have ever been encouraging and helpful, particularly Jefferson Adams, Raymond Clarke, Michael Davis, Annie-Claude Dobbs, Roland Dollinger, Dale Harris, Dean Barbara Kaplan, Gilberto Perez, Frank Randall, Judy Serafini-Sauli, and William Shullenberger. My students have patiently endured the working out of this book's ideas, and made their own contributions and helpful correctives. Such scholarship as this work contains was made possible by the librarians of the college, notably Janet Alexander, Cecily Burgard, Roseann Burstein, Charling Fagan, William Haines, Renée Kent, Judy Kicinski, and Patti Owen. I could not have obtained the illustrations without the help of Penny Bridgers, Charles Cottrell-Dormer, Sue Givens, Julie Grosse, Pat Singer, Dr. Philip Ward-Jackson, Sarah Brown of the Royal Commission on the Historical Monuments of England, Ted Gachot at Columbia University Library, Tom Rassieur and Eileen Sullivan of the Metropolitan Museum, Dr. Christina Thon of the Kunstbibliothek in Berlin, Edwin Wallace of the V & A, and especially Annette Weir at Photo Resource. In preparing the book for publication I was aided by a Hewlett-Mellon grant.

The notes show the wide range of my indebtedness, but I must single out Professors Roger Ariew, Elizabeth Brophy, Huguette Cohen, Karsten Harries, Hugh Honour, Madeleine Morris, Paul-Bernard Newman, Agnes Raymond, John Sitter, Diane Stevenson, Simon Varey, Dr. Peter Volk, and Jeanne Welcher. Professors Patrick Brady and Patricia Crown made useful comments about parts of this work, as did Robert Maccubbin. I am thankful to Professor Daime Stillman for his corrections and critique of an earlier version of the discussion of rococo and neo-Palladianism. I am also thankful to the editors of *Studies in the Novel* and *Etudes Anglaises* who have permitted me to reprint portions of chapters 1 and 4, which first appeared in their journals. Among eighteenth-century scholars I have a special gratitude to Jerry C. Beasley.

My oldest son, Jonathan, sent me to England to see the great Victoria and Albert exhibition, "Rococo: Art and Design in Hogarth's England." But I owe most to Marlene Park, who as art historian and wife has at every stage of its development made this book possible. To her I dedicate *The Idea of Rococo* with all my love.

Introduction: Rococo
and Period Style

[The Baroque] is bounded at one end by the Renaissance, and at the other by the new classicism which began to emerge in the second half of the eighteenth century; it lasted in all some two hundred years. Inside this period, however, baroque changed so much that it is difficult to think of it as a single whole. Beginning and end have little resemblance to each other and it is difficult to distinguish any continuity. Burckhardt has already observed that in any historical survey of the period a new sub-section should begin, about the year 1630, with Bernini. The early baroque style is heavy, massive, restrained and solemn. This pressure then gradually begins to life and the style becomes lighter and gayer; it concludes with the playful dissolution of all structural elements which we call *rococo*.[1]

GENERAL ARGUMENT

HOWEVER ONE REGARDS HISTORY, THE EIGHteenth century appears as the time of crisis, a time of extraordinary transformations, probably the most extraordinary that have ever taken place—feudal to bourgeois, classic to romantic, aristocratic to democratic, hierarchic to egalitarian, agricultural to industrial, religious to secular, from God the creator to man the creator. Even among religious thinkers the concept of God shifted from transcendent to immanent, from the God without to the God within,

from God the father to the human divine.

If one considers these changes according to the means of production then one notes that a fundamental reorientation of productive forces took shape in the second half of the eighteenth century, that it started in England, and that it was based on the steam engine, the new source of power that replaced the horse, the wind, and water, the driving forces of advanced agrarian societies. If one considers these changes aesthetically or culturally, then one speaks of classic and romantic, the classic cosmology prevailing at least from the time when writing began till the mid-eighteenth century when romanticism overturned this cosmology and established its own revolutionary myth, within which we have lived ever since.[2] And if one considers these changes religiously, one remarks on successive challenges to orthodox or traditional religious views, which in the eighteenth century culminated in the first predominantly secular culture, by which I mean that the majority of important writers and artists had for the first time in history either abandoned a religious outlook, one that saw human beings in both a natural and a supernatural context, or were, despite their private beliefs, content or resigned to regard mankind in a natural context alone. Looking at one end of the spectrum, Henry Adams saw thirteenth-century Europe united in its love of the Virgin; looking at the other, he saw it distintegrated in its worship of the dynamo, or power. Or as Foucault put it,

"For the nineteenth century, the initial model of madness would be to believe oneself to be God, while for the preceding centuries it had been to deny God."[3] Parts of this transformation are called the Enlightenment, other parts romanticism, but the two terms should be seen as overlapping and complementary as well as contradictory, for however much certain romantics such as Blake reacted to the "enlightened" rationality of Voltaire or Rousseau, all three of them in their various ways contributed to and celebrated the undermining of the *ancien régime.*

The only era that rivals the eighteenth-century Enlightenment as equally revolutionary or transitional is the Italian Renaissance. Of course, that movement was based on earlier renaissances, particularly the one of the twelfth and thirteenth centuries, which gave us Gothic architecture and scholasticism, the latter being not so much a school of dunces or monkish gloom, as it came to be regarded, but an incredibly liberating perspective that allowed nature and man to be studied in their own right, not as illusions or shadows, but as solid entities, which because God had made them had a being and worth of their own. This new direction in philosophy, a revival of Aristotelianism in a Christian context, made possible the humanism of the Renaissance and the scientific revolution inaugurated by Copernicus, Bacon, and Galileo. Standing back from these developments, we can see that these two most "transitional periods" (for of course all periods are transitional), are really one megaperiod (or megatransition) that began in the Renaissance and concluded in the Enlightenment. To put it another way, the Renaissance-Enlightenment period, or, if you will, the stages of the Renaissance, served as the crucible in which traditional society became transformed into the condition known as modernism.

We began speaking of the history of mankind and in the last two paragraphs have become Euro-centered. But for reasons not fully understood, the European powers, which in the fourteenth century seemed somewhat backward in comparison to China, between the fifteenth and nineteenth century were able to dominate the rest of the world.[4] To liberate themselves from the Europeans and their American heirs or to compete with them, other cultures have been forced to adopt European science and technology, which in turn cannot be separated from free inquiry, capitalism (either state or private),

democracy, and individualism, or as Montesquieu put it "reason, humanity and nature."[5] So for better or worse, Europe first underwent this transition from a traditional agrarian, aristocratic, and religious society to an industrial, egalitarian (or mass), and secular one. And for better or worse the Third World is following it into this condition of modernism. That non-European cultures will not experience the stages of the Renaissance goes without saying. But the process that Europe underwent during these centuries appears to be not just a local phenomenon but a historic variation of what seems to be, triumphantly or tragically, a universal development, though certainly not an end point.

Whether one regards the Renaissance as a transitional megaperiod ending in the Enlightenment,[6] or whether one records the rococo as the transitional period between the Renaissance and Enlightenment, all the indicators—economic, aesthetic, and philosophic—point to the eighteenth century as a unique moment of cultural change and transformation, of crisis and revolution. One would expect such an era to be characterized either by a unique and unusual style or by many styles, no one of which would be dominant. And in fact, when looking at the art of the time, one can justify either of these views. For on the one hand, we discover the rococo, as bizarre a style as ever occurred, and on the other, a pluralism of styles. Yet this book will argue that the peculiar, particular style, rococo, is a true period style.

If one disagrees with the universality of baroque in the seventeenth century and points to French classical style, the proponent of baroque will neatly demonstrate that the bulges of Vaux-le-Vicomte, the volumetric pillars of the Louvre, the shift of tectonic forces on the dome of the Invalides, the entire conception of Versailles, all testify not just to baroque influences, forms, and solutions, but to a thoroughgoing baroque mentality, though of course more regular and more refined, being French. To discuss Le Vau and J.-H. Mansart apart from the concept of the baroque would be to overlook an important aspect of their work, even though the baroque in its purest, most complete form exists only in Rome.[7] The proponent of rococo can make no such claims. For coexisting with rococo, one finds this same baroque (both in Italianate and French versions), a central European development usually called late baroque, neo-Palladianism, which, visually

speaking, is the antithesis of rococo, and several other styles, such as Gothic, whether revival or survival, not to mention eccentric individual styles, such as Hawksmoor's, which resist classification. The eclecticism of the period argues against regarding rococo as a period style, as being anything more than a minor and terminal variation or baroque. If one insists on finding a label for the first half of the eighteenth century, would it not be better to drop the case for rococo and settle for late baroque? Most of the styles including rococo, may be subsumed in that category, and those which cannot, like neo-Palladian, may be considered as avant garde, as harbingers of the neoclassicism to come.

Despite the reasonableness of these received opinions, I maintain that rococo was the essential style of the first half of the eighteenth century. First, rococo was too much of a revolution against the baroque to rest that comfortably within baroque categories and ideologies. Second, it was the only style unique to the time: all the others were revivals or continuations of earlier styles. Thus while rococo was but a part of the artistic scene, it serves, like one of its favorite devices, metonymy, as the part that best explains the whole. It is, in effect, the common denominator to all the other styles. The "late" in late baroque, the "neo" in neo-Palladian, the particular eighteenth-century look to the Gothic revival, all have something in common, and that something is either rococo itself or the aesthetic of rococo. Minguet states that although rococo cannot be extended to all phenomena, it is not without a relation to other forms,[8] and it is that relationship which most interests me. My idea of a period style is less absolute than either early proponents of the concept, like Hatzfeld, who categorized everything in France as rococo, or later qualifiers, like Brady, who admit only the purest examples into the category.[9] Hauser states very clearly that "the assumption that a style finds expression in the entire artistic production of an epoch or a region, in great works and in slight, in the monumental and in the minutest detail of decoration, everywhere with the same intensity and completeness, is untenable."[10] So if rococo is not everywhere, it is always nearby, and if it is not the only style, it bears family resemblances to the other styles. It is like a gene, usually dominant, though sometimes recessive, which may be traced in almost all the works of the first half of the eighteenth century, those of

Lord Burlington and Bach as well as those of Pineau and Pergolesi. And finally, though rococo as an *aesthetic* is not the only meaningful framework in which to regard the eighteenth century, many familiar contexts seem too parochial or limited. English scholars have long made good use of Augustan, for instance, or Georgian. But Augustan provides us with no means of relating Pope to Fielding or of either one to Marivaux or Voltaire.[11] Augustan and Georgian remain national terms, like *Régence* or Louis XV, by their very nature incapable of providing us with the international framework in which we may perceive the relationships that actually existed among the nations and arts of the first half of the eighteenth century. Rococo provides such a framework. That is why the title of this book is "The *Idea* of Rococo," for if rococo itself was not omnipresent, the ideas that governed it were.

My assumption throughout has been the rather simple one that in the eighteenth century Europeans shared a common culture and that the arts in one country are likely to parallel the arts in another. In this I am not asserting cultural uniformity. I am merely entertaining the hypothesis that countries that shared the same religion, however fragmented into sects, the same traditions, the same economy, the same politics and wars, the same crisis over science and secularism, though in varying degrees of intensity, and among whom the artists of the time for the most part traveled freely back and forth, are likely to produce arts that bear a relationship to one another. That we recognize these relationships and begin speaking of an age or a period may arise from our wish for order and relationship, from our desire to see what appears to be the chaos of history as in fact a work of art whose form is style and whose content is civilization, but we have been encouraged in our desire by more than a century of success on the part of those like Burckhardt, Wölfflin, and Panofsky, who have described those relationships with convincing exactitude. Sauerländer, objecting to these critics, warns against "historic aestheticism" whereby the conflicts of a "social constellation," which is complex and contradictory, are "dreamt of as symbolically unified,"[12] and history is regarded as a sunset, all in harmony. Sauerländer would confine the art historian to the formal study of artifacts as but one thing within a complex social constellation, but he gives no reason why a style may not be the visual

expression of such a constellation. He fears that when the art historian attempts to describe such larger or more abstract patterns, he is in danger of repressing the unpleasant aspects of history, but he does not say why the art historian could not be as fully aware as any other historian of the unpleasant, contradictory, complex, and unique, and still see a pattern, or why the pattern itself could not contain or even express the complexity. All too often, those who do concentrate on the unpleasant are as reductive as the aesthetes, as when Shakespeare's plays are seen as expressions of precapitalism or *Tom Jones* as being about the enclosure movement. Even Meyer Schapiro will allow that it is not the content of works that create the style, "but the content as part of a dominant set of beliefs, ideas, and interests, supported by institutions and the forms of everyday life, shapes the common style."[13]

Treating rococo as a common style may also offend some readers who will think I am belittling their authors, especially English Augustan ones, by squeezing them into such a frivolous continental context. I recognize this difficulty and hope the following pages will serve to calm the irate and persuade all that however peculiar the rococo style was, it expressed the yearnings and dilemmas of a civilization during an extraordinary time of crisis and transformation.

THE HISTORY OF ROCOCO

To understand the idea of rococo, it will be useful to survey the history of the term. Like Gothic, baroque, neoclassical, and Impressionist, the word rococo began as a pejorative expression. But unlike those terms, it has not completed its evolution and become merely descriptive or honorific, as words signifying an age or a style, or both. According to Fiske Kimball, in 1796 or 1797 a young wit in the atelier of David, Maurice Quai, coined the term by combining *rocaille* and *barocco*.[14] *Rocaille* meant a grotto style, a style of rocks, shells, scrolls, and falling water in an imaginative, pictorial combination rather than a logical or structural one. This style first became fully articulated in the designs published by Meissonier in 1734. *Barocco* (or baroque) meant misshapen or malformed or convoluted. It derived either from a Portuguese word describing defective pearls or an Italian word describing labyrinthine logic. It was first

applied to the works of Borromini. Since to a person of strict classical taste, *barocco* meant a kind of excessive art, the epitome of bad taste, its combination with *rocaille* signified an even more abominable style, as if to say, "If you thought *barocco* was bad, you should see *rocaille*." According to C. T. Carr, however, this analogy to *barocco* is untenable because *barocco* was not used in the eighteenth century for a style of art and because the Italian form of the word does not occur in French sources.[15] He thinks rococo derived from the combination of the first two syllables of *rocaille* and *coquillage*, two words frequently paired in contemporary accounts of what we now consider rococo works,[16] *coquillage* being the shell motif that accompanied the *rocaille*.

Carr's account is the more convincing of the two, but in either case, the word *roc-oco* or *rococ-o* came into being just as the style was vehemently and mockingly banished. Hundreds of beautifully carved and plastered interiors were demolished to make way for the purer austerity of neoclassicism. Madame du Barry rejected the *Progress of Love* (1771–73) by Fragonard, now at the Frick, in favor of more archeological paintings by Vien. In Bavaria, where rococo had reached its fullest expression, the Elector Max III Joseph, in 1770, forbad its use altogether. Though it did not disappear completely, seldom has a style been banished with as much suddenness and success, and for more than a century, it remained symbolic of a despised and decadent *ancien régime*, an association from which it has still not fully emerged.

Its rehabilitation began in the 1880s when baroque studies came into being. Thanks primarily to Wölfflin, baroque began to signify not just a corruption of Renaissance classicism but a style in its own right.[17] His successors further modified his ideas to show that it was not a universal type of art, that is, that all styles neither fluctuated between classic and baroque polarities nor evolved cyclically from archaic, to classic, to baroque (or decadent) phases, but that baroque was a style peculiar to the seventeenth century in Europe. From Borromini, scholars extended the term to include Bernini, Pietro da Cortona, and Rubens, and from them to their more classic contemporaries, Algardi and Annibale Carracci. From Rubens it was but a short leap to Rembrandt and Dutch painting, and once Mansart became involved in the term, French classicism

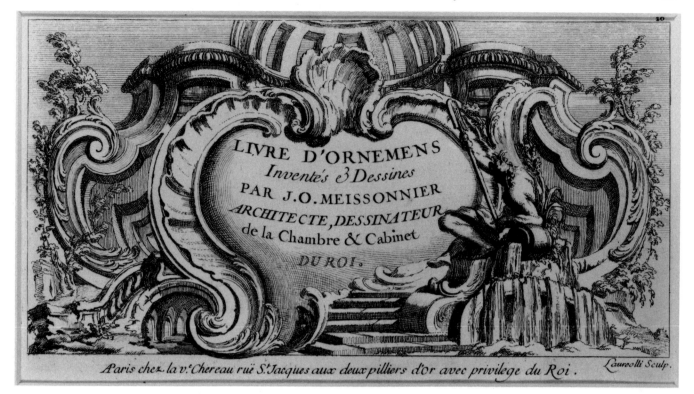

Juste-Aurèle Meissonier, Livre d'Ornemens, *1734.*
The Metropolitan Museum of Art, Harris Brisbane
Dick Fund, 1930. [30.58.2(136)]

followed as well, so that in our day the term baroque has come to mean the period style of the seventeenth century, though of course not everyone agrees with this usage. In fact, it has several meanings. As H. W. Janson put it, art historians have

> three alternative ways of employing Baroque: as an art historical period of the same order of magnitude as the Renaissance, as an art historical period within the Renaissance, i.e. the last major subdivision of the Renaissance conceived as a "megaperiod" (to use a term proposed by Erwin Panofsky) separating the Middle Ages from the Modern era (in this frame of reference, its order of magnitude corresponds to that of Gothic); and as one of several trends of style between 1600 and 1750, exemplified by Rubens, Pietro da Cortona, and Bernini.[18]

Although Janson was not entirely sympathetic to "inflation" of labels into overall period styles, we notice that he speaks of "alternative" ways of employing period labels; they need not be exclusive.[19] When one insists that baroque can mean *only* one of the three alternatives, he introduces an unnecessary rigidity, and if he insists on the third alternative to the exclusion of the other two, he is in effect denying periodization altogether. Such a reader will have little patience with this book.

Although Wölfflin more than anyone else established these concepts of the baroque—one may say that all subsequent works on the subject have been footnotes to him—he himself said that there was no such thing as a general Italian baroque style,[20] and that "we may not be far wrong in speaking of baroque as a purely Roman thing."[21] In such remarks he did not contradict himself as much as he revealed his grasp of the usefulness of *both* a strict and a loose, or magnified, usage. For Wölfflin baroque began with Michelangelo and what we now term mannerism, developed into the somber style of Carlo Maderna, reached its most definitive expression in Bernini, lightened up in a later phase, and then disintegrated into the rococo. In other words, he was fully cognizant of the *diversity* of what he called baroque, yet he saw and described certain features of style that gave a loose or rough *unity* to this large and complex period. Despite the reservations voiced by Janson, the term became so convenient and widespread as a shorthand for certain stylistic features of the sev-

enteenth century that by the 1950s literary critics such as Wiley Sypher could write popular books claiming that the poetry of John Milton was baroque.[22]

Once baroque became established as a period style, questions naturally arose as to the extent of the period. For many, the term covered European art (and of course music) from 1575 to 1760, a usage that still continues in some quarters. But almost two hundred years of intellectual ferment, political upheaval, and scientific innovation seemed too much to be characterized by but one term, even among hard-line periodizers, so "neoclassical" entered into the discussion, not the neoclassical of the late eighteenth century but the neoclassical of the late seventeenth century. Wylie Sypher, for instance, followed the usage of the 1940s and 1950s when he used this term to describe what he believed to be the last stage of Renaissance style, the late baroque.[23] But two neo-classical periods, one occurring at the end of the seventeenth century and one at the end of the eighteenth century, proved too confusing, so most scholars have dropped the earlier one and when discussing the late seventeenth and early eighteenth century speak of a classicizing baroque, of French classical baroque (the French of course resist this and still speak of classicism) or, if referring to England, of "Augustan."

The consciousness of changes within the baroque and particularly of a kind of tightening and rigidity that had set in by the end of the seventeenth century, not only in France but in Rome itself, opened the way for a new perception of rococo. From the 1840s onward, German art historians had been using the term as a normative one to signify the style of Louis XV, but it was also used synonymously with baroque or as a term describing the late phase of baroque.[24] As these studies became more refined, scholars began to differentiate between baroque and rococo and to see the latter not only as a late phase of baroque but in important ways a reaction to it. For on the one hand, as Wölfflin defined it, rococo continued the amorphousness, the blurring of contours, the breaking up of forms, their dissolution in the magic spell of light, the fluidity, the softness and suppleness of the baroque,[25] but on the other hand, it carried the baroque so far that it became subversive and destroyed the illusion, the epiphany, and the overarching hierarchy upon which the baroque depended.

The studies of rococo that see it as a style in its own right have centered in Bavaria and undoubtedly resulted, in some degree, from a justifiable Bavarian nationalism. Surrounded as they are by hundreds of magnificent eighteenth-century churches, some of them as inventive in their way as the greatest of Gothic cathedrals, the Bavarian scholars have not wished to see this native art categorized as merely late baroque, as the last decadent gushing of a dying style, but rather as something original. This conception of the rococo was already well advanced in the 1920s with Feulner,[26] but it came into its own fully in 1959 at the time of the Council of Europe exhibition on the rococo in Munich. In that year Rupprecht published his book on the Bavarian rococo church.[27] Sedlmayr also published several important articles characterizing the style.[28] And together with his student, Hermann Bauer, he published what is still the best single piece on the subject, the article entitled "Rococo" in The Encyclopedia of World Art.[29] Bauer himself published the indispensable book Rocaille,[30] and has followed that with Rokokomalerei, as well as specific studies such as his book on the Zimmerman brothers.[31] In 1983 still another Bavarian, Karsten Harries, a professor of philosophy at Yale, published his important The Bavarian Rococo Church, which though drawing heavily on these previous studies, brilliantly refined the characteristics of the Bavarian rococo and convincingly and definitively differentiated the rococo from the baroque.[32]

None of these later studies would have been possible were it not for the superb book by Fiske Kimball, The Creation of the Rococo, which appeared in 1943. Through his painstaking study of French engravings and drawings, he was able to pinpoint the very moment when the rococo began—it was in 1699 in an engraving by Pierre Lepautre—and to trace its almost day-to-day evolution.[33] But Fiske Kimball held a very strict view of the rococo, namely, that it was a French style of interior decoration. He neither concerned himself with its extension to other countries nor with the applicability of the term to other arts; he did not impinge on anyone's territory; he upset no received opinions. Rather, he fully documented the rise and fall of the rococo and did not try to extend the meaning of the term beyond the documentation. After reading his work no one could deny that a radically different and flamboyant style of interior decoration ex-

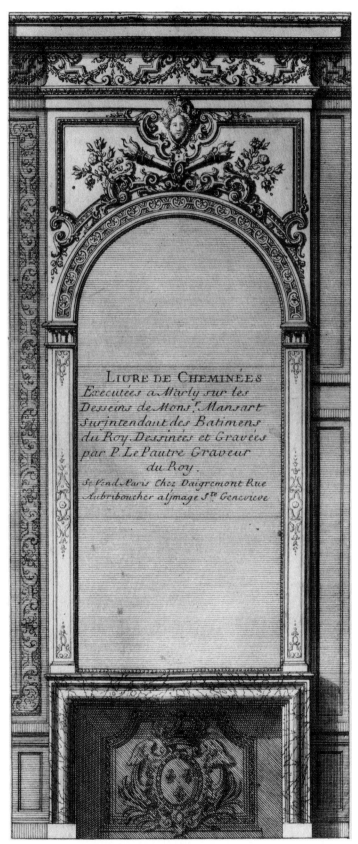

Pierre Lepature, title page, Livre de Cheminées, *1699. The Metropolitan Museum of Art, Harris Brisbane Dick Fund, 1933. (33.84(1), fol. 229)*

isted in France during the first half of the eighteenth century, a style that began at the royal palaces, extended during the *Régence* to the fashionable *hôtels*, was given its fullest statement by Meissonier,[34] became known as the *style rocaille, style moderne,* or *genre pittoresque,* was bitterly criticized starting in the 1740s, and, as we have seen, was ruled or laughed out of modishness by the 1770s. His is the strict definition of rococo.

The formal elements of this style—S-curves, C-curves, shells, mosaic, bat wings, falling water, miniaturization, and asymmetrical cartouches—may easily be traced from Paris to Bavaria, to England, to Italy, indeed to all European countries and their colonies, from St. Petersburg to Albany and Minas Gerais. Thus one could speak with certainty of a rococo design, a rococo room, or a rococo element in a particular building. But writers, critics, and art historians would not be contained by this strict, formal concept of rococo and kept extending the term: sometimes because a formal element linked two different art forms; sometimes because of the juxtaposition of two different forms in the same space; but most often because of a felt or perceived analogy between a rococo form and other works of art contemporaneous with it. Thus the term rococo, like the tendrils of its own artificial vines, spread from interior design to architecture, to painting, to sculpture, to landscape gardening, to music, to literature, and, significantly, to aesthetic theory.[35] It came to include not only the works of Lepautre, Pineau, Oppenord, Meissonier, Lajoüe, and Cuvilliès, but those of Asam, Zimmerman, Watteau, Boucher, Fragonard, Roubiliac, Kent, Couperin, Pergolesi, Gay, Marivaux, and Pope. But it has still not achieved the status of baroque and been accepted as a period style. The enthusiasm for periodization that followed Wölfflin and Spengler, especially in Germany, seems to have run its course, and Wylie Sypher's *Rococo to Cubism in Art and Literature* (1960) was the last book of any note to engage in the effort. Today rococo is, among the learned, regarded as an important style within a period, a period that resists definition except as the eighteenth century.

METHOD

I have already indicated my dissatisfaction with this state of affairs and the reasons why. But

to argue that rococo is *the* period style of the first half of the eighteenth century is a project beset with difficulties, not the least of which is periodization itself. In his famous article "Style," Meyer Schapiro has reviewed these difficulties. Surveying each of the methods of categorization: cyclical, polar, evolutionary, racial, technological, ideological, psychological, and sociological; and finding each one deficient in some regard, he concludes, "A theory of style adequate to the psychological and historical problems has still to be created."[36] Though most periodizers use a combination of these methods, Schapiro does not err in seeing that one approach usually dominates others. My own "method" depends on the ideological and the sociological. Of the ideological Schapiro says:

> The style is then viewed as a concrete embodiment or projection of emotional dispositions and habits of thought common to the whole culture. The content as a parallel product of the same viewpoint will therefore often exhibit qualities and structures like those of style.[37]

The trouble with this approach, he continues, is that "the attempts to derive style from thought are often too vague to yield more than suggestive *apercus;* the method breeds analogical speculations which do not hold up under detailed critical study." After criticizing the analogy between Gothic architecture and scholasticism, he allows that ways of thinking that have been "formulated as the outlook of a religion or dominant institution or class" seem "a more promising field for the explanation of a style." And he grants that such attempts to explain style, though "often a drastic reduction of the concreteness and richness of art, . . . have been helpful in revealing unsuspected levels of meaning in art."[38] Towards the sociological approach he is somewhat less critical, for the framework of art history itself assumes a relationship between style and the forms of social life. But even practitioners of this method shy away from external causes for fear of contaminating the ideal or spiritual with materialism. Marxist writers are among the few who have attempted to apply a general theory of society to artistic production, "but the theory has rarely been applied systematically . . . and has suffered from schematic and premature formulations and from crude judgments imposed by loyalty to a political line."[39]

There is something naive about Schapiro's skepticism, for if carried further, if applied with greater rigor, it causes not only *apercus* and analogies but also all correspondences of any kind to break down and disintegrate. Art and society, the artist and his work, even words and images can have no necessary connection with one another, in the manner of a mathematical proof, and mathematics itself is not invulnerable to such deconstruction.[40] Thus, Schapiro's own methodology precludes at the outset an adequate theory of style. But despite his skepticism and pessimism, Schapiro grudgingly admits some usefulness to a project like this one. And we see that scientists, despite theoretical difficulties and anomalies, depend upon the relationship between data and a hypothesis, the theory of evolution itself providing a useful model of how they work. That hominoids developed into humans, the biologist fully believes, yet he can single out no one fossil and say at this moment hominoids became human; rather he sees a process that occurred over long stretches of time. He can never *prove* that species x led to species y, or that there exists such a thing as homo sapiens and not just millions of discrete individuals each of whom is in a state of flux. Nevertheless he is *certain* that species x did lead to species y because of where the fossils were found, because of radio carbon dating, because of similarities and differences in bone structures, and because of analogies between these species and others for which there exist even more evidence, all of which fit into a general theory of organic development. Random and otherwise meaningless data are then given significance by means of the hypothesis, which, though it may contain some anomalies, is accepted by the biologist as a *fact*. He cannot organize his data without a theory, but his theory remains vulnerable to the skeptical charges of fundamentalists or literalists who "rationally" deny any necessary connection between fact and hypothesis, as well as disagreeing over the interpretation of the data. His theory of course remains subject to change in the light of new discoveries.

In the humanities, such a theory may only be derived by something akin to what John Henry Newman, in his own attempt to counter Humean skepticism, called "the probability."[41] According to Newman, in assenting to hypotheses of any kind—scientific, social, moral, or theological— the mind cannot rely on mathematical proofs, rather it depends on interlocking and interrelated probabilities that reinforce one another to such a degree that one can believe or assent to

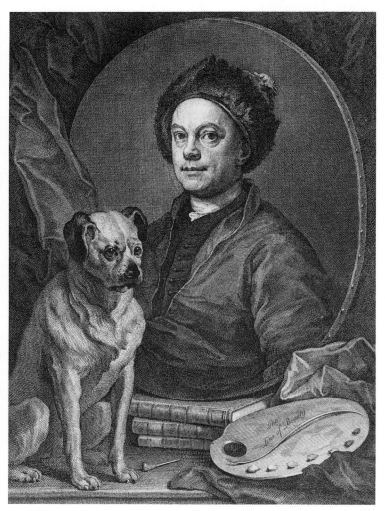

William Hogarth, Guiliemus Hogarth, *1749. Print Collection, Miriam & Ira D. Wallach Division of Art, Prints and Photographs, the New York Public Library, Astor, Lenox and Tilden Foundations.*

the hypothesis as certain. In art history, Arnold Hauser has defended the theory of period style on similar grounds. According to him, style cannot be derived literally from the works that carry it, nor is it ever as accessible as the feelings and conceptions aroused by the particular work. Those who think it should be he calls "positivists." Rather style is like a musical theme of which only the variations are known, yet it is a *fact* because the artist is always in a state of greater or lesser tension with it.[42]

Taking the idea of interrelated probabilities, let us look at how a formal motif can by analogy become a cultural sign. The S-curve, the serpentine line, is universally acknowledged as one of the distinguishing features of rococo style. To a literalist, an engraved, carved, or stuccoed

S-curve cannot signify anything except itself, yet such curves are commonly thought to be feminine. That is why Hogarth called the S-shape "The Line of Beauty," a word more commonly associated with women than men, instead of the line of strength, a word more commonly associated with men than women. In his engraved self-portrait of 1749, he prominently displayed this line in three dimensions on top of his palette. However, we cannot yet leap to the conclusion that the rococo is a feminine style or that the rococo period was one that marked radical changes in male-female relationships. The analogy only begins to convince us when we add other analogies and insights to it. For instance, the predominance of such S-curves in the rococo contrasts to the diagonal constructions favored by the baroque. As a result the baroque seems strong and tectonic in comparison to the soft and fluid—again, conventionally feminine—rococo. Furthermore, the baroque painter favored the heroic and strenuous, his favorite deities were the organizing ones of Apollo and Hercules, while the rococo painter favored the amorous and pleasurable, his favorite deities were Venus and Cupid.[43] Rococo is an interior style, again, by analogy, a feminine domain. Such interiors were employed as salons, where actual women, like the muses, presided over literary and artistic, as well as amorous discourse, as we may see in De Troy's *The Reading from Molière* (ca. 1730). Not only painters but writers, more than at any time since the rise of courtly love, placed women at the centers of their vision, and we see the rise of a new species of writing developed to the traditional concerns of young women, namely courtship and matrimony. The great man of the baroque becomes the good man of the rococo, and goodness is defined as domestic, as being a tender husband, more often than not instructed by his more virtuous wife. Further, at this same moment, we witness an extraordinary increase in professional women writers and painters, some of international reputation, who themselves help to promote a new felt urgency for women's education and women's rights. So by themselves, the S-curves seem virtually meaningless, and nothing particularly new, but combined and associated with so many other formal and social phenomena of their time, one ceases to doubt the *apercu* that they signify the feminine. Although a concern for the feminine, even as males perceive the feminine, is nothing new, one will not find prior to the rococo anything in

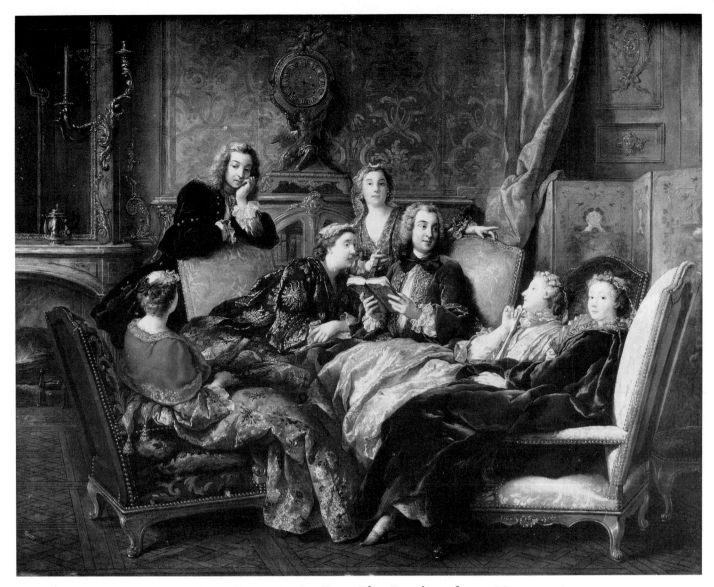

Jean-Francois De Troy, The Reading from Mo-
lière, *ca. 1730. Giraudon/Art Resource, New York.
Coll. Chomondeley.*

the West that brings together all of these motifs
and concerns and combines them in this par-
ticular way—the rococo look, based in part on
the line of beauty, is unique and unmistakable.
By such a process, a motif becomes related to a
style and a style to a period, and the three are
bound together into a *fact* of great significance to
the cultural historian.

Even when scholars agree that there are such
things as period styles at particular times in his-
tory, the practice of writing about them inevita-
bly creates its own distortions, for it tends to
categorize everything before or after the period
as different and everything within it as similar.
History then ends up looking like a neat parade
of prepackaged styles: Renaissance, mannerist,
baroque, rococo, neoclassic, each following the
other in close step. Such a practice overlooks all
that is distinctive and unique in individual
works and artists, one might say all that made

them worth studying in the first place. Further-
more, such a practice tends to subsume all the
local categories of school, or region, or nation,
which in their way are perfectly valid and useful.
In short, in one's efforts to clarify history, one
loses much of what makes history interesting
and worthwhile. But to deny the possibility of a
period style for the early eighteenth century
would also blind one to the discernible patterns
that unite work to work, artist to artist, nation to
nation. As Hauser put it, "The nature of a style is
not that of a schema to be applied again and
again, but rather that of a pattern not to be found
entire in any concrete instance."[44] Recognizing
such a pattern, in this case the rococo, increases
our understanding of the eighteenth century, not
by defining or limiting our thought about it, but
by providing us with one of several useful con-
texts in which its events and achievements might
be explored.

I
Rococo and the Arts

1
Rococo as Revolution

The fact that the development of courtly art, which had been almost uninterrupted since the close of the Renaissance, comes to a standstill in the eighteenth century and is superseded by bourgeois subjectivism which, on the whole, still dominates our own conception of art today, is well known, but the fact that certain features of the new trend are already present in the rococo itself and that the break with the courtly tradition really takes place in the first half of the eighteenth century is not so generally familiar.[1]

REVERSAL AND EQUALITY

THE ROCOCO BEGAN AS A SET OF REVERSALS. IF we look at Pierre Lepautre's design for a chimney panel of 1699 and then compare it to an earlier design for a chimney panel by his father Jean, we see at least four. First, what had formerly been filled with pictorial designs or arabesques, the space within the frame, in this case a biblical scene in an oval frame, has been left blank. Second, what had been structural or tectonic, the pilasters supporting the cornice and the urn above, has become so attenuated that it is a weightless design on the wall; above the arch the frame even breaks into a C-scroll. Third, what had been symmetrical, again the frame, has become slightly asymmetrical, for the two C-scrolls have been treated somewhat differently. And

fourth, what had been rigorously contained architectural ornament has now escaped from the frame to range freely above the arch.[2] None of this happens with the blare of trumpets; it is not a statement or manifesto. But it is the beginning of a revolution in style that corresponds to a revolution in culture, a "dove-footed" revolution as Sedlmayr called it,[3] but a revolution nonetheless.

Lepautre has announced one of its main principles, reversal, and has introduced key formal elements as well, namely asymmetry, atectonicism, and delicacy or lightness. Of course none of these by themselves make up rococo—or any other style—but their eighteenth-century combination does. I am sure Lepautre did not have a great vision and see himself as the father of a new style. Perhaps he did—I wish it were so—but it is more likely that he desired to please the king and used his imagination to create something a little different, out of the ordinary, whimsical, and amusing. What is of great significance to us is that his fantasy caught on, was repeated, and was then developed by other artists for the next fifty years. As we watch rococo develop through the work of Pineau, Oppenord, Boffrand, Meissonier, and Cuvilliès, we see the asymmetry become more exaggerated, the atectonic become more pronounced, the C-scrolls generating S-scrolls, and the addition of a whole vocabulary of ornament derived from the grotto,

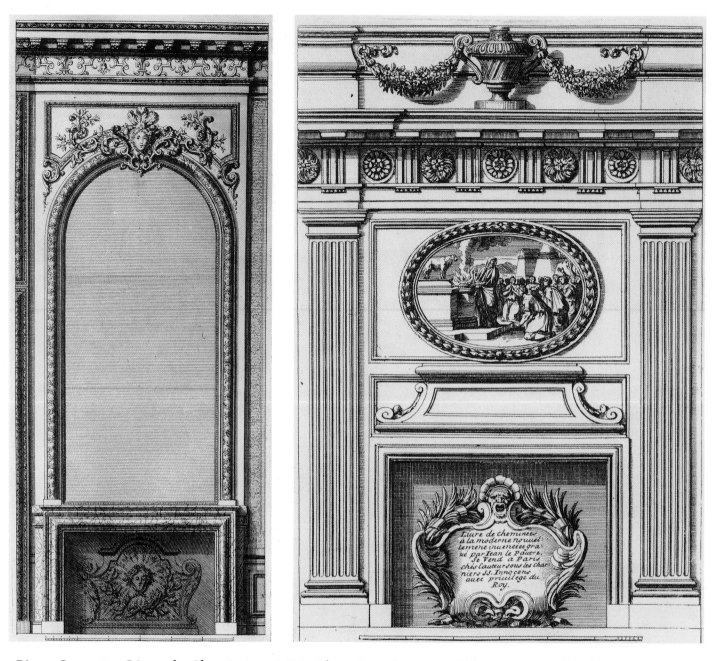

Pierre Lepautre, Livre de Cheminées, *1699. The Metropolitan Museum of Art, Harris Brisbane Dick Fund, 1933. (33.84[1], fol. 232)*

Jean Lepautre, Title page, ca. 1670, from Le Pautre Works, *Mariette Edition, Vol. I. The Metropolitan Museum of Art, Harris Brisbane Dick Fund, 1933. (33.84.1)*

the motifs of rocaille and coquillage, the rocks, the shells, the bat wings, and all the little naturalistic details that delight, or repulse, us today. The cumulative effect of this light, delicate, and playful, style is nothing less than the creation of a second structure—one is tempted to say a second world—made of ornament that partially conceals or masks the actual structure on which it depends. When one first enters a rococo interior, one may feel overwhelmed. Such feelings result from a kind of puritan horror in experiencing so much art—the exact opposite of the *horror vacui* that motivated the rococo artist—and a disorientation caused by experiencing the totality of rococo art. For, like the space aliens in the movies, it comes at you all at once, and there seems to be no order or ultimate arrangement to it; it has taken over the entire compartment and

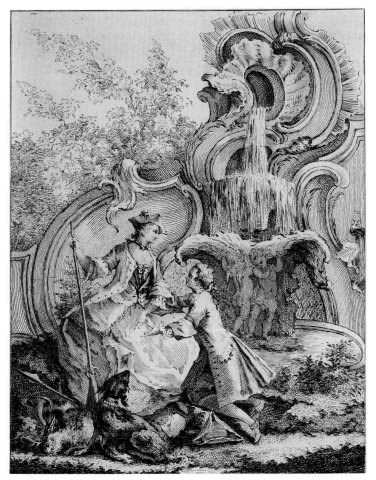

Jean Mondon, Le Galand Chasseur, *1736. The Metropolitan Museum of Art, Harris Brisbane Dick Fund, 1930. [30.58.2(65)]*

created a second disordered and uniform world of its own, or so it seems.

Decoration in general employs stylized or even abstract forms and unlike some painting does not try to deceive the viewer by its illusionism. What distinguishes rococo decoration is the way it simultaneously employs a naturalistic vocabulary and treats it artificially. For instance, in the Amalienburg pavilion (1734–39) at Nymphenburg, we see tendrils growing onto the ceiling through which flit birds and butterflies in low relief. The tendrils and birds and butterflies are meticulously detailed, a kind of *tromp l'oeil*, but they have been silvered over, giving them not only a decorative uniformity but a deliberately antinaturalistic elegance. Always we encounter masterfully rendered natural objects that insist upon their artifice.[4] In the engravings by Meissonier and Mondon what would normally be a frame becomes the principal subject of representation, as though it were real and not a frame anymore. In *Le Galand Chasseur*, though the lovers are presumably hunters at large in the countryside, they have paused before a fantastic fountain made improbably of cartouches and shells from which water spills in stages. In engravings and rooms alike, frames seem broken by natural forms, which then themselves become the framework. And if figures appear amidst the shells and rocks and waterfalls, we do not know whether they are Lilliputian characters at play in a normal landscape or normal characters at play in a Brobdingnagian landscape,[5] though we suspect the former, for the tendency in all rococo art is toward miniaturization.[6] Undoubtedly all representational art at some level consists of a play between art and nature, but rococo art deliberately forces this play, gently, upon our consciousness and uses illusionism to draw attention to the illusion.

Thus to the reversals instituted by Lepautre, subsequent artists added reversals not only of form and content but of the conventional relationship between nature and art. Reversal, miniaturization, and the self-conscious play of nature and art—though differing in degree or effect, all of these depend upon baroque conventions or vocabulary. From this perspective, rococo is indeed a development and even a continuation of aspects of the baroque. But that structural reversal from tectonic to atectonic and that quality of overflowing and dissolving contain within them the seed of radicalism, for what is being dissolved is nothing less than baroque order. By toying with this order, by mocking it, sometimes rejecting it, and always subverting it, rococo in all its aspects implicitly announced not just disorder but a new *system* of things, and of people, which was nonhierarchical.[7] From this perspective, rococo art is not just a shift in "taste" but the realization in art of a profound cultural transformation.

That royalty and the aristocracy patronized this art in no way contradicts its revolutionary aspects. They had, of course, been the patrons of all art, including the ecclesiastical, since the Renaissance. That they cultivated the rococo as well, perhaps the first subversive style in history, does not mean that they were unwitting dupes to their own deposition; what seems more likely is that they themselves felt stultified by the old order and, like Louis XIV, longed for something gay, something delightful, pleasant, and liberat-

ing, a liberation in which all might be able to share, certainly all the polite world, without any threat to established privilege. Rococo was a leveling and subversive style, but like the tendrils and grotto motifs that grew on the walls of the *piano nobile*, it leveled upwards[8] and subverted playfully, without challenging the assumed but invisible order over which it languorously spread itself.

This equalization manifests itself in every aspect of rococo art, beginning with the treatment of light itself. In the rococo salon, such as Boffrand's Salon de la Princesse (1735), light pours into the room through the elongated French windows; it strikes the parquet floors; is reflected up to the chandeliers, which have been deliberately lowered to receive and radiate more light; then glances off the white walls and mirrors, which have been strategically placed about

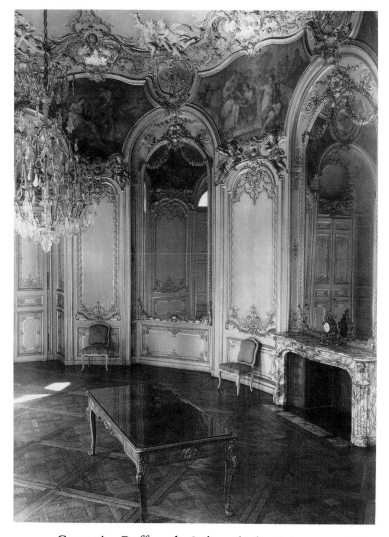

Germain Boffrand, Salon de la Princesse, 1735. Paris, Hôtel de Soubise. Giraudon/Art Resource, New York.

the intimate room. The result is a diffusion of direct and reflected light that creates a pleasant ambiance, an intimacy, even a disorientation, for one is no more sure of the source of light than one is of the exact shape of the faceted room.[9] At night when the light flowed only from the chandeliers, the diffusion would be even more pronounced. In this treatment, such a room was not unlike Pope's grotto where the poet enjoyed a similar play of light reflected and refracted off the gem-encrusted walls and ceiling,[10] for the rococo salon was a refined grotto and serves as an example of the upward mobility of artistic motifs. In contrast the baroque delighted not in generalized diffusion but in chiaroscuro, in a struggle between light and dark, the light itself being an instrument of hierarchy, shining on the figure or place of central importance. Light streamed into the Hall of Mirrors, but only to illuminate its geometrical grandeur.

The treatment of light in architecture has its parallel in the treatment of light in painting. In the seventeenth century the light that came from above was supernatural, revealing epiphanies and apotheoses. In the eighteenth century the light that came from above was natural, shining upon all alike, and no particular object or person is privileged under it, except as the artist chooses.[11] If we look at a representative *vedute* painting, Bellotto's *Dominican Church* in Vienna (1759–60), we see that the church has cast its shadow on the facade of apartments on the opposite side of the street. But that shadow has no significance except a natural one. It will move one way or the other according to how the sun moves; beyond that it conveys no meaning whatsoever, supernaturally speaking. Instead we have a moment, not an epiphany, a secular moment no different from any other moment during the day in the street in front of this church, and of course the people have been miniaturized. We see this same phenomenon in all *vedute* paintings, perhaps none more striking than Panini's view of the interior of the Pantheon (ca. 1740). Here, inside a religious building, the light coming through the oculus, a light that in the seventeenth century would have sought out the Pope or the statue of the saint, now falls indifferently on the wall, as indifferent to the people and sculpture as they are to the religious or historic significance of the structure, now but a setting for their miniaturized and private personal dramas. This empirical, scientific treatment of light, of course, began in the seventeenth century in

Holland, but by the first half of the eighteenth century it was fully established in Italy and throughout Europe. *Natura naturata* had triumphed over *natura naturans*, and the Italian view painters, such as Canaletto, were more interested in the actual look of the place than in its religious or humanistic or even naturalistic essence.

The treatment of time corresponded to the treatment of light. If the baroque painter loved the epiphany, the significant moment that stood out before all others, such as the revelation of Christ at Emmaus, the rococo painter loved all moments alike. The rococo painting is like a frame in cinema, which captures a fragment of an ongoing sequence. Like so much of the poetry of the age, it is a metonymy, not a metaphor.[12] Or, if the moment is significant, it is more likely to be erotic than religious. If we look at Watteau's *A Lady at her Toilet* (ca. 1717), we see her either putting on or taking off her shift—we cannot tell which. There is no apparent reason why the artist should have captured this moment and not the one before or after. But of course the randomness of his choice increases the intimacy of the scene, for we have caught the lady unawares and participate in what in film is known as a privileged moment, privileged just because it is ordinary and private, the very opposite of the spectacular and public baroque gesture. Such treatment of time has its analogue in the novel and its new technique of "writing to the moment." We should note too that this lady of Watteau's is not Susanna or Bathsheba, a significant nude, the only kind a baroque artist would choose as a subject, but an ordinary woman, perhaps a courtesan, perhaps not.[13]

In their attempt to eroticize space, rococo artists, like Watteau, caused nothing less than a revolution in painting. As Norman Bryson puts it, "For its erotic content to be fully yielded up, the body must be presented to the viewer as though uniquely made to gratify and to be consumed in the moment of the glance."[14] Therefore, the rococo artist denied perspective and brought everything forward toward the plane of the viewer. The best space, because it was closest, was the frame itself. Thus in a private apartment, the decorative panel containing an amorous or erotic scene is not a perspective window but a continuation, linked by the frame, of the wall decoration. The scene may undulate, like the wall decorations themselves, but everything is on the same level and seems undifferentiated. This

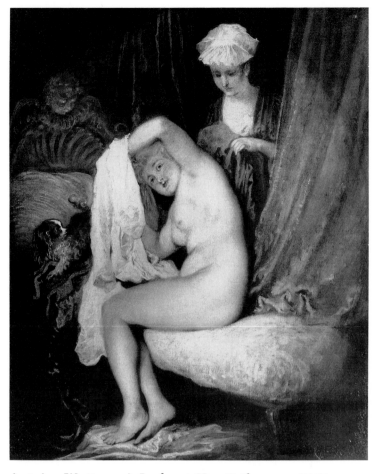

Antoine Watteau, A Lady at Her Toilet, *ca. 1717. Reproduced by permission of the Trustees of the Wallace Collection.*

treatment of space was characteristic not only of Boucher and Fragonard but also of Chardin, an artist not always perceived as rococo.[15] Chardin's work displays a strange harmony between people and things because everything is "evenly out of focus," a reversal of the fundamental idea of composition that determines the viewpoint of the viewer.[16] No object dominates any other because "the entire surface approaches equivalence, the vertical shape 'behind' the canvas can then be put through the first of its transformations: identification with the picture-plane." In Chardin, the "composition is rigorously 'democratic'."[17] These changes in space were of course accompanied by a change in color, the solemn browns, golds, and purples of the baroque being exchanged for the delicate pastels, the silvers, light blues, pinks, and mignonette greens of the rococo,[18] colors that may not be more democratic but are certainly less imposing or intimidating and rather than contrasting with one an-

other, present a shimmering palette of almost equal tone and value.

If light, time, and space underwent a kind of demystification or secularization, we should not be surprised if social hierarchy and class were similarly leveled or equalized. Louis XIV, the epitome of the baroque monarch, was known as *le roi soleil.* His great grandson and successor, Louis XV, was known as *le bien aimé,* a telling example of how amiability and ease had replaced stern virtue and power. Nowhere is this shift more evident than in Watteau's *Gersaint's Shopsign* (1721), in which we see elegant men and women, flirting and admiring pictures, for the most part of an amorous nature, while a portrait of The Sun King lies on its side in the street, undoubtedly being packed or unpacked, but nevertheless caught in this unhierarchical moment in a most undignified position. At the first big party thrown by the Regent after the death of Louis, a party held in Paris, not at Versailles, the new ruler appeared as Pan, the universal demiurge, not as Apollo, the organizer of light.[19] Eros raises, or lowers, us all to the same level. As Dancourt expressed it:

> Au Temple du fils de Vénus,
> Chacun fait son Pèlerinage,
> La Cour, la Ville et le Village,
> Y sont également reçus.[20]

The frankest, most direct sculptural statement of the rococo's aesthetic and cultural program appears in Bouchardon's *Amour se faisant un arc de la massue d'Hercule* (ca. 1750). Here we see the organizing deity or demigod of the baroque, Hercules, forced to give way to the disorganizing deity of love, as Cupid, here a pubescent teenager, fashions the brutality of Hercules's club into the sensuous grace of the bow. And just as the bow curves, so does the whole statue, the bent left knee subtly balanced by the bent right arm, which protrudes only slightly into the viewer's space, thus allluding to a baroque formula while subtly rejecting or refining it, the style and composition of the statue being in perfect accord with its subject. Perhaps more daring or whimsical than most eighteenth-century sculpture, Bouchardon's piece is also representative of them. For they too, through playfulness or virtuosity, extended the limits of baroque artistry into something almost antibaroque. The playfulness undermined baroque seriousness and gravity; the virtuosity created a realism that violated decorum or sacrificed overall composi-

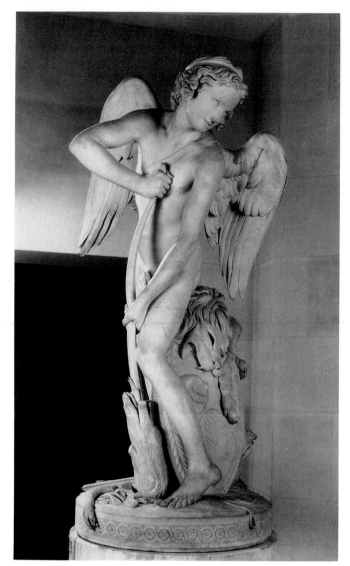

Edme Bouchardon, Amour se faisant un arc de la massue d'Hercule, *ca. 1750. Paris, Louvre.* Giraudon/Art Resource, New York.

tion to flowing and melting surface textures, not unlike those found in the paintings.

The democratic revolution of the rococo may better be seen in literature than in painting, especially in the novel, which turned its gaze away from the court and the king to the country house and the private gentleman. But it is obvious in painting, too. When a prince or an aristocrat sits for a portrait, he has abandoned the attributes of his station and appears as a gentleman, not a gentleman in the style of Van Dyck, not with that easy but arrogant composure, that *haut mien* of the upper classes, but a gentleman taking coffee, in *déshabillé,* relaxed and, like the nude female, accessible to the viewer.[21] In Desmarées' portrait of the Elector Max III Joseph (the one who banned rococo) and his Intendant Count Seeau

(1755), the tapestry above and the crown on the table indicate a royal presence, but his posture, his expression, the fact that he is off-center, that he holds a lapdog, that rather than being distanced, he engages you at eye level, and that his Intendant, who stands above him, casually places his hand on the Prince's chair, all create an informality that equals or surpases that of middle-class portraits or conversation pieces. The portrait in general undergoes an equalization, not altogether an admirable one, in that the clothes become as important, perhaps more important or better rendered, than the face, and the faces look alike, all of them softened and somewhat doll-like. I am speaking not only of minor artists, not of Nattier, Drouais, Desmarées, and Devis, but also of Boucher, Hogarth, and, in his early period, Gainsborough. One could ascribe this quality to conformity, to aesthetic norms, conventions, or taste, yet all classes, from shrimp girl to royal mistress, from servant to king, were treated alike.

Of course, the lower classes are refined. They look like gentlemen and ladies, gentlemen and ladies perhaps masquerading as their inferiors. To a radical all this becomes insufferable because class struggle and conflict have been turned into a game, and the equality I am speaking of appears completely bogus and upper class. But why play this game and not some other? Again, as in the structure of the interior, we notice a kind of doubleness about the rococo; on the one hand it celebrates the leisure, ease, pleasure, and good life available only to the rich, but on the other hand, it pretends that everyone can participate.[22] Though the revolutionary content of its vision is displaced and unthreatening, it nevertheless is present and very much a part of consciousness.

A similar doubleness characterizes early eighteenth-century notions of genre. Connoisseurs, critics, and artists of the time were as aware as anyone ever had been of the genres of painting and voiced allegiance to them. But typically what was most vital about rococo art occurred in either new or hybridized forms. Watteau inaugurates rococo painting with the *fête galante*, in part, an imaginary landscape; in part, a genre scene, an ultrarefinement of the "Merry Company" depicted in a seventeenth-century Dutch tavern; in part, portraiture of his friends; and in part, a representation of theater.[23] Another new species is the "Conversation Piece," which has been called an anglicization of the *fête galante*.[24]

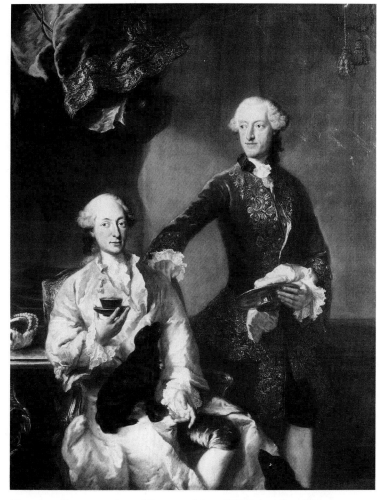

George Desmarées, Elector Max III Joseph of Bavaria with His Intendant Count Seeau, *1755. Munich, Schloss Nymphenburg.*

It, too, consists of components of several established genres—group portraiture, landscape, topographical painting—all combined to present an intimate, playful, and unhierarchical picture of the family, though of course their wealth and affluence are more than implied. Some works do not form new genres but blend several existing ones, for instance Oudry's *The Dead Wolf* (1721), which is a strange, almost surreal mixture of a still life and a hunting scene. And perhaps the most striking example of a new genre is Hogarth's "Modern History Painting," for instance *The Marriage à la Mode*. Instead of depicting Biblical or historic scenes, the paintings, like de Troy's *tableau du mode* represent contemporary ones; instead of being large, they are diminutive; and instead of being heroic or tragic, they are comic or satiric. Governed by a serpentine "line of beauty," which brings the action forward into one plane; rich in their play of nature and art, the paintings and all the human

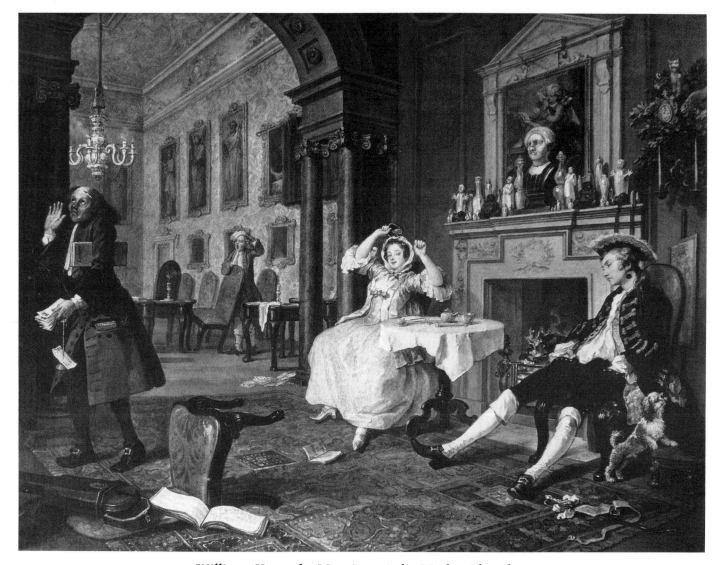

William Hogarth, Marriage à la Mode: Shortly
After the Marriage, *1745. London, National Gal-
lery. Foto Marburg/Art Resource, New York.*

artifacts comment upon the action, critical of
upper and lower classes alike; delicately painted
yet at times grimly realistic, these are in every
respect as rococo as the *fêtes galantes* and may be
seen as a corollary to them.

Had Watteau not lived, one suspects a similar
development would have taken place, for many
rococo elements appear independently in the
court painters Largillière and Rigaud. In por-
traiture the clothes seem as important as the
face, for the clothes allowed the full play of brush
stroke and a realism of surface in which one can
almost hear the rustle of the silk. Even an artist
such as Allan Ramsay, who was capable of ren-
dering exact likenesses of his subjects—com-
pared to Devis or Gainsborough or Hogarth his

portraits now seem like photorealism—devoted
equal attention to the likenesses of their clothing,
which, of course, in the fashion of the time, pos-
sess the rosy hues and pastel shades of the
rococo. The baroque diagonal, as a principle of
composition gave way to the rococo serpentine,
which undulated two-dimensionally across the
surface.

Italian painting of the first half of the eigh-
teenth century presents similar developments.[25]
Pellegrini, for instance, while working in En-
gland began to paint decoration *as* decoration.[26]
In Piazzetta, Pittoni, and the Riccis, one can see
the same melting, the same softening, the same
concern with the surface of the work, which
breaks down distinctions by suggesting that

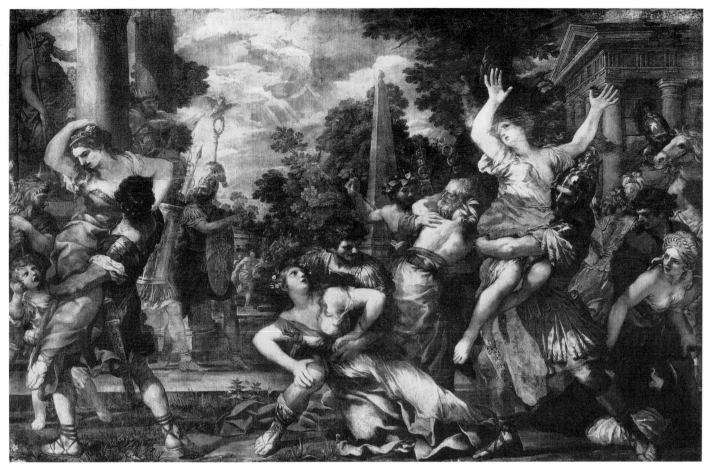

Pietro da Cortona, Rape of the Sabines, *ca. 1628.
Rome, Palazzo dei Conservatori, Pinacoteca. Al-
inari/Art Resource, New York.*

everything beneath is also alike, and the same diffusion, which tends to sentimentalize or feminize the heroism of the baroque. It is very instructive to compare Cortona's *Rape of the Sabines* (ca. 1628) to Sebastiano Ricci's (1701), though the latter is certainly a history painting in the baroque tradition. The surface brush strokes, the gluey attachments of the figures to one another, the delicacy of the colors, the busyness of the composition, the less structured relation of background to foreground, the questionable architecture of the temple behind, the introduction of still-life or genre detail in the foreground, all seem to work against the gravity of the subject. In his and his nephew Marco's "monumental" paintings, such as the *Homage to Sir Clowdisley Shovell* (1725), the human figures become dwarfed by the antique settings, and that is after all what they are, mere stage scenery, and the scenery itself looks insubstantial, as though Rome were indeed going to melt into Tiber. In still other works he is entirely rococo, as

in *The Last Supper* (1710–20) in Washingon, where Christ and his disciples are depicted as players in a drama, framed within a proscenium arch within the painting itself, an effect of self-consciousness completely alien to baroque religious standards.

At first glance the verisimilitude of the *vedute* paintings would seem to separate them from the paintings so far mentioned. But like Chardin's still lifes, they stand at the realistic pole of the rococo aesthetic. We have already mentioned how Bellotto and Panini have secularized light, and as in Chardin's paintings, the light and all the subject matter of the work have been treated equally; there is neither architectural nor social nor even the formal hierarchy that chiaroscuro might lend. Rather we are presented with a view—it seems almost arbitrary—in which every detail has the same value and is rendered with the same care. The humans within the view are miniaturized, which means a double miniaturization, for most of the works of Canaletto

and his nephew Bellotto, the two most formidable artists of this genre, are themselves small in scale, smaller by far than the typical seventeenth-century topographical painting, from which they descend. These paintings turn the city into a work of art. Of course, as a human artifact cities are works of art, but until the eighteenth century they were rarely treated as such by artists, the most notable exception being Vermeer's *View of Delft* (1662). These view painters of Italy traveled throughout Europe, Canaletto monopolizing the English trade, the most lucrative one of the time, and his nephew "doing" the Holy Roman Empire and Poland. What they added to the tradition of topography and landscape was not only the cityscape as a genre but the consciousness of the city as a work of art. Baroque planners such as Bernini and Wren created urban spaces, if not cities, but the view painters both objectified and prettified such spaces, popularizing them and turning them into souvenirs and saleable properties. In *vedute* painting we see once more the heady conjunction of commerce and consciousness that was present in Watteau and the dialectic between art and nature that characterizes all rococo works.

Inseparable from the equalization of the rococo is its feminization. One does not know whether this feminization resulted from the breakdown of hierarchy and thus male dominance or whether the rise of women caused the changes. In neither eighteenth-century society nor art did the status of women measure up to modern expectations. Legally women were no better off than they were in the seventeenth century. Artistically, they tended to be the objects of male voyeurism and erotic fantasy. Nevertheless an extraordinary change, which is everywhere apparent, had taken place not only in sensibility and consciousness but in practice. As Lawrence Stone has pointed out, in England by 1660 the affectionate marriage had become the norm in all classes but royalty itself; that is, women and men chose their mates according to their affections, not according to parental arrangements.[27] The parents still had a veto on the daugher's choice, but she had a veto on theirs. To an eighteenth-century reader, the behavior of the Harlows towards Clarissa, forcing her to marry the odious Solmes, or Squire Western's to Sophia, forcing her to marry Blifil, was already old-fashioned and almost as outrageous as it would be to us.

The adjectives used to describe the rococo are feminine, or customarily associated with femininity: tender, delicate, soft, intimate, erotic, playful, curvaceous, pleasant, dissolving, and, pejoratively, disordered, frivolous, and superficial.[28] It is not a style suitable for tragedy. Its formal motifs, its rocks and shells, its little animals and insects, derive from Venus and Mother Nature. Of the four elements, water and earth are the most predominant, as are, among the seasons, spring and summer. It celebrates fecundity as well as pleasure, for the interior spaces of the rococo, both secular and religious, can be seen as glorified wombs, every surface of which is equally alluring and desirable.

In all the arts the baroque *great* man, whether Louis le grand or Almanzor, had given way to the rococo *good* man, whose sphere of action was not the heroic world of the epic but the domestic one of the novel. In the heroic world women are marginal; they weep or cheer on their champions. They may be the objects of victory or the motives for the war, but the action centers on the men. This cannot be so in the domestic world, where women are the center of attention and the equals of men, for there men must engage the women on women's own terms. If the action in the heroic world is a battle, the action in the domestic one is a courtship. And because courtship and violence are antithetical, the villain of the rococo world is a rapist, the man who confuses masculine and feminine values and the heroic and domestic worlds. Typically this rapist is "old-fashioned," an aristocratic anachronism from a former age, Lovelace in *Clarissa* being the best developed example of the type.

Given this domesticity and femininity, it does not surprise us that the greatest portrait done by Boucher, the court painter to Louis XV, was not a portrait of the king himself but of his mistress, Madame Pompadour (1756), who presided over the arts of France in the 1740s and 1750s. And Boucher's greatest mythological painting did not depict Apollo, the organizing masculine principle, but Venus, the (by male standards) disorganizing feminine one,[29] indeed it is entitled *The Triumph of Venus* (1740). In the Amalienburg, the epitome of the secular rococo, we find in the bedroom matching portraits of the Elector of Bavaria, Karl Albrecht and his wife Maria Amalia, for whom the building was named. Both the Elector and his wife are seated, both are in hunting costume, both have dogs at

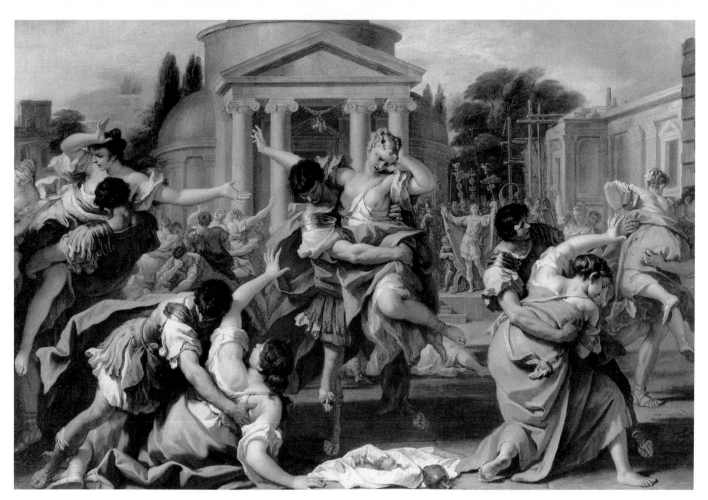

Sebastiano Ricci, Rape of the Sabines, *ca. 1703. Collections of the Prince of Liechtenstein, Vaduz Castle.*

their feet, and both of them hold guns, an attribute of power usually reserved for the male. Such complete equality did not merely exist at court. In all of Watteau's paintings men and women are treated similarly, the men being no larger than the women and having the same attenuated, delicate physiques. The *fêtes galantes*, the conversation pieces, the landscapes, the mythological panels, the genre scenes, in all the types of eighteenth-century painting of the first half of the century, we see women as the center of attention or as the equals to men. And if a man stands over a woman, which is very rare, or if a woman is meant to be the inspiration to the man, as when Mrs. Garrick plays the muse to her husband David in the portrait by Hogarth (1757), we may be sure that the man is depicted not at court, not in battle, not in the clouds of virtue, not in any place where she would be an attribute to his power and glory, but in the inner space of

William Hogarth, David Garrick and His Wife, *1757. Copyright Reserved to Her Majesty Queen Elizabeth II. Hamilton Kerr Institute, Cambridge University.*

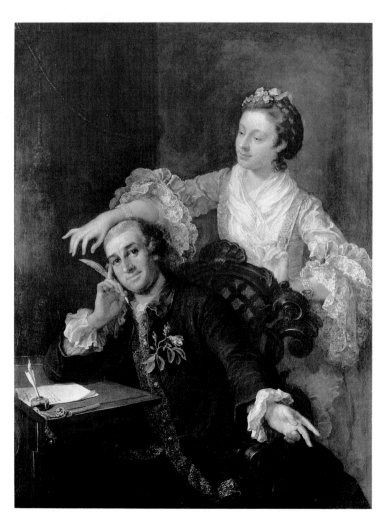

her own domestic world, a world revolutionized and eroticized by the comfortable upholstery, curving furniture, charming place settings, exquisite china services, and delicate wall colors of the rococo.

All this was no more a game or a passing fancy than it was a taste. Women had become not only the center of interest to artists but artists themselves, particularly novel writers, the novel being a species of writing about them, for them, and by them. They patronized literature and the other arts; they presided over salons; they organized women's literary societies, one of whose chief concerns was the rights of women. However superficial or unthreatening the rococo style may seem to us today; however suspicious we are because it did not assert the violent overthrow of the *ancien régime* and institute structural changes, it did announce a far deeper change in human consciousness, a change so deep that no subsequent period, despite strenuous, at times hideous, efforts in both the nineteenth and twentieth centuries, has been able to reestablish the male, heroic ideal.

POLARITY AND DIALECTIC

Hauser, as we have seen, recognized the revolutionary quality of rococo art, but he also said that rococo is "still a very aloof, very refined and essentially aristocratic art." He believed the attack upon it came from two different directions, the emotionalism and naturalism of, among others, Hogarth and Richardson, and the rationalism and classicism of Lessing, Wincklemann, Mengs, and David.[30] Both of these directions represented bourgeois taste and values, which by the end of the century had triumphed completely over the courtly tradition. Yet, it is not so easy to separate courtly and bourgeois elements within the rococo because, as Hauser states:

The rococo really represents the last phase of the development which starts with the Renaissance, in that it leads to victory the dynamic, resolving and liberating principle, with which this development began and which had to assert itself again and again against the principle of the static, the conventional and the typical. It is not until the rococo that the artistic aims of the Renaissance finally succeed in establishing themselves; now the objective representation of things attains that exactness

and effortlessness which it was the aim of modern naturalism to achieve.[31]

Thus, although the middle-class art that Hauser first sees appearing in the rococo "was already something fundamentally new," and fundamentally opposed to traditional art, middle-class art and culture had their origins "in the elite cultures of the Renaissance, the baroque and the rococo." So, according to Hauser, rococo is at once courtly and anticourtly, traditional and new, elite and bourgeois, and so subversive that it subverts, or dissolves, even its own traditional elements. To understand it, one must appreciate the dialectic to which it gives such full expression. Hauser continues:

The rococo itself prepares the way for the new alternative, by undermining the classicism of the late baroque and by creating with its pictorial style, its sensitiveness to picturesque detail and impressionistic technique an instrument which is much better suited to express the emotional contents of middle class art than the formal idiom of the Renaissance and the baroque. The very expressiveness of this instrument leads to the dissolution of the rococo, which is bent, however, by its own way of thinking on offering the strongest resistance to irrationalism and sentimentalism. Without this dialectic between more or less automatically developing means and original intentions it is impossible to understand the significance of the rococo; not until one comes to see it as the result of a polarity which corresponds to the antagonism of the society of the same period, and which makes it the connecting link between the courtly and the baroque and middle-class preromanticism, can one do justice to its complex nature.[32]

So while Hauser can discuss middle-class or bourgeois elements in a rococo work of art and can see middle-class culture developing within the last style of an elite culture, in fact, as he admits, rococo cannot be properly understood as long as one imagines it as merely an aristocratic style into which bourgeois elements have crept. Rococo contains these two polarities, among others, in dialectical opposition. It is both aristocratic *and* bourgeois. Here Hauser's theory is very similar to McKeon's about the origin of the novel, for the novels of the mid-eighteenth century, like rococo style, contain within them aristocratic, progressive, and conservative perspectives.[33] When we look at a painting by Boucher, for instance, *Diana at the Bath* (1742), we can say,

François Boucher, Diana at the Bath, *1742. Paris,*
Louvre. Alinari/Art Resource, New York.

following Hauser, that the mythological subject and the beautiful representation of it are courtly and rococo, but that the expressiveness of the nude and the eroticism of the painting are bourgeois. The technical quality of the piece may belong to one or the other. Or if we look at the Boucher portrait of Mme. Boucher, we must say that the subject matter is definitely middle class as is everything about her room, except the negligence of her pose and the charming disorder of her attributes, which are more courtly and appropriate to Mme. Pompadour or Diana. In both instances it becomes extremely difficult to disentangle rococo and middle-class styles or values. What Hauser might in one context call middle class, he would in another call courtly, for the

rococo is like a trick postcard that displays a different picture according to how one holds it.

Patrick Brady has suggested that the essence of the rococo may be seen in a structure of these binary opposites that he lists as "naturalness and artificiality, negligence and precocity, reality and fiction, truth and illusion, freedom and constraint, skepticism and utopianism, immediate pleasure and ideal beauty."[34] To these I would add eroticism and domesticity, decoration and expression, profusion and simplicity, surface and interior, ancient and modern, town and country, aristocratic and middle class, high and low, big and little, morality and pleasure, irony and feeling, the head and the heart, secular yet pious, and trivial but essential, or "grave in trifles."[35]

François Boucher, Madame Boucher, *1743. New York, The Frick Collection.*

Almost all of these may be subsumed under the category of art and nature: the art including the artificial, constrained, ancient, aristocratic, high, superficial, and ironic; the nature including the natural, free, modern, middle class, low, subjective, and passionate. Of course in practice the oppositions do not work so neatly, for the art may be spontaneous, expressive, and pleasurable while the reality may be constrained, superficial, and moral. Certainly in the novels the freedoms of the aristocracy are opposed by the morality of the middle class, who are typically more genteel and traditionally virtuous. The dialectic of the rococo, and the wit of the age, lay in the mixing up and confusing of these oppositions. Boucher's *The Dark-Haired Odalisque* (ca. 1745), is painted to look like a sofa or a bundle of dry goods while the presumed *Mme. Boucher* (1743), though fully clothed and respectable, has a piquant look that promises greater sexual bliss. To further confuse matters, the courtesan and the middle-class lady may both in fact be portraits of Mme. Boucher, or at least the same woman.[36]

Just as Boucher combines courtly and middle-class techniques and subjects, so does Chardin, who has traditionally been seen as his antithesis. From one point of view he *is* his antithesis, just as Fielding and Richardson are antithetical. But

of the work, not the artist, who is not unlike a flagon or copper vessel in a still life. The painting may now arouse more pathos than a painting by Greuze, such as *The Punished Son* (1778), which aims directly at arousing our feelings, but Chardin's neutrality toward his subject corresponds perfectly with his equalization of space and light. Though itself closer to the pole of naturalism, the painting still draws our attention to the other pole of artifice.

Both of these tendencies appear in the work of Louis François Roubiliac (1702/5–62), one of the greatest of eighteenth-century sculptors. Of Huguenot descent, he left France early to study in Dresden with Permoser, a student of Bernini's, returned briefly to France, and then left to pursue a career in London. Whinney calls him the "most accomplished sculptor ever to work in England."[38] In 1738 he completed the two great sculptures that established his reputation. One was the portrait of Handel that was commissioned for Vauxhall Gardens; the other was the portrait bust of Alexander Pope. The Handel is indisputably a rococo work. The artist sits casually in a state of *déshabillé*, happily strumming

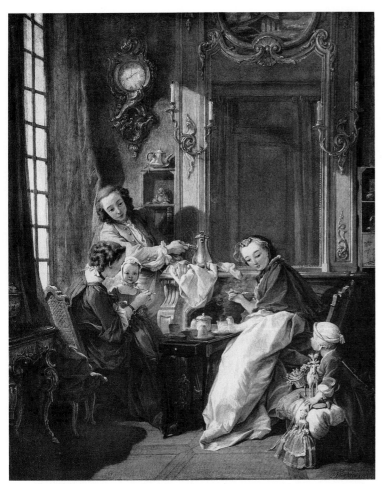

François Boucher, Le Déjeuner, *1739. Paris, Louvre. Alinari/Art Resource, New York.*

like Fielding and Richardson, the two share so much in common that from another point of view, the differences in their art may be seen as the polarities *within* one period and one style.[37] We have already referred to Bryson's illuminating discussion of rococo space, which explains the common techniques and goals of both artists. To this we would add that, like Chardin, Boucher painted middle-class genre scenes, such as *Le Déjeuner* (1739); they are in fact among his greatest works. And like Boucher, Chardin favored women and children. His love of open vessels, inner spaces, and open doorways, the delicacy of his works, their diminutive size, all attest to his full participation in the feminization of art and the triumph of the domestic vision. Even in works that might be considered bourgeois realism, such as *Young Student Drawing* (1738), we see not only that the artist lacks a good coat, chair, and model, but that the work is about art; one might say that art, the copying of a drawing or the painting of a painting, is the actual subject

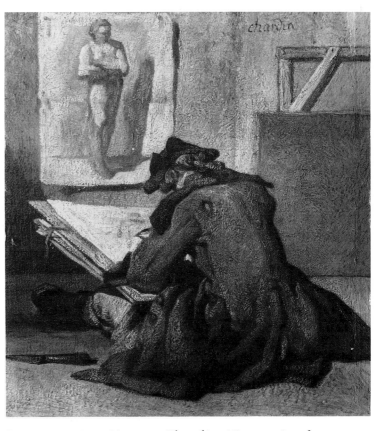

Jean-Baptiste-Simeon Chardin, Young Student Drawing, *1738. Stockholm, Nationalmuseum.*

Jean-Baptiste Greuze, The Punished Son, *1778.*
Paris, Louvre. Giraudon/Art Resource, New York.

an imaginary lyre, one slipper off his foot. The composition's serpentine curves, its air of playfulness and ease, accord perfectly to the rococo aesthetic, which from one point of view may be seen as an extension or loosening up of established baroque formulas. Yet from another point of view, the work asserts radically new values. "The rhythms are quick, the pose informal and realistic, and above all the expression of the face, with the composer listening intently to the notes he is playing, is an example of that interest in transitory mood, in change rather than permanent ideal, which is a fundamental characteristic of the Rococo."[39] It was the first public sculpture ever devoted to an artist; all previous ones depicted monarchs, military heroes, or saints. It

was designed specifically for a public pleasure garden, not a royal park or country estate but an urban, public garden, where the middle class could go to enjoy not only the music of Handel but sculptures and paintings like this one. And it was commissioned by the middle-class entrepreneur, Jonathan Tyers, who owned Vauxhall. Only one year before in France, the inauguration of the Salon, a parallel event, "marked a removal of art from the ritual hierarchies of earlier communal life." It "was the first regularly repeated, open, and free display of contemporary art in Europe to be offered in a completely secular setting and for the purpose of encouraging a primarily aesthetic response in large numbers of people."[40]

Handel was a sublime artist, but Roubiliac

artfully rendering surface textures—the lines and cavities of Pope's face.

Other sculptors working in England displayed the same polarity. Guelfi's *Monument to James Craggs* (1727) introduced the casually cross-legged stance, the face leaning on one elbow, the whole body twisted and formed into an S-shape, a posture that became a norm in both painting

Louis François Roubiliac, Handel, *1738. London, Victoria and Albert Museum.*

Louis François Roubiliac, Handel, *detail, 1738. London, Victoria and Albert Museum.*

treated him not as anyone extraordinary but as an everyman, a happy amateur. The bust of Alexander Pope seems another matter altogether. The incredible realism of the piece, the veins starting out on Pope's face, the look of nervous tension and pain, might be called bourgeois naturalism. Yet, the liveliness of the work's surface and its naturalism are actually rococo characteristics, as is the moment in which Pope has been captured, characteristics that immediately distinguish this work, even if one did not recognize Pope, from baroque or Victorian realism. Here, then, in two works done by the artist in the same year, we see both the originality and the polarities of rococo style: an artfulness that is rendered naturalistically—the weight of Handel's arm presses down the folios of his compositions—and a naturalism made possible by

Louis François Roubiliac, Alexander Pope, *1738. The Barber Institute of Fine Arts, The University of Birmingham.*

tures than had been customary,[43] and their portraiture set new standards not only for naturalism but for capturing the spontaneous and the living moment, as when at Notre Dame, we see at prayer on either side of the chancel altar Louis XIV, by Coysevox, and his father, by Guillaume Coustou (1715). One remarkable work is Robert Le Lorrain's *Les Chevaux du Soleil* (1723–29), a relief over the stable door at the Hôtel de Rohan. As though emerging from the stone, Apollo's horses appear, rearing, twisting, in great agitation, unharnessed, wild, on the verge of stampeding, as their attendants struggle to contain them, as in Tiepolo's great conception at Würzburg. Le Lorrain, the Coustous, Coysevox, these men were the first generation of rococo artists, but the style was given its fullest expression by the second generation: Jean-Baptiste Lemoyne, Edme Bouchardon, Jean-Baptiste Pigalle, Louis-Claude Vassé, and Etienne Falconet. Like Roubiliac, each of them produced playful works, cupids or sensuous bathers, alongside more serious funerary and equestrian monuments. And as in Roubiliac's sculpture, the "frivolous" pieces are based on close observation and the serious ones contain unusual anatomical detail, veins and muscles carefully delineated, or an almost trompe l'oeil representation of clothing and drapery. In the church of St. Sulpice in Paris, Pigalle carved a rock, covered with naturalistic little creatures, which supports a great shell containing holy water (1745). Though naturalistically rendered, the rock is clearly an artifice; its virtuosity amuses us but never deceives us, whereas Bernini's rocks in the *Four Rivers Fountain* in the Piazza Navonna could possibly be real, or so they seem. In Notre Dame de Bon Secours in Nancy, on the tomb of King Stanislas (1768–72), by Vassé, a baby cries at its mother's breast, in the moment, presumably, before she gives it her nipple. In the best sculptures, such playfulness and realism are combined. For instance, Pigalle's *Mercury* (1742) displays the god in a moment of repose, a privileged moment, as he picks a thorn out of his foot. In the terracotta version of the work at the Metropolitan in New York even his usually stiff steel helmet droops and flops with a kind of ease and languor. Because terra cotta caught the impression of the moment and allowed for fluidity, eighteenth-century artists favored it for final works much more than did their predecessors. When one compares a bust by Bernini, for instance *La Constanza* (1635–38), to a woman by LeMoyne, one sees

and sculpture,[41] one of the best examples being Scheemakers' statue of Shakespeare (1740) in Westminster Abbey. Even Rysbrack's *Monument to Sir Isaac Newton* (1731) shows Newton sprawled across his tomb, his arm casually leaning on some books. Grave putti record his thoughts, while above him Astronomy drapes herself over the globe. Margaret Whinney describes the composition as a balancing of diagonals,[42] which is true except that the diagonals are broken and S-shaped, the whole spirit of the work being much more rococo than baroque.

These same tendencies existed of course in France. Just as rococo interior decoration began under royal patronage, so did rococo sculpture, chiefly from the school of Versailles. The two Coustous and Coysevox gave more movement and verve even to their massive garden sculp-

Robert Le Lorrain, Les Chevaux du Soleil, *1723–29. Paris, Hotel de Rohan. Giraudon/Art Resource, New York.*

immediately that despite Bernini's realism and despite his capturing a moment in time, that the rococo artist has provided even more surface detail and realism and the momentariness is still more greatly heightened. All of Bernini's work speaks to eternity; Lemoyne and the other rococo sculptors give us the sense of having seen something through the keyhole, of having caught their subjects in a moment of privacy and self-bemusement. In his TV program *Civilization*, Lord Clark called one of the episodes devoted to the eighteenth century "The Smile of Reason," and he created a clever montage of eighteenth-century sculpture in which all of the subjects had this same little smile of amusement or knowingness, a smile that is not public but private.[44]

Because the eighteenth century *in toto* is often regarded as the *ancien régime*, twentieth-century students often miss its middle-class dimensions. If anything, the rococo, which is sometimes

Jean-Baptiste Pigalle, Mercury, *1742. The Metropolitan Museum of Art, Bequest of Benjamin Altman, 1913. (14.40.681)*

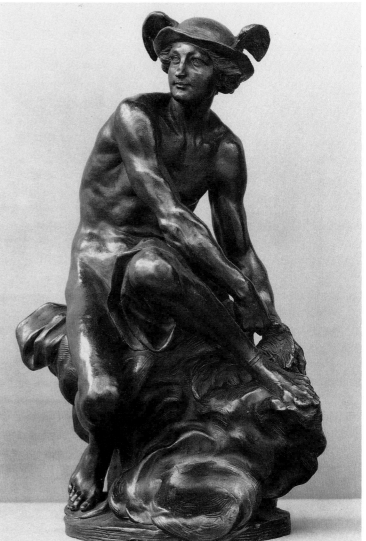

thought to be the very limit of upper-class refinement or decadence, was more of a middle-class than an aristocratic style. As Sypher put it, "Rococo shrinks the grandeurs of the preceding Baroque, but without in the least vulgarizing the manners of a new middle-class society that could hardly take monarchy as seriously as it was taken in the splendid days of Louis XIV."[45] Its purest examples came in the form of prints by Meissonier, Mondon, Lajoüe, and Nilson, or in porcelain miniatures, the very kind of art that the middle class could afford, as opposed to the paintings and interiors of the very privileged. It appeared in everything from watch cases and cane heads to hunting rifles, from tea services to fans, from dress designs to wallpaper, wallpaper itself being a much cheaper way to make one's rooms *à la mode* than tapestries or carved paneling. The very "refinement" of so many eighteenth-century rococo *objets* signifies the middle class's efforts to imitate or share the tastes of the rich. In fact, the rococo was the first historic instance of the widespread commercialization of a style, and its rapid spread to all the nations of Europe and to all strata of society bears witness to what has been called the "Consumer Revolution."[46] One notices that a great deal of the repugnance toward the rococo, starting after its popularization through the prints in the 1730s and 1740s, came about because aristocrats and intellectuals thought it *vulgar.*[47] As Cochin said ironically in his famous attack on the rococo, "Can one lack taste when one has money?"[48]

Nowhere do we see the fusion of the elite and the popular in the arts more clearly than in porcelain, the most typical, representative, and essential works of the rococo. From 1708 or 1709 when a German alchemist, Johann Friedrich Böttger, rediscovered how the Chinese made it, the craze for porcelain swept over Europe. In the seventeenth century, genuine china had been a luxury item, affordable only by the rich. The Elector of Saxony bankrupted his state collecting it; this was the same ruler who held Böttger under house arrest until he could rediscover how to make it. Fortunate Böttger, and fortunate Saxony, whose capital Dresden and its adjacent town Meissen, where the porcelain factory was located, gave the new product its generic names. Although the Electors of Saxony wished to keep their industrial secret, and although Dresden led in the technology and artistry of china ware, at least until Frederick the Great shelled and de-

Franz Anton Bustelli, Lalage, *Nymphenburg, ca. 1758. The Metropolitan Museum of Art, Gift of R. Thornton Wilson, 1943, in memory of Florence Ellsworth Wilson, 1943. (43.100.56)*

stroyed much of Meissen during the War of the Austrian Succession, the demand for porcelain was too great. Other alchemists went to work, and Meissen artisans escaped or left Dresden, carrying its secrets to other capitals, to Vienna, to Sevres, to Chelsea, and to Munich. If china did not become exactly common, its widespread acquisition and use extended far into the middle class; a phenomenon that once more attests to the democratization one finds in every aspect of rococo style. For one does not find aristocratic china and middle-class china. Such distinctions might apply to silver, but the porcelain shepherdesses, the Chinese peasants, the monkeys, the fruits and animals, and best of all, Bustelli's

between art and nature, as in *Chinese Pavilion* (ca. 1770) by the German artist, Lück. So the porcelain figures are not merely (for Europe) a technological innovation but a worldview, a view that not only combines art and nature in a new and self-conscious way but also unites art and commerce, high and low.

Karl Gottlieb Lück, Chinese Pavilion, *Frankenthal, ca. 1770. The Metropolitan Museum of Art, The Jack and Belle Linsky Collection, 1982. (1982. 60.294)*

characters of the *commedia dell'arte,* were found alike on the tables of palaces, salons, and middle-class dining rooms.

These porcelain sculptures epitomize the idea of the rococo. They depict human beings, but the humans have been miniaturized. Like the figurines of the commedia dell'arte, the humans play roles, wear costumes, and though puny, are artful. Yet such roles are natural to them, the paradox being that it is human nature to be artificial. The monkey orchestras make the same point: though we are but animals, and therefore ridiculous, we are aesthetic creatures and therefore charming. Whereas the baroque artist saw human beings caught in an epic struggle between the supernatural and the natural, the rococo artist saw them more ironically in a play

Jean Restout, The Death of St. Scholastica, *1732. Tours, Musée des Beaux-Arts. Réunion des Musées Nationaux.*

That the rococo was not merely secular and erotic, we may see in religious paintings of the period. Perhaps the most famous is Restout's *The Death of St. Scholastica* (1732). The figures are arranged along serpentine and C-scroll lines, heads and bodies closely grouped, as though they will merge, just as the drapery and garments seem to flow together or turn to feathers. Throughout the artist has maintained a constancy of value. The colors are soft and delicate and the changes are slight. Even the whites have been somewhat diffused and are not too bright. Compared to baroque paintings, the figures have been reduced in size or scale and confined to the lower half of the painting, and the baroque diagonal of the staff has been counterbalanced by the diagonal of the crucifix. Instead of being baroque, the painting alludes to the baroque and demonstrates how the religious tradition of the seventeenth century has been transformed by the rococo. The presence of rococo even here in this serious, grave, and pious subject, one of the most successful of eighteenth-century religious paintings, argues for its being a true period style.

Because the rococo is perceived as merely frivolous, one has no difficulty in recognizing the statues by Ferdinand Tietz in the Gardens of Veitshöcheim (1765–68) near Würzburg as representative works. Such deities, such as *Pallas Athena*, fit well into the category of *camp* by which one condescends to rococo style. Yet Germany produced a number of extraordinary sculptors in the eighteenth century, many of whom were architects or stuccoists as well. Even more extraordinary, they were men of devout and exemplary lives, whose primary works celebrated the glory of God and his church on earth. That rococo, which is usually thought of as a secular style, could be just as effective in expressing deep religious devotion is but another argument for its being a genuine period style. E. Q. Asam, the Feichtmayrs, Dominikus Zimmerman, J. B. Straub, and Ignaz Günther stand out as individual geniuses, but many of their assistants and helpers were almost as talented. Together they created the sinuous, curving, attenuated, good-natured and sublime figures that inhabit the niches, pulpits, and altars of the full-blown rococo churches, such as Günther's *Guardian Angel* (1763) in Munich. These works, of course, derive from Bernini and the baroque, but like the architecture and decoration that accompany them, they have developed into a further, one

Ferdinand Tietz, Pallas Athene, *1765–68. Veitshöchheim, gardens. Foto Marburg/Art Resource, New York.*

must say extreme, stage of agitation, delicacy, or self-consciousness, which separates them from their stylistic origins. For instance, in the church of St. Michael at Berg-am-Laim, in Munich, we find J. B. Straub's statue of the angel Gabriel in the act of announcing to Mary her unique role in the salvation of humanity (ca. 1767). We see to the right of the angel a putto, holding an inscription of Mary's response, *"Ecce ancilla domini,"* but Mary herself is missing. Is this a parody of one of the most sublime moments in human history? Undoubtedly not. The church is dedicated to one archangel and another is shown on the altar, with his attribute. Mary need not be represented here because the whole church not only reminds us of her but is, in a profound sense, Mary herself, the vessel through whom divine grace is obtained. But the playfulness and liberty of rococo style far transgress what baroque piety

and both merge with the stucco work running wild throughout the churches. But then, this same effect occurs in all the rococo churches, the white and gold and polychrome of the sculptures merging with the decoration to produce a uniform field of naturalistic artifice.

AMBIVALENCE AND RESOLUTION

The greatest Italian painter of the eighteenth century was Tiepolo, who, like his collaborator Balthazar Neumann, stands at that point where late baroque and rococo become one. His fluid brushstroke, his open compositions against pale skies, his hybridizations of the naturalistic and the allegorical, his love of pastels, his extraordinary synthesis of grandeur and sensory pleasure all speak of a rococo sensibility. On the ceiling of

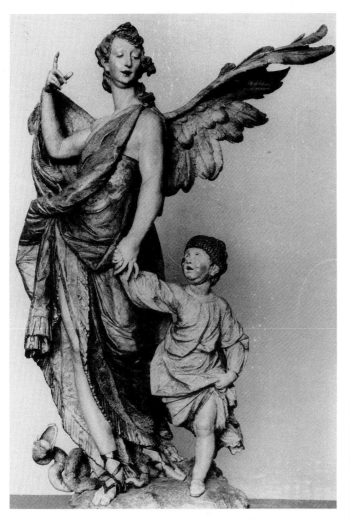

Ignaz Günther, The Guardian Angel, *1763. Munich, Burgersaal. Foto Marburg/Art Resource, New York.*

Johann-Baptist Straub, Annunciation, *St. Michael, 1767. Munich, Berg-am-Laim. Hirmer Fotoarchiv.*

would allow.[49] Likewise at Rohr, the Mary being wafted up to heaven in E. Q. Asam's representation of the Assumption (1717–23) appears at first extraordinarily realistic—how did the sculptor make her float in mid-air?—but the apostles beneath her seem too theatrical, their amazement expressed by too much contortion, and Mary herself has a painted face, like a doll, so that the extraordinary virtuosity of the piece is countered by its own silliness, or so it would seem to a viewer schooled in Renaissance, baroque, or modern taste. To these eighteenth-century Bavarian geniuses the self-conscious artistry drew attention to the limits of both representation and reason, beyond which lay the mysteries of the faith. To the Bavarian people, the art celebrated the gaiety and joyousness of redemption. In the work of the Asam brothers, the sculpture becomes painterly and the painting less pictorial,

the great stair at Würzburg (1750–53), Apollo is not driving his chariot across the heavens, rather he is caught in a moment of some disarray, his attributes scattered over the 30-meter by 18-meter fresco, the largest ever painted, as large as the sky itself it seems. Here is Apollo, not as the sun god but as the patron of the arts. In other words, the painting is not about deity, virtue, or heroism, the usual baroque subjects, but explicitly about painting itself, just as Pope's *Rape of the Lock* (1714) is about poetry. Instead of calling our attention to a dramatic center as Rubens would by using the greatest oppositions—black, white, and red—Tiepolo uses grey, white, and rose, and adds a pastel blue, creating a less stable, less dramatic, and more diffused and elegant color scheme. As Kitson says, on the Tiepolo ceiling there is no pretense that the figures are actually there. "Architecture became more sculptural, sculpture more pictorial and painting itself more strictly concerned with visual appearances; that is by a greater stress on light, shade and colour rather than form or outline, painting was made to reproduce more faithfully what the eye sees as distinct from what it knows to be there."[50] Such a secular notion and such self-conscious treatment of it, within an epic or heroic tradition, are typical of rococo. Were the subject or treatment more grave, were the von Greiffenklau family, whose Bishop drifts upward on a medallion towards Apollo, more important, were the city actually an imperial capitol instead of a petty bishopric, the ceiling over the staircase at Würzburg might be considered the greatest painting in the world—that is the "flaw" of the rococo, its pettiness—but as it is, no painting, not even the Sistine ceiling or the *Night Watch* or *Las Meninas* is better. In it, the great tradition of fresco painting merges with the modern conception of pure art.

Whether we look up at the artificial sky or down at the real stairway, we see the rococo artists' mastery of a complex and sophisticated art which appears to be easy and natural. Stairways are functional parts of building and exist in all eras. But why were the best ones done in the eighteenth century? They are so much better than anything before or since, so much more spatially complex and playful, so full of surprises, so imaginative and daring, that one must at least allow the possibility that they had some special, though perhaps not fully conscious significance to eighteenth-century architects.[51]

Pommersfelden (1714–18), the Palazza Madama (1719–21), Schleissheim (1720–25), the Upper Belvedere (1721–22), Bruchsal (1731), Brühl (1740), Caserta (1754–74), and best of all Würzburg (1737)!—Versailles and the baroque, the Escorial and the Renaissance have no equals to these. And the stairways of the nineteenth century are by comparison only academic exercises. The stairway at Würzburg and its painted ceiling by Tiepolo—and they must be considered together—if not the greatest work of art in the world, and I believe it to be a contender for this title, is certainly one of the supreme achievements of rococo style. But all the great stairways are not in palaces. They were built for villas, such as Lord Burlington's at Chiswick (begun, 1725), or for town houses, such as the magnificent stairs at 44 Berkeley Square (1742–44), designed by William Kent.

Of course one should argue that these stairways were not rococo but late baroque or neo-Palladian. The Caserta might be seen as neoclassical. But they were all designed between 1700 and 1760, and I cannot help thinking that the extraordinary invention of these stairways—the care, thought, and expense that went into them—was very curious. For on the one hand they emphasize the status and grandeur of the owners, to whom one must ascend as though going to heaven, but on the other hand, they are a bridge between high and low, like so much else in the period, an upwardly mobile phenomenon. Then too, in every building I have mentioned, save Chiswick, they are by far the most interesting architectural feature. After the stairway, the building itself is an anticlimax, and in the case of the Palazza Madama, the building itself was never completed. One could attribute this greater interest in stairways to baroque showiness and display, but Versailles offered no such disparity between stairway and what it led to. The lost *escalier des ambassadeurs* was but the prologue to the Hall of Mirrors and the king. I would rather attribute this interest not only to the architects' fascination with movement in space, both a late baroque and rococo concern, but also to their consciousness and ambivalence about social mobility, a mobility from which they themselves benefited, all of them having risen socially by their ability, among other things, to design such magnificent stairways.

One great eighteenth-century stairway, however, was indisputably rococo—the Spanish

Filippo Juvarra, Stairway, 1719–21. Turin, Palazza
Madama. Alinari/Art Resource, New York.

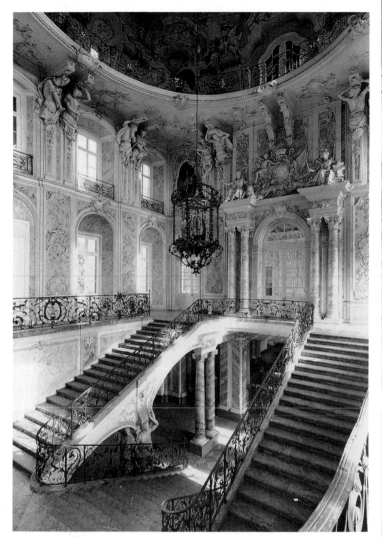

Balthazar Neumann, Stairway, 1737. Würzburg, Residenz. Foto Marburg/Art Resource, New York.

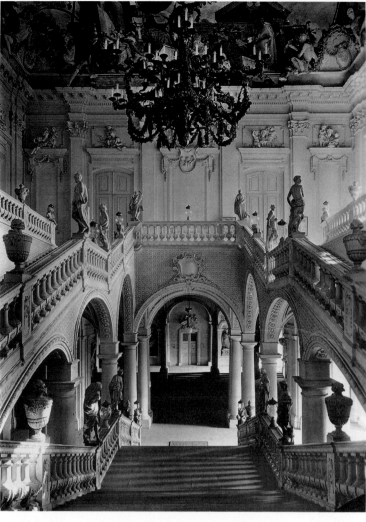

Balthazar Neumann, Stairway, ca. 1728. Brühl. Foto Marburg/Art Resource, New York.

Steps (1723–26), which connect the Via Sistina to the Via Condotti in Rome. It is an ingenious work, not unlike a waterfall, as its lines of force move from level to level, now flowing freely, now turning back upon themselves in an eddy or counterflow. No doubt its asymmetry results from the difficulties of the site, but instead of making the steps appear regular, as Bernini might have done, de Sanctis exploits the irregularity by creating a pleasing tension between balance and imbalance, between changing heights and varying widths. Altogether it is a magnificent artifice, but all its undulations, movements, and countermovements remind one

Lord Burlington, steps, Chiswick House, begun 1725. Chiswick. Photo by William Park.

of nature, and one imagines that if the Steps were removed the hill beneath them would bear some rude resemblance to de Sanctis's masterpiece. Though the Steps are useful to the Pope and the princes of the Church, they are a completely public space open to the populace and all the world. If the Piazza of St. Peter's is the great baroque space that converts irregularity into harmony, the Spanish Steps are the great rococo space that converts irregularity into easy, accessible delight. As Norberg-Schulz says, "The solution well expresses the change of attitude from the more abstract rhetoric of High Baroque axial layouts toward the sensuous interpretation of an empirical problem characteristic of the eighteenth century."[52]

We began by arguing that the rococo was a revolutionary style, though we have never denied its profoundly conservative dimensions. We have accepted Hauser's idea that the style is made up of polarities, perhaps more so than most styles, or more self-consciously so. We do not believe that bourgeois art existed in the rococo period, but that rococo includes, as one of its polarities, bourgeois art. For even at its purest, most courtly, and decorative, even in the designs of Meissonier and the paintings of Boucher, rococo was implicitly subversive of baroque order and contained what he would call bourgeois elements. The polarities of rococo, which Hauser sees as arising from class antagonisms, often resulted in double structures, parodies, and mockheroics, but this does not mean that rococo art consisted only of dialectical oppositions juxtaposed or fused together by irony and wit. Undoubtedly, the rococo contained the seeds of its own dissolution and was more a transitory style than its baroque predecessor. But its greatest artists succeeded in creating works of remarkable aesthetic unity nevertheless, works that not only resolved or synthesized these polarities but used them to realize greater degrees of significance. Hogarth was not a bourgeois artist who used rococo techniques, not a rococo artist who employed bourgeois subjects; he was both. Individually his works have great unity, and collectively they indicate a unified, though of course complex, vision.

One supreme instance of this kind of synthesis is *Gersaint's Shopsign*. What could be a "lower" type of art than a sign for a shop, a type we would now call folk, naive, or primitive? People's art. Yet in it Watteau depicts the upper classes,

Giovanni Paolo Panini, Scalinata della Trinità dei Monti, *drawing, ca. 1757. The Metropolitan Museum of Art, Rogers Fund, 1971. (1971.63.1)*

though somewhat satirically. He must be poking fun at the connoisseur who, dressed so elegantly, posed so artfully, gazes through his glass at the crotch of a nymph. Louis XIV lies on his side amidst the packing, out in the street with a mean-looking fellow and a dog. Yet another aristocrat hands his lady into the shop in a most gallant way, and the other buyers look upon one another or the shop girl with a fondness that is all too human. As in *The Rape of the Lock*, their little artifices bespeak but a natural passion, the *metaphysique du coeur*. Despite their finery and wigs and pretensions, as Gersaint himself said, "the whole was made from life; the positions were so true and so relaxed; the disposition so natural, the group so well understood that it attracted the looks of the passerby; and even the most skillful painters came several times to admire it."[53] So we see satire and acceptance, high and low, aristocrat and bourgeois, tradition and novelty, and above all, art and nature. In being artful, the people are being natural, but art in the

form of traditional paintings completely surrounds their human nature; the sign on which they are realistically painted is a miniaturized version of the actual shop, called "Au Grand Monarque," over whose entrance it was placed, where surrounded by works of art, it was gazed at by real aristocrats, by shop girls, and by plebeians in the street. Gersaint, the patron of the work, was a merchant, not an aristocrat. That the King of Prussia finally acquired the merchant's sign and that it is now in a public museum only adds to the dialectical play and synthesis notable in the work itself and in its original situation, an ordinary work of elegance set in a bourgeois shop dedicated to high art and a king, both of whom are being mocked by this painting.

Gersaint's Shopsign appeared during the phase of the rococo called in France the *Régence*. Watteau painted it in 1721, the year he died. A work of even greater sociological synthesis is Gainsborough's 1748 portrait of Mr. and Mrs. Andrews. The oppositions still exist but one feels their resolution more than the tension between them. The couple are exquisitely dressed and painted, and in this regard they seem aristocratic. But Mr. Andrews stands at ease, in the crossed-legged posture that had already become a convention of the period for men of all classes. This might be the king, but the immediacy of the fields suggests to us that it is a country gentleman and his wife and that the painting celebrates not only them but their most important possessions, as in other conversation pieces. The painting hybridizes and unites portrait and landscape, the couple linked to the fields by the lovely rococo serpentine bench on which Mrs. Andrews sits. One would wish that in such a superbly painted piece the faces would be more attractive or interesting, instead of looking like dolls suffering from colic. But to some degree the couple themselves are the artifice amidst the bounty of the ripening corn. Nature here would seem to triumph over art, but it is a nature dominated by Squire Andrews, his gun, his dog, his wife, and the natural artistic form on which she sits. This is a small painting, but there is something commanding about it, for we are looking not just at Mr. and Mrs. Andrews

and their estate but at the new icon of the age, the country gentleman and his wife, the "representative" couple, who by reconciling high and low, nature and art, manners and property, have become the norm for the artistic and literary imagination. The gun points to the ground; no one has been killed; but a revolution has occurred, a revolution that finds perfect expression within the free confines of rococo art.

To a writer such as Albert Boime the rococo revolution of which I have been writing represents little more than the merging of the landed and the monied classes at the expense of the poor. The portrait of Mr. and Mrs. Andrews particularly comes under attack for not telling us who tilled the fields. To Boime, Gainsborough "emphasizes the ability of the protagonists [the Andrews's] to command the process of labor itself."[54] That may be, but we see the Andrews in command, not George II or Lord Burlington. Admittedly, to see this revolution requires considerable historical imagination, for from the perspective of someone living in a dominantly middle-class white society, the shift from the Princess of Cleves to Clarissa seems to be a minor adjustment, not more than one F stop of social light, between two sets of privileged subjects, the aristocracy and the gentry. Thus the portrait of Mr. and Mrs. Andrews by Gainsborough can arouse ire or indignation. But one should no more overlook the "progressive" components of the painting than its beauty and technical virtuosity. For when the gentleman and his house replaced the king and his court as the center of the imagination, when portraitists hybridized and painted aristocrats and gentlemen alike, then two bourgeois *and* radical principles have gained ascendancy. First, each man could be his own center, a center that did not depend exclusively on birth, for every man, as Jefferson believed, could be a natural gentleman. And second, power and prestige depended not on hereditary position but on property, which came from money, the greasiest of all social lubricators. And it is just this change from one center to many centers and this extraordinary new fluidity, not just of forms, but of social life, to which rococo art gave expression.

2
Rococo, Late Baroque, and Neo-Palladian

In the early years of the eighteenth century there were two absolutely fresh artistic initiatives—wholly independent in their actual genesis, though sharing the trend to the picturesque: the Rococo in France from its very beginning, Romanticism in England from less than a score of years later.[1]

SEVENTEENTH-CENTURY ART EMBODIED TWO conflicting tendencies, an irregular and sensual one that came to be called "baroque," and a regular and restrained one that was called "classical." The baroque was centered in Rome; the classical in Paris. Hauser believed that an even greater division lay between Catholic courtly art, of which Rome and Paris represented the two main subdivisions, and Protestant middle-class art.[2] These divisions themselves could be further divided into various national schools, such as the Dutch or Spanish, and local schools, such as Harlem and Seville, within them. But contrary to what one might expect, the more precise the school and its definition, the more difficulty one has in confining it. The Roman baroque has a classical tendency within it, and the French classical seems very baroque. Protestant art could aspire to the grandiose, and Catholic to the simple and plain. According to Hans Rose, many of the principal motifs of French classicism derived from Dutch sources.[3] Stylistically speaking, the Catholic courtly, Spanish, Sevillian Velazquez has more in common with the Protestant bourgeois Amsterdamer Rembrandt than either has with the artists who preceded them in the Renaissance or followed them in the eighteenth century, as Wölfflin clearly demonstrated. Kitson, while noting the differences between seventeenth-century classicism and the baroque, pointed out that practitioners of both styles shared a belief in the ideal, a concern for eloquence of expression and gesture, the use of the same architectural vocabulary, the use of saturated colors and luminosity, and the desire for psychological realism.[4] And even Hauser, who is very critical of Wölfflin for his unsociological method, admits to a unity in the period, a unity that he believes derived from the new scientific world view.[5] For reasons such as these, the larger, seemingly more abstract and cumbersome concept of "baroque," itself derived from a part not the whole, has proven more practicable and enduring than any other to characterize this era.

51

The tendencies and polarities that make up baroque continue into the eighteenth century. The sensual, theatrical, flamboyant and religious aspects of the baroque thrived most notably in Northern Italy, Austria, Bohemia, and Bavaria. The restrained, ordered, and rigorous or classical aspects of the baroque persisted in France and Northern Europe. Both of these tendencies have been called late baroque,[6] a designation that seems more appropriate to the southern than the northern branch of development, especially since the northern branch must include neo-Palladianism. As I indicated in the Introduction, I have no difficulty in seeing European art from 1575 until 1760 characterized by the general term baroque, as long as one then discriminates, as Wölfflin indicated, the several styles within this larger category. For me, the trouble with late baroque, when applied to the architecture of the eighteenth century, is that it does not do justice to the innovations and achievements of the era. It is not unlike the term "preromantic," which went out of favor a generation ago because it placed the eighteenth century in the context of the nineteenth rather than seeing it in its own right. So late baroque places the eighteenth century in the context of the seventeenth. Of course, there is a truth in this categorization, but it is a half-truth, and it gets in the way of discovering what was new and original in the first half of the eighteenth century. I would rather confine the term late baroque to the years from 1660 to 1700 or at latest 1720, when the high baroque of Bernini, Borromini, and Cortona was modified, extended, lightened up, or restrained by Guarini, Le Vau, J.-H. Mansart, Fontana, Wren and Fischer von Erlach. And rather than referring to Guarini and Fischer as late baroque and Le Vau, Mansart, Fontana, and Wren as neoclassical, I would pay more attention to the similarities and influences they had upon one another and see the differences between them as the polarities of the late baroque style.

So I am attempting to reverse the usual procedure and instead of seeing rococo as an aspect of "late" baroque, I wish to assert *both* continuity *and* change and to persuade the reader that what in the years from 1720 to 1760 is customarily referred to as "late" baroque was *also* an aspect of rococo. Such a reversal or double perspective is not as whimsical or perverse as at first it might seem. I have mentioned that rococo was the only style unique to the eighteenth century, that it

was a reaction or revolution against the baroque, and that all the concurrent styles of the first half of the eighteenth century have something in common with it, either by employing rococo in their interiors or making use of its aesthetic. Let us now consider rococo architecture proper, in the strict definition of that term, and then compare it to its baroque and neo-Palladian companions.

ROCOCO

The very nature of this style would seem to prohibit its being anything more than interior decoration. Given that interior decoration can effect an atectonic appearance that denies the supporting function of the wall, how, one might ask, can a building or structure itself be atectonic? Thus rococo interiors are usually housed in baroque or classical structures, and we see the relationship between interior and exterior mostly in scale and genre. For, despite excellent examples at Versailles, Munich, and other palaces of the eighteenth century, on the whole palaces that already existed and merely redecorated rooms in the latest fashion, rococo was a style suited best to private *hôtels* and *petites maisons*. And despite its gilding and artistic virtuosity, one should never forget that rococo, a concoction of wood and plaster, was a much more inexpensive style than the marbled baroque. When a new palace was built in the new style, the palace was miniaturized, as in the Amalienburg and Sans Souci. In one regard, however, the "light" rococo forced changes in the architecture itself, for the structure of the rococo room becomes masked, transformed, or lost altogether, another instance of the "dissolution" that characterizes the style. At the very least an extraordinary tension exists between the flamboyant plastering, carving, and painting and the rather simple structures of the rooms, so that one may speak of a double structure, the ornament being one, the architecture being another, and the two more juxtaposed than fused together, though of course rococo at its best creates an aesthetic whole out of such extreme contrasts.

Though rococo as a form was fully developed only in interiors, at least one exterior style is also considered rococo, that of the *hôtels* and *maisons de plaisance*. Sedlmayr and Bauer describe this style as follows: "the external planes consist of

two, and only two, elementary architectural forms, namely, undecorated, slender, semicircular or segmental arched openings (windows, doors, French windows), all of which are flatly framed or cut into the surface." The surface is extremely flat; sculpture in the round appears only "as cartouches in a frame or as the crowning of a balustrade." The delicate grooving of the stone gives the wall an impression of being made by delicate plates that are "liberated of weight by the many large openings, by the organization of the stories, and by the low-pitched roofs." Most revolutionary were the abandonment of the orders of columns and the avoidance of engaged columns that might emphasize the "three-dimensionality of the wall mass."[7] L'Assurance's Hôtel de Maison (1708) and Hôtel d'Auvergne (1708) in Paris set this style for the next fifty years,[8] but the most felicitous example is Courtonne's Hôtel de Matignon (1721), now the official residence of the President of the Republic. The favored height of such buildings was two stories, the top story repeating the lower one, another example of doubling, as was the arrangement of the rooms themselves, for instead of a single line of apartments, the new *hôtel* introduced the *appartement double*, which enabled the rooms to be reached without going through others and which also made them into practical groups rather than a single row.[9] Thus they were described by terms such as convenience, comfort, practicality, privacy, and, externally at least, a "noble simplicity."[10]

Only in the Germanic states may we speak of full-fledged rococo *buildings*, inside and out, most notably the Zwinger (1709–32) in Dresden. It, of course, is based on extraordinary reversals. Instead of occupying the center of its *platz* or being oriented at one end of the *platz*, the Zwinger surrounds or creates the *platz* within it. This is not just a courtyard within a city palace; it is a huge civic square in the midst of a building. Thus the relationship between interior and exterior has been reversed, the exterior of the building, the *platz*, being where one would expect the interior. Furthermore, despite the monumental appearance of parts of the facade, we notice that the building is only two stories high and that it has practically no width, being throughout but the thickness of one room. So the grandeur of a royal palace has contracted into a slim, attenuated shell, a joke of a building really, though one of the most interesting ever built.

More serious are the rococo churches of Bavaria. Rupprecht cites five characteristics that distinguish them from baroque churches:

1. A central space is formed, illuminated by mostly indirect light.
2. The boundaries of this space remain indefinite.
3. Traditional architectual forms are transformed, isolated, and displaced.
4. An ornamental stucco zone is placed between fresco and architecture.
5. A point of view near the entrance is the most important; it determines the perspective of the main fresco; at the same time it lets us see the space in its entirety as a pictorial whole.[11]

The three paradigmatic churches, Steinhausen (1729–33), Wies (1745–54), and Zwiefalten (1744–65) also announce themselves as rococo. Steinhausen and Wies employ purely decorative shapes for the windows. In addition, Steinhausen uses a pilaster-like bandwork, which is entirely decorative, and the Wies church has such an eccentric exterior that it departs altogether from any baroque categories. Zwiefalten appears more baroque, until one notices that the massing of triple columns on the facade serves no structural purpose whatsoever. In all three, the exterior announces discretely what the interior proclaims definitively, namely the playful merging, reversal, and confusion of architecture and decoration, the one serving for the other where one least expects it.

Harries has amplified Rupprecht's distinctions and gone on to discuss two major components of the rococo aesthetic.[12] First, he explains how the rococo churches demand more participation on the part of worshippers. They do not merely witness the sacred drama but are part of it. They must proceed through a series of frescoes, each one bringing them closer to the central mystery of the Church. At Birnau (1746–50) this sequence climaxes in the mirror placed in the altar fresco, in which the worshipper by looking upward may see herself supported by angels and putti receiving the rays of divine grace emanating from the Christ child, still in the womb of the Virgin. Second, he calls attention to a very fundamental difference between the baroque and the rococo, namely how representation or illusion is used.[13] In the baroque church, where one typically finds

Jean Courtonne, Hôtel Matignon, garden facade,
1721. Paris. Giraudon/Art Resource, New York.

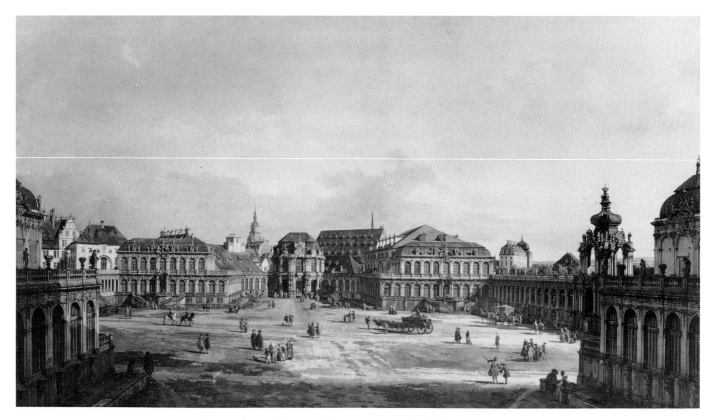

Bernardo Bellotto, The Courtyard of the Zwinger,
1749–53. Dresden, Gemäldegalerie. Giraudon/Art
Resource, New York.

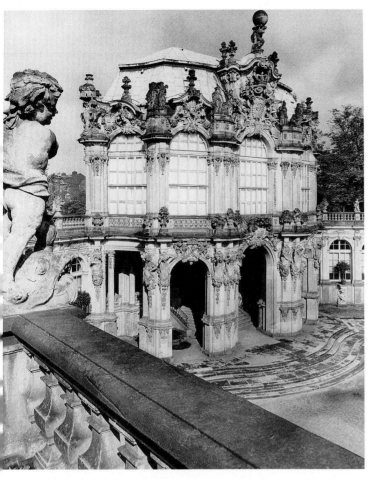

Matheas Daniel Pöppelman, Zwinger, 1709–32. Dresden. Foto Marburg/Art Resource, New York.

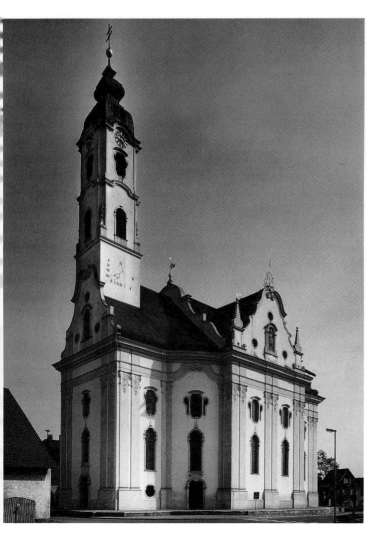

Dominkus Zimmerman, facade and windows, Pilgrimage Church, 1729–33. Steinhausen. Wolf-Christian von der Mülbe.

but one fresco in the nave, the ceiling seems to open up and show heaven, towards which a saint ascends supported by angels and surrounded by virtues. By standing at the right point in the central aisle one feels as if he is seeing an epiphany in which Heaven and earth have been united. In the rococo church, one also sees a vision of Heaven, but the illusion calls attention to itself. If the ceiling fresco does not contain something incongruous, like the earth, which makes it into an analogous space rather than a continuous one, it will certainly be surrounded by the ever-present decorative zone, which reminds the worshipper that the ceiling it frames is a work of art. Paradoxically, as Harries points out, the antiillusionism of the rococo church may result from an ever deeper religious understanding than the illusionism of the baroque, for it signifies the limits of empirical knowledge and sensual experience and reminds us that ultimately Christianity is a religion of faith. "Blessed are they who have not seen and believed."

"LATE" BAROQUE

In his book *Late Baroque and Rococo*, Christian Norberg-Schulz says that "In general . . . the Late Baroque conserved the belief in a great comprehensive synthesis, while the Rococo takes differentiation and individuality as its point of departure. . . . In reality, however, it is hardly possible or necessary to make such a distinction."[14] It is hardly possible because the two styles are intermixed and intertwined with each other, the "pure" rococo of the Salon de la Princess (1735) having been created by the "classical" Boffrand, while the ultimate late baroque work, Vierzehnheiligen (1743–63), having integrated into it startling rococo elements, such as the three-dimensional rococo altar rising above the holy ground where the fourteen saints and the Christ Child appeared. Yet as Norberg-Schulz continues his analysis, he makes clear that this style, which he calls late baroque/rococo, is much more than a mixture of two styles or a continuation of the baroque tradition. Juvarra, Vittone, the Dientzenhofers, and Neumann—the architectural geniuses about whom he writes—

tion and replaced it with a more subjective approach so that how the church appeared became more important than the proportions of the church. The baroque retained proportions, but they could be adapted rather freely to make room for considerations of site and the perspective of the worshipper. Most important was the achievement of an overall unity that contained within it the opposites of concave and convex, vertical and horizontal, solid and void, light and dark. But despite the drama, on the whole, the baroque, with the exception of course of Borromini's churches, settled on a longitudinal church whose plan was clear, whose construction was solid, and whose proportions were massive. What drama occurred took place on the facade and in the play between architecture and the *quaddratura*, usually in the center of the nave or in the dome over the crossing.

The late baroque or rococo architect com-

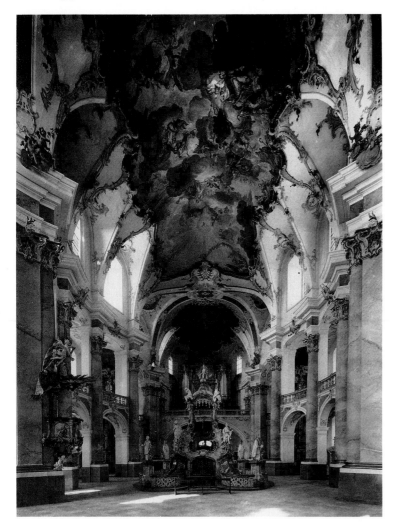

Johann Jakob Michael Küchel, Altar, Pilgrimage Church, Vierzehnheiligen, 1743–63. Vierzehnheiligen. Foto Marburg/Art Resource, New York.

were so daring, so technologically brilliant, that they not only carried the baroque and the classical tradition to its very limits but also went beyond that tradition to create something almost antithetical to it.[15] This is why the term late baroque, implying as it does a mere continuation of a style, or, as it is used by Sypher and others, the contraction of a style, cannot do justice to their achievement, which is among the greatest in the history of architecture.

Renaissance churches are based on a simple, harmonic beauty, derived from a system of proportions that correspond to heavenly order.[16] Disrupting this harmony, the baroque interjected into it tension, conflict, and drama, a perfect example being Baccicio's fresco, *Adoration of the Name of Jesus* (1674–9), in the Gesù in Rome. It did away with the modular system of propor-

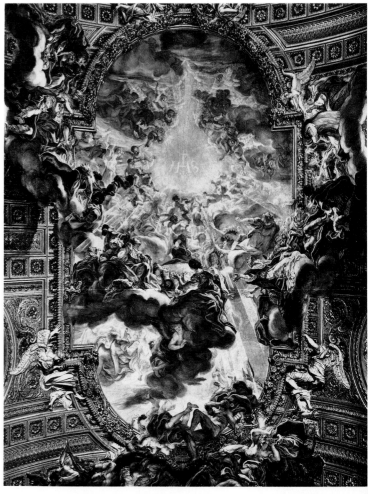

Giovanni Battista Gaulli (Baccicio), Adoration of the Name of Jesus, *fresco, 1674–79. Rome, Gesù. Alinari/Art Resource, New York.*

pletely unsettled this kind of order. One might almost say that he turned the illusion of the *quaddratura* painting into a reality, into the church itself, for what the painting represented, the light of heaven pouring down into the architecture, the architect literally achieved by opening up all the spaces of the church and flooding it with light. Instead of containing an epiphany, the church became one. The white light of the sun, which represented God, is not transformed by colored glass into prismatic colors but pours through the clear windows into the inner space of the church itself, where the believers may transform it into their own interior light. God is neither mysterious nor gloomy but may be discovered in the brightness of nature and of reason, a belief held in the eighteenth century by Catholic, Protestant, and Deist alike. Such illumination in such enormous churches required once more the technological daring of the Gothic period, with which the late baroque in Central Europe and in England has many affinities.[17] If the church has a dome, it will seem to float in space, an effect achieved by Wren in St. Stephen Walbrook (1672–87) and St. Paul's (1670–1709) but carried even further by Juvarra and Vittone. The essential longitudinal plan of the baroque has been countered by a strong centralizing force that results in what Norberg-Schulz describes as "spatial interpenetration" and "pulsating juxtaposition."[18] The supreme example of this dynamic system is probably Neumann's Vierzehnheiligen, where because of an error by the previous architect the site of the altar did not correspond with the crossing, under which it should typically stand. Neumann's problem then, which he brilliantly solved, was to find a way to integrate crossing, nave, and altar, when the three were, so to speak, out of sync. Instead of devising a dome, the usual Renaissance and baroque way of treating the crossing, he twisted, extended, and double curved the transverse arches so that the vaults close in upon one another to create one of the most daring and original spaces in the history of architecture.[19] Such flexibility of forms, such openness of space, such incredible plasticity of mass and volume are of course architectural analogues to those same characteristics found in rococo design, which is why such designs find a natural, suitable home in these churches. When one considers the consummate achievement of Neumann and his contemporaries, one begins to wonder whether he should be called late baroque or whether the Italians of the seventeenth century should be called prebaroque.

The opening up of space, the lightness of the forms, the white or lighter colors used in decoration, the almost omnipresent rococo decoration itself, the double structure or *Zweischaligkeit* that makes so many of these churches seem a "diaphanous, centralized structure,"[20] all these have the curious double effect not only of allowing the outside to penetrate within but also of turning the space itself inward and making it autonomous. Paradoxically, the architectural triumph by which space has seemingly been liberated from mass has dissolved the architecture and left the spectator in a deliriously undulating interior in which he must inevitably be slightly disoriented. Thus the great synthesis of central and longitudinal forces, of decoration and space, of expression and order, of an overall system and individualized rooms results in a different look or style and a different experience than one encounters in the churches of the baroque. If rococo still seems too diminutive and superficial a term to apply to this magnificent architecture,[21] one cannot ignore how many of its effects, particularly the sense of dissolution, doubleness, and disorientation, are the signs of the rococo imagination at work. At the very least one must admit that the architecture has many analogies with rococo design, that it was accompanied by such designs, and that late baroque and rococo styles—if they are different—somehow merge together into beautiful, harmonious wholes. As I have asserted before, the "late" in late baroque architecture consists either of rococo decorative and color schemes or of architectural analogues to rococo design.

Before considering neo-Palladianism, let us look for a moment at one of the last of England's late baroque architects, Nicholas Hawksmoor (1661–1736), who provides some curious and interesting links between baroque, neo-Palladian, and rococo. Hawksmoor was the assistant for many years to Wren and the collaborator with Vanbrugh at Castle Howard (1699–1712) and at Blenheim (1705–24), the former of which employs a *zweischalig* structure in its Great Hall.[22] We can see his independent work chiefly in the series of churches he designed during the last years of Queen Anne, her final Tory administration authorizing in 1711 the building of fifty new churches, though only a dozen were ever erected,

the Whigs, who held power from 1714 to 1760, not being so favorably disposed to this use of public funds. Hawksmoor is rightly classified as baroque, though his is a very eccentric, English kind of baroque, making use of original forms and combinations. Wittkower called him a "rational mannerist."[23] Kaufman believes that Hawksmoor, whose basic architectural idea was the "antithesis of the elements," was trying to overthrow the baroque.[24] To me, he was the first major English architect to exhibit rococo tendencies.

What seems rococo about him is his carrying of architectural illusion into self-conscious humor or trickery. For instance, when one approaches Christ Church Spitalfields (1714–29), the facade of the church completely dominates the street and the approach with its enormous mass and high steeple. Yet when one walks to the side of the church or approaches it at a right angle to the normal approach, one notices that Hawksmoor has cut in behind the facade so deeply that it is virtually only a facade; no structure stands immediately behind it, only a void, then a structure. Such contrasts may be called baroque, but the extremity of the contrast and the architectural joking, which would seem to have caused it, indicate a less grave sensibility than one is accustomed to find in baroque churches.[25] Cedric Reverand calls attention to how the western facade has "at least six Venetian-window puns, including a Venetian-Window-Triumphal-Arch; it is a marevlous experiment, a flat motif enlarged, reduced, stretched, punctuated, twisted, and turned inside out. This is vitality and energy (and perhaps a witty nose-thumbing at the Palladians as well)."[26]

Similarly, St. George's, Bloomsbury (1716) displays other rococo qualities. One enters this church from the south, which means that the altar is on one's right. The site on Bloomsbury Way caused this unorthodox arrangement. But Hawksmoor, instead of creating a porch on the south side and then orienting his church west to east once one is within, had done just the opposite. The church is oriented south-north, yet— here is the rococo surprise—the altar is still at the east end. So, as you enter the space, you are led to look for the altar in front of you, but instead it stands over to the right. The pews, of course, help you to find your way, but the organization of the space and the pews are at odds with

Nicholas Hawksmoor, Christ Church Spitalfields, 1714–29. London. Royal Commission for Historic Monuments.

one another. This is one of the first Christian churches in the world to have a classical temple facade, which one may take as a sign of neoclassicism, but strangely enough it has an enormous steeple projecting upward on one side of the church, a steeple that is completely, blatantly, self-consciously opposed to the classical purity of the central temple.[27] Hawksmoor has juxtaposed components of two styles into a startling incongruity, which calls attention to itself. Even more audacious was James Gibbs's treatment of the same motifs at St. Martin's in the Fields a few years later (1721), for Gibbs, following James at St. George's, Hanover Square (1712), thrust his magnificent steeple through the roof of the temple. Because this church became the prototype

that produces show again what I have been calling the rococo imagination, an imagination that whimsically undercuts his baroque and his classicizing tendencies.

NEO-PALLADIAN

There are many ways to regard neo-Palladian architecture: as a tradition that runs from Vitruvius to Lord Burlington, as a precursor of the great neoclassical movement of the late eighteenth century, and as something in its own right. Regarding it as rococo would seem to be absurd, for never were two styles more disparate, at least at first glance.[29] Neo-Palladian consists of flat walls, straight lines, and clearly articulated central pediments, usually supported by columns or pilasters and flanked by symmetrical cubes and rectangular blocks. It is more a style of building than of interior decoration. Rococo consists of disguised boundaries, undulating lines, and asymmetry. It is more a style of interior decoration than of building. Neo-Palladian derives from Vitruvius, Palladio, and Inigo Jones. Rococo derives from Borromini, the arabesque, and the grotto. Neo-Palladian is anticourtly, bound up with Whiggism and Freemasonry.[30] Rococo is courtly, bound up with the *ancien régime*. Neo-Palladian is primarily English and Protestant; rococo French and Catholic. In the sense that Gulliver describes the style of the Brobdignagian language as "clear, masculine and smooth, but not florid," so we may see neo-Palladian as masculine; rococo has always been seen as feminine. For the Burlingtonians, neo-Palladian, it would seem, represented good taste, rococo bad. For instance, in a 1751 illustration for Pope's "Epistle on Taste," Blakey depicts the tasteless Sir Visto seated in his rococo room being offered a collection of monstrosities.

Hardly anything would encourage one to associate rococo and neo-Palladian were it not for two anomalies. One, perhaps of lesser importance, is the almost exact correspondence in the life of the two styles. Both began at the outset of the eighteenth century; both had established themselves by the 1730s; both were widely imitated in the 1740s and applied to projects for which they were not originally intended, neo-Palladian to palaces, such as Wanstead and Holkham, as opposed to villas; rococo to churches, such as Zwiefalten and Wies, as op-

Nicholas Hawksmoor, Clarendon Building, 1713. Oxford. Photo by Marlene Park.

for colonial churches in North America, it does not look so strange to us as it must have to men of classical or baroque taste at the time it was built. Of course, its interior was stuccoed in rococo style.[28]

Hawksmoor's Clarendon Building in Oxford (1713) would at first sight appear to be a classical building, until one looks closely at the wall surface, particularly the window frames. It is extremely hard to determine which plane represents the actual wall, for the planes move from level to level and back again without ever clarifying their exact relationship to the structure. This is all done in a sculptural, geometric way, which in one respect is antithetical to rococo, but the playfulness that we encounter here, the doubling or tripling of structure, and the overall confusion

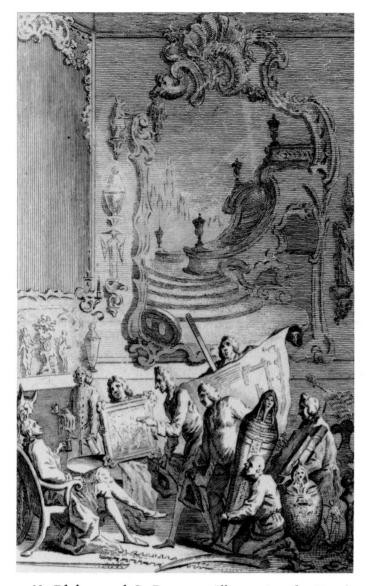

N. Blakey and S. Ravenet, Illustration for Pope's "Epistle on Taste." London, 1751. Beinecke Library.

posed to salons. And both were rejected by the neoclassical artists who came into prominence in the 1760s. Everyone recognizes the revulsions against the rococo, because it was dramatic and vocal, but not everyone recognizes the distaste for neo-Palladianism, primarily because of the obvious continuities between it and neoclassicism.[31] Yet the Adam brothers claimed that by 1763 Robert had launched a "revolution" in architecture.[32] Nowhere is this transformation more striking than at Kedleston (1761), where Lord Scarsdale dismissed the "late" neo-Palladian architect Paine to hire the even more neoclassical Adam.[33] Thus on one side of the building we see Paine's typical neo-Palladian facade, complete with columns, pediment, and rusticated ground floor, while on the other we see

Adam's neoclassical one, done in the manner of a triumphal arch. Similarly, the neo-Palladian organization of the town square, as developed by Wood at Queen's Square (1729 onwards) in Bath, gave way to the flatter, more sharply cut Adam style of Fitzroy Square (1790) in London, where again he used triumphal arches rather than columns and pediments. Though one might attribute this shift in taste to the brilliance of Adam himself—and that is not a bad reason—one must also acknowledge that the Adam style was but a local or national version of a European-wide neoclassical revolution. Thus in England, as Adam style replaced neo-Palladianism, so in France at the same time, Louis XVI style replaced Louis XV, as one may see within one building, Versailles, by comparing the rococo profusion of Louis XV's bedroom (1738) to the neoclassical austerity of Marie Antoinette's library (1777).

That the two styles had parallel lives may, of course, be only a coincidence, lacking in any architectural or historic significance, were it not for the second anomaly, the conjunction of the two styles within Palladianism itself. What received opinion has categorized as antithetical styles seem, in fact, to have coexisted so harmoniously together that one suspects a deep affinity between them, despite their obviously different appearance. Thanks to the recent exhibition at the Victoria & Albert Museum, "Rococo: Art and Design in Hogarth's England," we can no longer overlook the fact that in England the rococo was not an odd occurrence, evident only in eccentric interiors such as Luke Lightfoot's at Claydon (1757–71), but almost a norm of interior design and furnishings from the 1730s to the 1760s.[34]

Both were reactions to the grandeur, which had come to look like bombast, of the baroque.[35] In France and England this reaction set in among the upper classes—it was Louis XIV who initiated the rococo when he asked for all to be light and gay; it was Lord Burlington who led the Palladians in England—yet in both countries what began as an aristocratic movement received widespread support from the bourgeoisie. Wittkower speaks of the "democratic classicism" of English Palladianism in that its adherents broke down the traditional hierarchies of buildings and spread professional architecture to all classes and building types, including cottages and farm houses.[36] Norberg-Schulz says that "In general Bath represents the beginning of a new 'democratic' architecture, where everybody finds

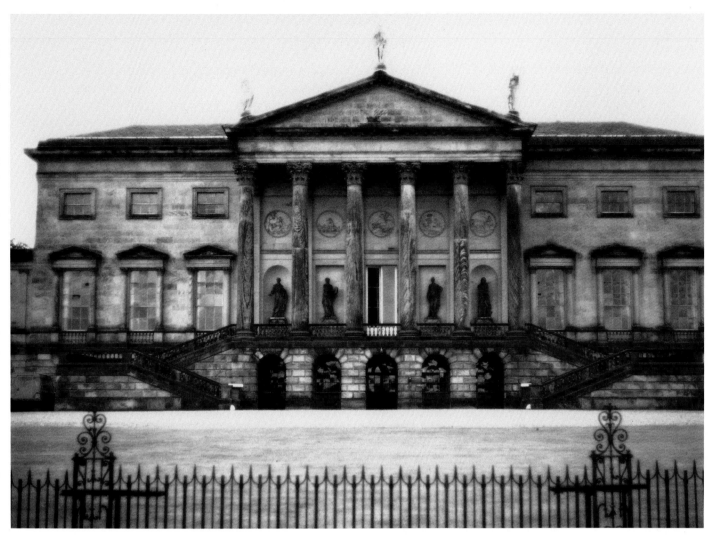

James Paine, main facade, Kedleston, 1759. Kedleston. Photo by Marlene Park.

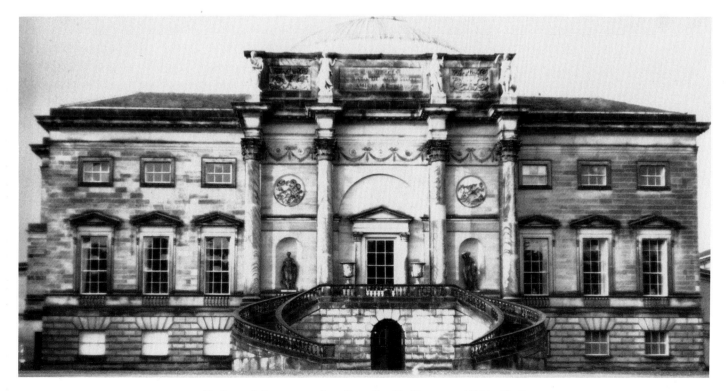

Robert Adam, garden facade, Kedleston, 1761. Kedleston. Photo by Marlene Park.

a place within a flexible totality."[37] In Rome during the first half of the eighteenth century, architects rejected many of the late baroque canons, returned to mannerism and the eccentric Borromini, and created a style now called Roman rococo, which for the first time extended professional architecture to middle-class apartment buildings.[38]

As part of this rejection of baroque grandeur, both rococo and Palladian artists favored the familiar and the intimate. Thus, in England we see the creation of the villa, such as Chiswick, and on the Continent the retreat, such as the Amalienburg, built by princes or aristocrats who wished to escape from the cares of the court. The names tell us the nature of the places—Sans Souci, Mon Repos, Lustheim, Mon Bijou, Bagatelle. And of course the bourgeoisie escaped its cares as well. Voltaire, that great intellectual entrepreneur, called his retreat, Les Délices. Summerson referred to Chiswick's "toy-like unreality,"[39] and

we remember Lord Hervey's remark that Lord Burlington's villa was "too small to inhabit, and too large to hang to one's watch."[40] Because this architecture was on a much smaller scale than the rural palace of the seventeenth century, it is a case of the miniaturization characteristic of rococo art.

Harries argued that the worshipper in a rococo church was a participant, not a spectator. This distinction may not be an absolute one, for it would be hard to deny participation in some baroque works, particularly those by Bernini, yet rococo works do demand a greater sense of movement, physical movement, on the part of the viewer. For instance, the major fresco of a baroque church, which one must see from a fixed point of view, contrasts to the series of frescoes in a rococo church, which make a sequence, as in a film, which one must walk through, beginning at the west end with depictions of the foundation of the church and stories of local saints, and pro-

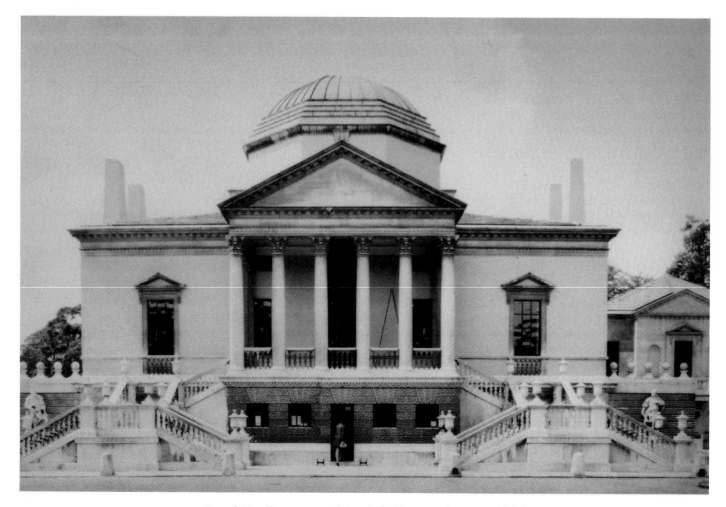

Lord Burlington, Chiswick House, begun 1725.
Chiswick. Photo by Marlene Park.

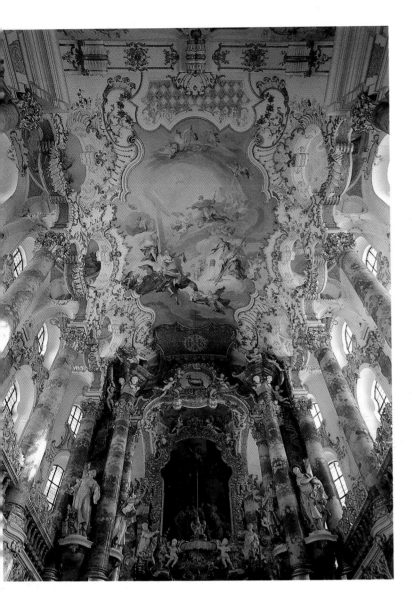

Dominkus and Johann Baptist Zimmerman, Wies Church, choir fresco, 1745–54. Steingaden. Photo by Wolf-Christian von der Mülbe.

Johann Baptist Zimmerman, Steinhausen, ceiling fresco, central portion, 1729–33. Steinhausen. Photo by Wolf-Christian von der Mülbe.

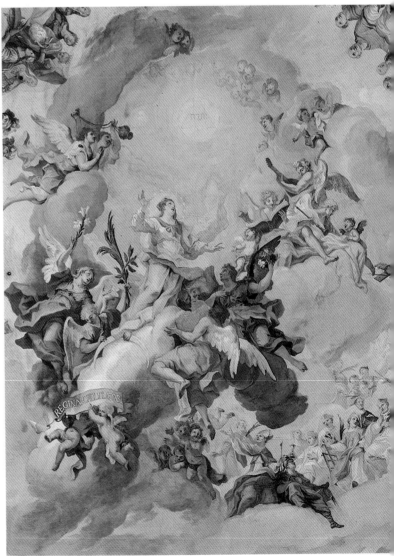

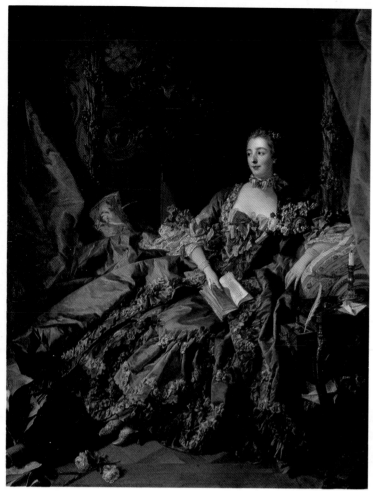

François Boucher, Madame Pompadour, 1756. Alte Pinakothek, Munich. Bridgeman/Art Resource, New York.

Dominkus Zimmerman, Wies Church, interior, 1745–54. Steingaden. Photo by Wolf-Christian von der Mülbe.

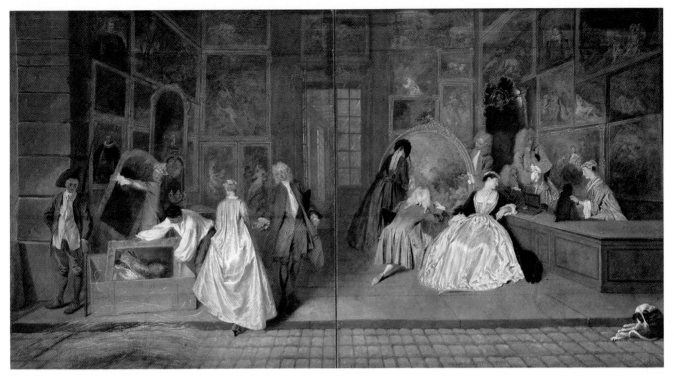

*Antoine Watteau, Gersaint's Shopsign, c. 1721.
Charlottenburg, Berlin, Scala/Art Resource, New
York.*

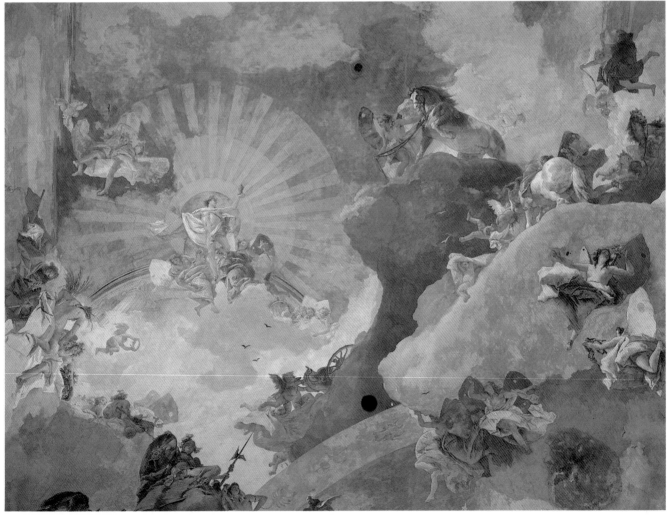

*Gian-Battista Tiepolo, Stairway Fresco, central
portion, 1750–53. Würzburg, Residenz. Photo by
Wolf-Christian von der Mülbe.*

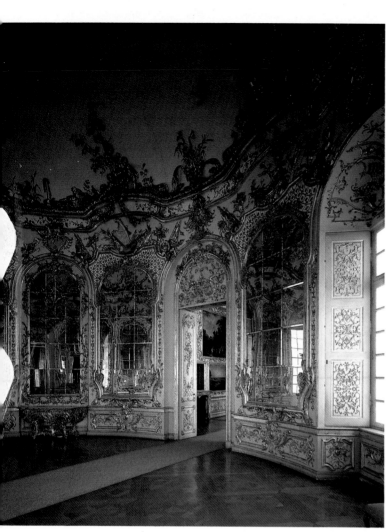

François Cuvilliès and Johann Baptist Zimmerman, Hall of Mirrors, Amalienburg, 1734–39. Munich, Nymphenburg. Photo by Wolf-Christian von der Mülbe.

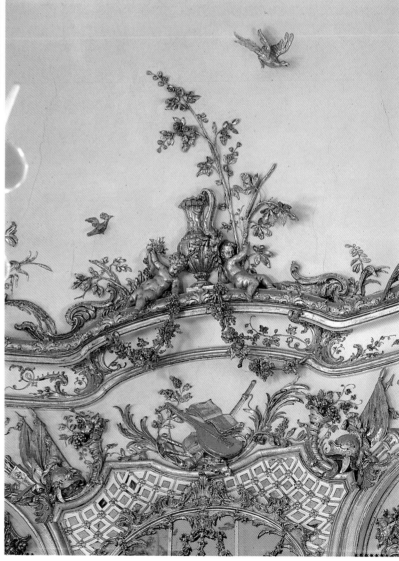

François Cuvilliès and Johann Baptist Zimmerman, Hall of Mirrors, detail, Amalienburg, 1734–39. Munich, Nymphenburg. Photo by Wolf-Christian von der Mülbe.

ceeding, as one approaches the altar and choir, to the mysteries of the Assumption and Trinity. Watteau's famous *Embarkation for Cythera* (1717) exhibits this same cinematic quality, the various couples in postures of rising and moving toward the bark seeming as though they are but one couple perceived in a sequence of time frames. Wylie Sypher remarked, "Since rococo space is emptier than baroque space, it seems to be merely an area for motion, giving rococo environment an elasticity lacking in the more monumental baroque arena."[41]

In contrast, Palladio based his buildings on heavenly harmonies and modular ratios.[42] They are meant to be microcosms of the macrocosm, and as such they have a sense of "being," of completion. The Villa Rotunda looks the same from every angle because it is the same and because it fixes the four compass points of the world in its plan. But the neo-Palladians based their buildings on tables of proportion, not modular ratios.[43] In neo-Palladianism, as in the rococo, the spectator is asked to participate, not only mentally but physically, for the buildings are a kind of anthology of approved and sometimes whimsical architectural features. They are meant to be tasteful pictures, and as such they have a sense of "becoming," not completion. They must be experienced by the spectator from a variety of perspectives. Thus each facade at Chiswick is different, designed to please and perhaps surprise the man of taste who knows his Vitruvius, Palladio, and Inigo Jones. One does not contemplate the building, one walks about it, enjoying the *associations* that it evokes. The landscape gardens that surrounded the buildings are enjoyed in the same way—by moving through them, by experiencing them as a sequence of pleasures, as narratives rather than as epiphanies.[44] And just as the exterior presents variety and surprises to the spectator, so does the interior, for rather than being rectangular or square, as in Palladio's villas, Chiswick's plan presents a variety of shapes—square, rectangular, circular, elliptical, and hexagonal—none of which could be anticipated by the visitor as he moves from one room to the next. For instance, the visitor has no hint as he walks through the apsidal gallery that the room he enters on the west will be circular or that the room on the east, which corresponds to it, will be hexagonal. And he should be equally amazed as he leaves the rectangular Red Velvet Room to

FIRST FLOOR PLAN

Lord Burlington, plan, Chiswick House, begun 1725. Chiswick.

encounter not only a different shape but a strikingly different color in the Blue Velvet Room, which is square. Such an aesthetic of surprise grows not from a linear axial conception of the rooms, but from the back-and-forth motions of sociable intercourse. As in rococo design, there is no one way to "read" these rooms.

In addition to having parallel histories, to championing the small, familiar, and intimate, and to requiring greater participation, rococo and neo-Palladian share some formal principles as well. As Wittkower has demonstrated, the mannerism one finds in neo-Palladian architecture is not serious, but playful.[45] For instance, the Venetian window, a kind of Palladian *sine qua non*, began as a device, used incidentally only once by Palladio himself, and that in his youth, which emphasized the center of a building and

Lord Burlington, Chiswick House, begun 1725.
Chiswick, London. Photo by Marlene Park.

reconciled the horizontal and vertical tendencies of the facade.[46] But as Colin Campbell used it at Wanstead (1715–20), or as Lord Burlington used it at Chiswick, or as Kent used it at Holkham (begun 1734), it has become a piece of decoration, a motif that could be repeated throughout the wall surface, which is exactly what happened in these examples and in most other neo-Palladian buildings. The Venetian window provides a rhythm and a pictorial unity to neo-Palladian facades, but it has nothing whatsoever do to with the structure of the wall in which it appears. Summerson writes of Kent's Horse Guards (1751–58):

> The plans of the Horse Guards building make it amply clear that its architect studied the design from outside in. With its complex of projections and recessions and varied skyline it is irresistibly picturesque—especially in its spacious park setting and with the linen sheen of two-centuries-old Portland stone. But as a rational building the Horse Guards is decidely quaint. The plan is a collection of square or nearly square boxes, squeezed into a predetermined composition—and a composition, at that, full of points of emphasis, which, on analysis are revealed as grotesquely out of harmony with the function of the elements of which they form a part. Thus, of five imposing Venetian windows toward the Park, only one lights a room of any consequence—the Commander-in-Chief's audience room—and two are miserably squeezed in at the corners of small offices.[47]

Summerson goes on to say that "Kent never saw a building as a thing with an artistic life of its own, but only as a delightful ornamental property, a piece of full-scale scenery,"[48] yet how can one see Kent as an inept practitioner of neo-Palladianism or as unrepresentative or atypical, when he was Burlington's chief protégé, when he received the only commission for a Palladian public building in London, and when he designed one of the largest, most grandiose of Palladian country houses, Holkham? Summerson's critique of Kent cannot be separated from neo-Palladianism itself.

What is true of the Venetian windows also applies to the bosses on window and door surrounds. What began in mannerism as a device to express the ambiguity between two systems of wall surface became in neo-Palladianism merely decorative, as, again, one can observe on Kent's Horse Guards. Such treatment, Wittkower says, is a conception "which tends toward the arrangement of linear patterns on a surface,"[49] a description that perfectly characterizes rococo as well, for in both styles one senses not only the use of architecture as decoration but also the disjunction or disparity between surface appearance and actual structure, which is, in both, typically a flat wall.[50] All styles are arbitrary, but neo-Palladianism and rococo, unlike classicism and the baroque, call attention to their arbitrariness.

In *Rocaille* Hermann Bauer speaks of rococo as a *"meta-stil,"* by which he means a species of art that exhibits itself or is consciously self-referential.[51] This phenomenon occurred when *rocaille* decorations shifted from the margins to the center of the work and when what before had been clearly defined as ornament became an integral part or backdrop to the scene being represented, as when Mondon depicts lovers beneath a *rocaille* crag. Bauer claims, and I believe rightly, that the preference for Palladian architecture in the eighteenth century is an expression of this same phenomenon, for in neo-Palladianism, architecture becomes a picture, a monument to itself.[52] As Wittkower puts it, "Italian architecture must always be judged for its plastic values; an English eighteenth century building should be seen from a distance like a picture."[53] As an example of this self-referential style we may cite the famous Egyptian Hall (1730) in York. There Lord Burlington disregarded the actual use the building would be put to, namely to provide a setting for dances, in order to create "the most severely classical building of the early eighteenth century in Europe." The Egyptian Hall was, Wittkower says, an "uncompromising realization of a revolutionary idea," the idea being "absolute architecture,"[54] that is, an architecture that breaks from use, site, convention, proportional analogy to heaven, and emblematic expression to become something in itself. Both rococo and neo-Palladianism, then, may be regarded as harbingers of modernism in that they both assert, in different ways, the autonomy of art, though of course rococo does this much more consistently and ironically.[55]

Perhaps the most unusual aspect of both styles

is the lack of stylistic correspondence between inside and outside.[56] There is no way that a reading of a neo-Palladian facade, whether at Chiswick, Houghton (1722), or Holkham, can indicate the richness and profusion one becomes accustomed to find within. Likewise, the simple facade of the Amalienburg, whose bowed-out temple front imposed on a rusticated ground floor suggests some playful hybridization of Palladianism, bears no resemblance to the extravaganza of rococo decoration within. Indeed, the most fully developed rococo interior in Paris, the Salon de la Princesse, lies within what at first look seems the strict classical facade of the Hôtel de Soubise (1704–9). In fact, however, though this facade precedes the Salon by some thirty years, it already exhibits some strange departures from architectural decorum: a merely decorative rustication, only an inch thick; a strangely deep string course on which rest sculptures; the absence of sculpture in the niches provided for them; and arches surrounding windows that they do not fit.

Were there not rococo facades such as the Asam Church or the Wies Church, and Palladian interiors, such as Chiswick and the Egyptian Hall, one would be tempted to see the two styles as one, but as it is, they complemented each other and were often joined, as at Claydon, Kirtlington (1747–48), the Mansion House at Doncaster (1751), and Chesterfield House (1752), the latter built by Burlington's protégé Isaac Ware, who published designs of rococo interiors in his Palladian book of architecture, though he criticized the mazes of "unmeaning ornament."[57] As Gervase Jackson-Stops said, "To a large extent rococo in fact became the official style of interior decoration, particularly for smaller and more intimate rooms, among this new generation [Vardy, Brettingham, Ware, and Paine] of the 1740s and 50s, but posed no threat to the established conventions of exterior architecture."[58] Ralph Edwards had written earlier, "In the decade 1750–60, the Rococo came as near to universality as any style that has obtained in England."[59] One suspects that this constant disparity between external simplicity and internal profusion, especially noticeable at Kent's 44 Berkeley Square, derives from a conscious aesthetic, one that is based not merely on contrasts but on extreme contrasts, brought in a mannered and self-conscious way to the attention and enjoyment of the spectator.[60]

If the two styles were sometimes joined to-

Pierre-Alexis Delamair, Hôtel de Soubise, 1705–9. Paris. Giraudon/Art Resource, New York.

James Gibbs, William Smith, John Sanderson, Kirtlington Park, 1742. Oxfordshire Photographic Archive, Department of Leisure and Arts, Oxfordshire City Council.

gether as exterior and interior, I think one can safely say that they were, in England, by the mid-century *always* juxtaposed as exterior and garden. Nikolaus Pevsner was probably the first art historian to refer to the English garden, specifically Pope's, as rococo, "with its wiggly paths, its minute mount, its cockle shells and minerals, and its effects of variety on a small scale."[61] According to Pevsner, the sources of the garden were Whiggism and rationalism, which in architecture took the form of Palladianism.

> But in gardening the very term imitation of nature was bound to create quite different associations. . . . For this he [the virtuoso] needed architects and gardeners. And they—brought up in the atmosphere of early Rococo—could not help interpreting the nature of the Whig, the nature of the rationalist, the nature of the virtuosi into a nature of the Rococo, wiggly, puny, and playful.[62]

Pevsner makes this association of neo-Palladian and rococo sound like an unlucky break rather than an organic connection, which is the more positive view articulated by Bauer.[63] However one values rococo, the English garden, at least in its early eighteenth-century phase, with its serpentine waters; its delight in surprise; its placing of a house in a picturesque setting; its use of the antique as ornament and architecture as toy, as in garden buildings that are miniaturized temples; and above all in its play between nature and art, in which what is natural results from artistry and what is artistry, such as a ruin, is subject to nature—in all these regards the English garden reveals its rococo identity.[64] That the *jardin anglais* expressed European as well as English sensibilities helps to explain its enormous popularity on the Continent. And recently Wiebenson and Dennerlein have shown that the Continental garden itself, apart from English influence, was undergoing a similar and, to a degree before unrecognized, independent development away from the formal gardens of Le Nôtre.[65]

Twentieth-century scholars have been somewhat uneasy about this juxtaposition of "romatic," informal, or rococo garden and "classical," formal, or neo-Palladian house, and have been at some pains to explain their genealogy from common sources. Pevsner, as we just saw, said they derived from Whiggism and rationalism; Wittkower said that garden and build-

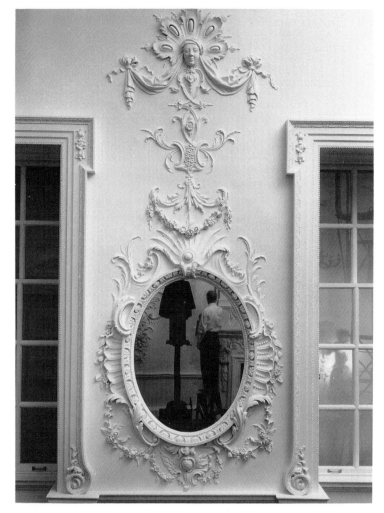

Charles Stanley, Dining room decoration, Kirtlington Park, ca. 1745. The Metropolitan Museum of Art, Fletcher Fund, 1932. (32.53.1)

ing were "two sides of the same medal" inscribed Liberty.[66] In a recent article John Dixon Hunt insisted on ancient Rome, arguing that the garden, like the villa, was a version of antiquity "mediated to the present via Italian Renaissance examples."[67] Whether the sources were Whig politics, the ideals of the Enlightenment, Italian paintings, Virgilian landscapes, antique villas, Augustan values, or theatrical design,[68] or all of these, as I believe to be the case, everyone agrees that what on first sight to modern eyes seems incongruous was to the eighteenth-century artist a natural relationship and that a common aesthetic or taste united the garden and the villa. In other words, the relationship between rococo and neo-Palladian (or Augustan) is not superficial but deep-seated.

Looked at in the context of the rococo aesthetic, the gardens, which are themselves rococo,

continue the playful contrast of interior and exterior (common to both rococo and neo-Palladian) and create still another contrast, now between the geometric exterior and the undulating surroundings. All three—interior, exterior, and garden—belong to one another in principle as well as in practice.[69] The facade but separates the garden, where nature is treated as an emblematic work of art, from the room, where art in this case stucco work and wood carvings is made to represent natural, growing forms. We have then not a conflict or war of styles but a *set* of three art forms intimately related to one another. Together they form an *ensemble* or *gesamtwerk* that must be appreciated and understood in its entirety. Is not this ensemble a picture, as it were, of the self-image of the "Earls of Creation" who built these country houses and landscape gardens? The gardens were the half-wild feminine nature,[70] over which the owners had asserted their benevolent and discrete mastery; the villas represented the cool and decorum, the good manners and taste with which the owners surveyed their possessions and the world, confident in their debt to no one but themselves and Providence; while the luxuriant decoration within represented the rich furnishings of their private imaginations and the proper setting for domestic bliss. Guarded by the formality of the exterior, this inner space could, artificially, run wild. Here one fully realized the ideals of Mr. Spectator and Lord Shaftsbury. It was indeed the *locus classicus* of a new set of sexual, economic, political, and intellectual attitudes, all intertwined and interrelated. And the neo-Palladian style and the concept of Augustan cannot fully describe or account for the phenomenon. Neo-Palladian, then, and rococo may at least be looked upon as two aspects of the same work of art. Just as they dwell in the same building, so they inhabited the imaginations of the same artists.

Jackson-Stops has spoken about the ease with which Palladianism and rococo existed among the second generation of Palladians. It seems to me that they coexisted in the minds of at least two artists of the first generation, William Kent and Alexander Pope. In Rome, at the Accademia di San Luca, Kent had actually been a classmate of Cosmas Damian Asam, one of the greatest of Bavarian rococo artists.[71] If Kent is to be slighted as an architect and called a "decorative painter,"[72] what style did he paint in? His com-

positions are far too airy, too fragile, too filled with open spaces to qualify for late baroque; gravity and the grand style eluded Kent, if he ever desired them. As an artist he is at his best in drawings, such as the one of the little dog sitting up and begging, which was used as the cover for the recent exhibition catalogue of his work. It displays the surface tensions typical of the rococo, and it is not unlike Watteau's kittens at the Fitzwilliam.[73] The variety, eclecticism, and invention of Kent are too complicated to be easily characterized, though to me he was a kind of eccentric rococo artist, just as Hawksmoor was an eccentric baroque artist. No small part of the English genius is its inability to follow Continental models. But everyone from Lord Burlington onwards has thought that Kent's real genius lay in the sphere of interior decoration and garden design, the two arts most appropri-

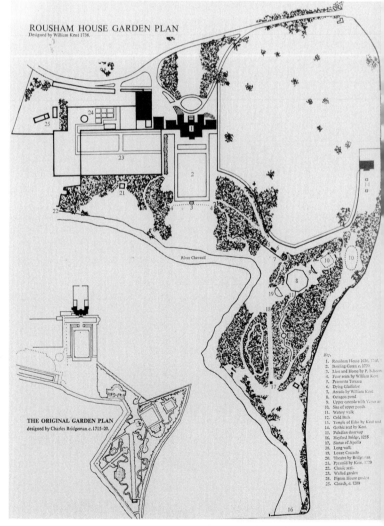

William Kent, Plan of Rousham, 1737–42. Rousham, Oxfordshire.

ate to the rococo. And Kent did create one rococo masterpiece, the garden at Rousham (1737–41). The plan, which resembles an asymmetrical cartouche;[74] the miniature scale, as opposed to Stowe; the homage to Venus; the serpentine rill, which here appears in England for the first time; the *pittoresque* use of ruins, similar to those at Nymphenburg; and the charming way its path turns back upon itself, surprising the wanderer with the revelation that the terrace from which he initially looked across the Cherwell was actually the top of the Praeneste, a classical temple to Fortune—all these comprise the rococo aesthetic at its very best. To Horace Walpole, of course, this, "the most engaging of all Kent's works," was "elegant and antique."[75] But if it was "perfectly classic," it was classic "in little."[76]

If neo-Palladian and rococo may both be applied meaningfully to the art of Sir William Kent, the terms are also relevant to Pope. Pope is a Palladian not only because of his association with the circle of Lord Burlington but more so because his poetry is "Augustan." Just as Augustan signifies a poetry based on Roman models, a poetry that is moral, urbane, civilized, and critical, so neo-Palladian is also based on Roman models and represents the best of a grand tradition that needs rescuing from an age fallen into decadence and vulgar luxury. Yet, like Kent, Pope was an originator of the rococo *jardin anglais*. Who else literally constructed his own *rocaille* chamber, the famous grotto, where like an inhabitant of one of Meissonier's prints, the poet enjoyed the play of diffused light and listened to the soft sounds of falling waters? Not surprisingly, the best contemporary view of Pope in the grotto comes from Kent himself. And just as Pope's poetry may be characterized as Augustan, so it has been called rococo; indeed, to some it represents the epitome of the style.[77] The point then is not that sometimes Pope was neo-Palladian or Augustan and sometimes rococo, that his villa was in one style, his garden in another, or that this poem is Augustan and that rococo. Such a view is not only overly categorical but absurd. No one had a more unified style or sensibility than Pope, no one a more consistent voice. The point is that the same artist may be seen, accurately, as *both* Augustan and rococo. The terms do not exclude but complement one another, as I should hope the case of Pope demonstrates.

Having considered some points of similarity and even identity between rococo and Palladian, let us look, from a rococo point of view, at two of the most famous Palladian ensembles, the first, the original Palladian Bridge (1737) at Wilton. As one approaches it, it looks like an archway, and like archways in other gardens, it draws us onwards. We approach closer—it is very important that the path and the arch be lined up exactly for this effect—and not until we have almost entered the arch do we discover that it is a bridge. And looking at this bridge, for how can one resist being pulled off the path at this point to gain some aesthetic distance, we connoisseurs make still another discovery, namely, that the bridge is done in the style of a house, a Palladian house in fact, having a rusticated ground floor and a tripartite *piano nobile* above it. The bridge has no exact precedent in the works of Palladio himself, but the bridge, which Palladio did design and which could have been a prototype for this one, was much larger, having three aisles.[78] Lord Herbert's Palladian bridge, then, is constructed on the same principles as rococo art, namely, reversal, surprise, hybridization, and miniaturization. And its imitator at Prior Park may be even more rococo in being but a picturesque folly, leading from nowhere to nowhere.

In Bath, the movement from Queen Square to the Circus (begun 1754) to the Royal Crescent (1767–75) is justly admired as one of the triumphs of urban planning and architecture.[79] Again, if we regard this ensemble from a rococo point of view, we see on a larger scale the same principle of variety and surprise we found within the villa at Chiswick. We also notice that the facade of Queen Square is itself a hybridization, namely a mixture of a row of town houses and a palace or temple, a species of architectural wit that might even have surprised Palladio. The Circus is even more audacious. Not only does it hybridize town houses and Colosseum, but also it turns the Colosseum inside out, making the interior facade the exterior one. Furthermore it miniaturizes and domesticates the Colosseum, transforming a Roman circus or amphitheater designed to hold some forty thousand spectators into a private residence for thirty-three gentlemen and their families. The Circus is not an instance of adapting an existing structure, as was done in Medieval times, to contemporary use; it was a self-conscious, entirely new creation by the artist. From the Circus one spur led "to a group of streets surrounding the New Assembly Rooms, together with another square turned inside

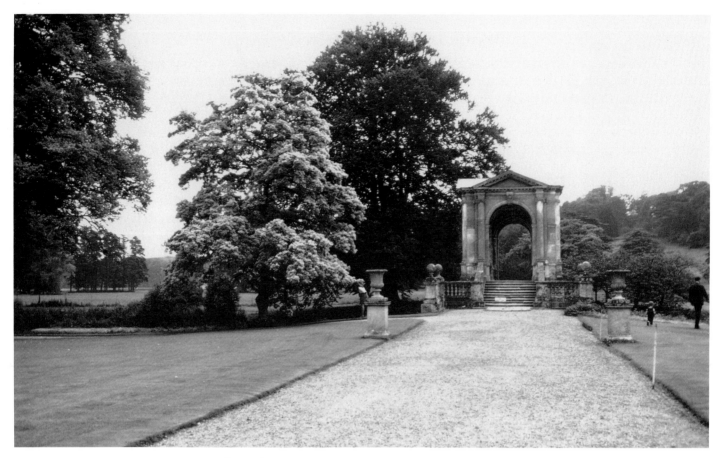

Lord Herbert, view toward the Palladian Bridge, Wilton House. Wilton. Photo by Marlene Park.

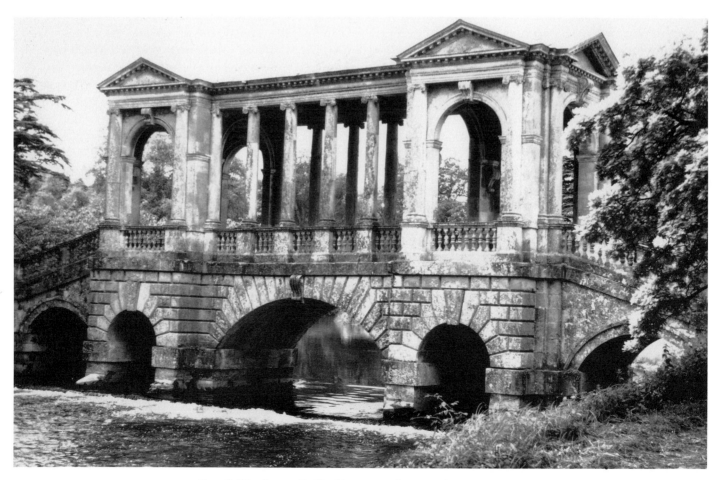

Lord Herbert, Palladian Bridge, Wilton House, 1737. Wilton. Photo by Marlene Park.

out,"[80] and another to the Crescent. The Crescent is half a Colosseum, also turned inside out, and like so many other rococo hybridization and inventions, such as the novel and the comic and ballad opera, it became a genre in its own right. John Wood, when he was attempting to be most Roman, most historic, most emblematic, and most Palladian, was, at least in principle and effect, *also* being most rococo.[81]

Finally, let us consider the engraved portrait by Picart of Palladio that appears in Leoni's famous book of 1716.[82] It is an eighteenth-century interpretation of the man. The attributes would appear to be the reality and the portrait artificial, framed by an oval window in an actual wall, or is the wall painted? And to further confuse the issue, the folds of Palladio's mantle spill over the framework, making them seem alive while at the same time drawing our attention to the artifice, and one hopes, good humor of the entire composition. Is it stretching the point to see this portrait as an emblem of the neo-Palladian movement, combining as it does allusions to Palladio and, what turns out to be, an eighteenth-century contemporary style, which like other rococo portraits surprises us? Another instance, the portrait of Oudry by Perroneau in the Louvre (1750)[83] at first seems to portray the subject on the canvas, but as we follow the curving line of his arm down to the chair, we discover that he is actually standing in front of the canvas and that the painting is, among other things, a goodnatured visual joke. Or consider the self-portrait by Hogarth of 1745. As Paulson observed, the painter's portrait is the artifact, the symbols—the dog, the books, the palette, and the line of beauty—are real.[84]

Though we could never overlook the differences between neo-Palladian and rococo, we can recognize similarities, affinities, and points of identity between them, a few of which I have sketched above. At the very least the two styles complemented one another. At times, the rococo dissolution acts as a foil to the neo-Palladian order; at other times, the order provides the necessary frame for the rococo dissolution, or freedom. In both styles one can discern, in certain regards, a common aesthetic, and eighteenth-century artists had no difficulty in moving from one to the other, or employing them both in the same work.

What is true about the relationship between rococo and neo-Palladian is true of all the styles

B. Picart, Portrait of Palladio from Leoni's edition of Palladio's Four Books of Architecture. *London, 1715. Avery Library, Columbia University.*

of the eighteenth century. The Gothic of the eighteenth century was similarly playful and decorative, not structural, and has long been considered a subdivision of rococo,[85] as of course has Chinoiserie. The same may be said of the Churrigueresque style in Spain, through which decoration, wild and inventive and going far beyond its Plateresque origins, takes over the whole surface of the facade. This style of the first decades of the eighteenth century was succeeded by an outright rococo style,[86] which achieves its fullest expression in Tomé's Transparente (1721–32) in the Cathedral in Toledo and in the Chapter Room of the monastery of Cartuja in Granada. There the wall, executed by unknown artists between 1742–47, seems to have literally melted and then

reformed into layers like the earth itself. If the rococo in Spain insinuated itself into the Gothic and the baroque, the French "classical" tradition was the very home of the rococo and made use of the same contrasts between exterior and interior as the neo-Palladian. And in many instances that classicism itself was modified into the rococo hôtel style discussed at the beginning of this chapter. Finally, the late baroque has so many rococo features that it is difficult to separate the two from one another. Wherever we look in the eighteenth century, we see an architecture that is rococo, that has been modified by rococo, that has predominant rococo elements, or that has been juxtaposed or joined to rococo.

If all the works of art during the first half of the eighteenth century looked exactly like a Meissonier print, then the period would have been very dull indeed. And if that sort of conformity is necessary before one can accept rococo as a period style, then it will never be accepted, for the eighteenth century, more so than previous centuries, exhibited great liberties, daring, and playfulness within the Renaissance tradition it inherited. But if the near universal presence of either rococo itself or its aesthetic can qualify it as a period style, then the first half of the eighteenth century throughout Europe should be regarded as the rococo period. For it was this idea of rococo that gave the art of the time its distinctive, unmistakable, and unique appearance.

II
Rococo Culture

3

The Rococo Vision

Having achieved this fictional view of the world, the enlightenment found it could dispense with myth, that magical view of the "Spirits and Powers which control events, and which can be evoked and, to some extent, controlled themselves by human practices." Milton tried to take a mythical or magical view of the world in the baroque theatre of *Paradise Lost*, where the universe was not yet neutralized by science, where anthropomorphic images of God and Satan could still be invoked. For Milton as poet the gods are still, in a sense, on Olympus, and he could still animate his world—Eden, at least—by human agencies. But even Milton was having trouble with these magical images and supernal agents, and after the enlightenment set in, all such mythological figures became either the sprites of Pope's *Rape of the Lock* or the personifications of eighteenth-century verse. The language of myth is, prevailingly, metaphor, since metaphor dramatizes the world, anthropomorphizes reality. Popes uses the simile, not the metaphor, as his usual poetic device.

Whatever we believe myth to be, there is a difference between a baroque and a fictional view of the world. Here is the importance of rococo as a style—to this extent the first modern style.[1]

T HAT HISTORY HAS TWO ASPECTS, CHANGE AND continuity, few would deny, yet an enormous amount of scholarly heat has been expended defending one or the other half of this proposition, as for instance in the polemics between essentialists and relativists. Periodization may be looked upon as a golden mean between the two extremes, accounting, as is it does for change, but seeing that change in the context of a tradition that has been significantly modified. Baroque makes no sense whatsoever without the concept of Renaissance, nor can rococo be meaningful without baroque. One may argue vehemently that rococo is but a late phase of baroque or that it is a style in its own right, when both propositions are true. Baroque and rococo both continue their predecessors in important ways, but both alter previous conventions or practices. Style is much less an either/or concept than a both/and.

According to Meyer Schapiro, although periods are arbitrary, four criteria exist for establishing them: political, dynastic, aesthetic, and cultural.[2] No outstanding political or dynastic events, such as the ascendancy of Louis XIV and restoration of Charles II in 1660 or the French Revolution of 1789 mark off the rococo era. Rather they mark off "the eighteenth century" itself, a period though not a period style. The best dynastic criterion would be the era of Louis XV, beginning with the Regency in 1715 and ending with his death in 1774, but that extends beyond

the period of rococo dominance, and, though indicating the French origin of the style, it seems alien to the Brothers Zimmerman and Alexander Pope. Nevertheless *Louis Quinze* style is a synonym for rococo. One could say that rococo began with the War of the Spanish Succession (1700) and ended with the Seven Years War (1762), but those two world wars, though having extraordinary consequences in the New World and in Asia, were from a European perspective but part of an ongoing struggle for dominance among the great powers, a struggle that began in earnest during the Renaissance or Age of Discovery and lasted into the twentieth century. They neither changed European tactics nor brought any lasting peace. Yet they coincide perfectly with the rococo, and one wonders whether the cynicism that the first produced and the new visions of empire and world mastery that resulted from the second did not play a part in fostering and rejecting the rococo vision. One might say that the rococo was intended as an antidote to the horrors of the wars and the times, something like Hollywood musicals of the 1930s. We know that it began because Louis XIV, depressed about the death of his children and grandchildren, depressed about his dwindling treasury, depressed about the military successes of the Engish, asked his artists to make everything gay. Here we have an exact correlation, but why should the style have spread to happier more victorious lands? A more convincing argument would be that the period 1700–1760 was no worse and in many ways better—warmer weather, larger harvests, fewer plagues, and a rising standard of living—than any era before it, and rococo gaiety expressed success and optimism.

But the best criterion for the rococo period, obviously is the aesthetic one, the one that derives from the origin and life of *l'art rocaille*. As we have seen, this began in 1699 in Paris, spread throughout Europe, where it joined with several indigenous national developments, or *Sonderformen*, and went into sharp decline in the 1760s. Jacques Vanuxem takes the not uncommon view that the rococo did not equal the baroque, that it did not express a general tendency, and that it was only a style of interior decoration. Yet a few pages after making this pronouncement, he remarks that the rococo was the most perfect example of how a style spreads.[3] Sedlmayr says the rococo was only one of several stylistic pos-

sibilities in the first half of the eighteenth century, but that everything was touched by the "breath" of its new spirit.[4] That the style took root in so many places, that it was ubiquitous in the Europe of the first half of the eighteenth century, that it makes its presence felt in painting, architecture, and sculpture, argues for its being a genuine period style. But what provoked this study was not merely the strong aesthetic criteria for regarding rococo as a period style but the accompanying cultural criteria. Some of these we have discussed in the first chapter: the secularization and equalization of time and space, the breakdown of traditional hierarchy, the new and greater role in the arts of the bourgeoisie and women. Happily, one cannot separate very easily the aesthetic and cultural, and the most compelling arguments for perceiving the rococo not only as a revolution but as a period come more from the contents of the works of art than from their wanton and provocative forms.

Nevertheless, one would like to cite specific cultural *events*, like Beatlemania, which correspond to Lepautre's innovations and serve to inaugurate the period. From a materialistic perspective, no singular occasions stand out. Rather one sees, in accord with Braudel's vision of Europe from 1400 to 1800, the continual rise of the middle class; a steady but not radical improvement in technology, the one exception being clocks, which became so well-made that they could be relied upon to determine the longitude; and the more widespread use of credit and capitalistic financing, methods that had been invented in Italy in the Middle Ages but had now spread to the centers of the North Atlantic (and world) economy, Amsterdam and London. In other words, one sees an accretion of knowledge and wealth but nothing like an economic revolution or sudden change that would mark off a period, Braudelian perspectives affording perhaps too wide a view to focus on stylistic fashions. That power had been shifting to the middle classes had been shown by many events: the success of Parliament against the Court in England and the development of a Prime Minister (from the House of Commons); or the establishment and success of the Bank of England. There are hundreds of such facts. But one recognizes the changes more clearly, more startlingly, in the arts than in the slow accumulations of economic history. In France, for instance, Fouquet, Louis XIV's finance minister, garnered enough wealth

and credit to build Vaux-le-Vicomte (1661), where he combined for the first time the talents of Le Vau, Le Notre, and Le Brun. Thus, the famed Louis XIV style had a private, entrepreneurial origin, or was it, as Louis claimed when he arrested Fouquet and confiscated the property, a corrupt political one? The end of that style and the triumph of the rococo is also marked by a work of art, *Gersaint's Sign* (1721), which, by showing Louis XIV on his ear, tells us as much at a glance about the Regency than a lengthy analysis of the rise of John Blount and the stock market crash called "The South Sea Bubble" that his policies brought about. If I had to choose one event that inaugurated the rococo, it would be the decision in 1694 by the Neapolitan, Giambattista Gemelli Careri *to travel around the world for pleasure*, a feat that he succeeded in accomplishing, making a small fortune en route by buying cheap and selling dear at each port of call.[5] His one action combines the miniaturization of the world, the pursuit of pleasure, and the commercial outlook.

From an ideological perspective, the immediate sources of the rococo are somewhat easier to determine. Of the hundreds of seventeenth-century works that in retrospect led up to the rococo—works such as *Don Quixote*, the arabesques of Berain, the buildings of Boromini, the paintings of Luca Giordano, the *Maxims* of La Rouchefoucauld, Dutch genre painting—four books published in the late seventeenth century are most important: Newton's *Principia* (1687), Locke's *Essay on Human Understanding* (1690), Leibniz's *New System* (1695) plus his widespread correspondence, and Bayle's *Dictionnaire historique et critique* (1696). That Lepautre read them all I have not yet been able to determine, but what he began perhaps as whimsy, pure invention, or fantasy, developed into a style that expressed in plastic form the philosophical and social implications of these works.

When we turn from the plastic arts to writing, however, our methodological difficulties increase. Ever since René Wellek demolished Fehr for describing eighteenth-century poetry in terms of an art historical style,[6] literary scholars have, on the whole, despite some notable exceptions, shied away from such analogies, and certainly the current emphasis on textuality, structure, deconstruction, and hermeneutics does not provide a favorable climate for such an investigation. Walter Binni gave a very fine summary of

the concepts and usefulness of a literary rococo and concluded, not unlike Wellek on the baroque, that the term applies best to the plastic arts and that in literary history, it is more useful to describe aspects of works as rococo rather than use the term to characterize either a period or a particular work.[7] Such a view represents the consensus more or less agreed to by the scholars of the late 1950s and early 1960s, from Sedlmayr to Sypher, who, while willing to generalize more than most, begins his own discussion by saying that rococo "is not one of the major styles and appears during the first half of the eighteenth century as a fugitive manifestation of the decorative arts."[8] And there, since on the whole literary criticism has turned away from questions of periodization, the matter has rested.

Yet if the *idea* of rococo permeates architecture, painting, and sculpture, if it breathes on all the arts, an open-minded investigator might at least inquire whether these same ideas appear in eighteenth-literature as well. But literary historians who write about period style can only be as good as the art historians who have preceded them, unless they become art historians themselves, for one cannot make analogies of any worth between two conceptions unless they have been based on careful observation. Wylie Sypher was much more successful than Fehr because he had the work of Fiske Kimball and Hauser to draw upon. And we have the advantage of Sedlmayr, Bauer, Minguet, and Harries, even though all of them are more modest or prudent in their claims than the present author.

Despite the disarming caution of his opening statement, Wylie Sypher has best understood and described the relationship among Newton, Locke, and the rococo. As he put it, "In rococo the firm, thin architectural skeleton, which almost vanished, was like a Newtonian world-order erected by mathematical concepts, those colorless mental fictions behind the intricate appearances of things; or, perhaps, like Locke's idea of a state of Nature as the invisible design beneath the social order."[9] That is, the disorder of the rococo depends upon the certainty of an underlying order, in the case of the flamboyant decoration, the geometrical wall beneath it, in the case of social license, the "fiction" of a state of nature and a social order, a "fiction" that signifies a new self-consciousness about "tradition." Similarly Leibniz's system asserted an optimistic belief in a divine order that allowed all created things, or

monads, to have their own freedom of movement and uniqueness. And Bayle ridiculed both traditional theology and Leibniz's new scientific version of it, that is, all theologies that based themselves on reason, but he did not present a system of his own. Rather, like Locke, he advocated tolerance and pluralism. Thus, as we have seen, the rococo could be "free" or subversive, like Mardi Gras, without directly challenging the status quo.

THE DOUBLE STRUCTURE

What characterizes the rococo style and rococo culture, then, is *Zweischaligkeit*, or the double structure. Because the universe is ordered, the artist may play with appearance. Because of the certainty of metaphor or metaphysical analogy, the artist is free to use metonymy. Because human nature is fixed and everywhere the same, the writer may explore subjective states and inner feelings without losing his bearings. Because the thinker assumes a rational scheme of things, he may be empirical. Such is the bright surface of the double structure, and looking at it from this perspective, one sees a healthy, vital culture, so secure, so certain, so successful, that it could *play* with the assumptions upon which it was built. But the age that gave us the phrase *"Vive la bagatelle,"* was not that simple or optimistic, for the double structure has shadows and depths as well. Fontenelle's *Entretiens sur la pluralité des mondes* (1686) has as its counterpart Swift's *Gulliver's Travels* (1726). That Newton's scheme explained the fundamental laws of the universe was well and good, but it explained only matter and motion. Where in such a scheme was the personal and loving God? It is very hard to *worship* a distant clockmaker, who seems to have removed himself not only from the hurly burly of transitory existence but also from its pain and suffering. So despite the fact that Newton himself was a mystic and a devout believer, his system, while affirming a belief in the Lawmaker through His discovered laws, further fostered the alienation and doubt that had begun in the seventeenth century and led, via Hume and the other philosophes, to the science vs. religion controversy. As Hinnant has reminded us, it was not Johnson who destroyed the notion of a great chain of being, the *plenum* of the theologians and phi-

losophers, but Newton himself, for his system does not affirm the continuity between God and his entire creation, but rather introduces the idea of void or vacuity between them.[10]

As Newton explained the external world, so Locke explained the internal one. But like Newton, Locke, though giving some readers assurance, created as many difficulties as he did certainties, and the chief of these was nothing less than the lack of any apparent relationship between the mechanics of the mind and the mechanics of the universe. Rather the two structures seemed juxtaposed, like the ornament and the wall or the interior and exterior of a Parisian hotel. Of all the efforts to supply the links or the organic connection between them, the most interesting and successful was *Tristram Shandy* (1759–67), which to cope with the normal chaos of the human condition (brought on by Lockean association) and mortality (signified by Newtonian gravity) advocated laughter and sympathy. But these do not proceed from logic or experience. Even were Locke's epistemology not at odds with Newton's cosmology, his work introduced numerous anomalies into philosophy. The entire course of eighteenth-century British thought—the empirical school—devoted itself to exploring them. If one line of investigation led to the "common sense" philosophers of Scotland, another led to the complete skepticism of Hume, who thought that only "carelessness and inattention" chased away skeptical doubt.[11] So even in Hume, within the empirical Lockean structure, we see two structures, a rococo one of carelessness and abandonment to the moment and beneath that a depressing skepticism, the one derived from his own experience, the other the result of rational speculation upon it.

On 10 January 1714, writing to Nicolas Remond, chief counselor to the Duke of Orleans (soon to be the Regent of France), Leibniz rather breezily states that in the controversies between materialism and metaphysics "both sides are right, provided they do not impinge on one another; everything in nature happens mechanically and metaphysically at the same time, but the source of mechanics is in metaphysics."[12] Not only did the systems of science and religion each have its own validity within its own sphere, but each soul, according to Leibniz, was unique; each one had its own special point of view and could perceive, represent, and express its own subjectivity. No longer was there a fixed center to

things, but a pluralism in which every point, every soul, was itself the center. Yet God, the all-comprising monad, made individual perspectives accord with one another. What could be less baroque and more rococo, or modern, for Leibniz's view bears striking similarities to the new science of chaos.[13]

In *Novissima Sinica* (1697), Leibniz was the first European philosopher "to succumb to the charms of Cathay," a sign of his genuine pluralism, for he thought China could teach natural religion to Europe and Europe revealed religion to China.[14] To Bertrand Russell, Leibniz suffered from "general duality; he had a good philosophy which (after Arnauld's criticisms) he kept to himself, and a bad philosophy which he published with a view to fame and money. . . . I think it probable that as he grew older he forgot the good philosophy which he had kept to himself, and remembered only the vulgarized version by which he won the admiration of Princes and (even more) Princesses."[15] Of course Leibniz and the Princesses (we note Russell's chauvinism) did not see it this way.[16] Leibniz believed the two systems supported one another and that no full account of human expressions could be given without metaphysical enquiry. Although his oscillations in mood between optimism and pessimism reflected what Philip Weiner has called a "radical dualism," Leibniz did as well as any of his predecessors in reconciling the divine and the natural.[17] Ironically, his vulnerability to Bayle's skeptical attacks came about precisely because his own method of reconciliation was based not on dogma or revelation but on mathematics and science. Kant may have realized, as Barbara Stafford said, that Leibniz "provided the model for two systems no longer on speaking terms," and that the union between noumena and phenomena could only occur "through the fiat of divine, absolute, monarchial intervention, or by an idiosyncratic, arbitrary, and 'unnatural' theurgy of correspondences,"[18] but most writers of the first half of the eighteenth century accepted something akin to Leibniz's double system. By this I do not mean that Leibniz was *the* philosopher of the rococo, as was St. Thomas Aquinas for Scholasticism, nor do I believe he provided the *Formprinzip* that poets studiously followed, especially in Germany.[19] But his system was representative of what we could now call the "strategy" whereby writers in the early eighteenth century attempted to negotiate between the new scientific cosmology and tradition, enthusiastic about the former, more or less faithful to the latter. Like Pope they may have been genuinely gifted with a double vision that could simultaneously entertain contrary perspectives; like Johnson, they may have feared the absurdity that would overtake man were there no belief in the divine; like Swift's nominal Christian they may have assented merely out of inertia or custom because there was no better alternative; or like Leibniz himself, or Bishop Butler, they may have believed in the rational and necessary relationship between the two. Leibniz's follower, Christian Wolff, actually believed God had created two universes, one spiritual, one material.[20] Stafford wonders whether an intensive study of the eighteenth century might not contribute to our own postmodern sense of being in between.[21] This is not to say that we are merely projecting back onto the eighteenth century our own position between systems that are not on speaking terms, or our own consciousness of a binary computer-modeled universe. But a generation whose "representative" critic, Jacques Derrida, might well have as his own motto, *Vive la bagatelle*, should be sensitive and sympathetic to the ambivalence and double perspectives of the rococo world, which hoped that all chance was but direction that they could not see.

Whereas Newton and Locke concerned themselves with science and nature, and Leibniz with God and logic, Bayle's *Dictionary* was critical and historical. Here too we find a double structure, for Bayle typically juxtaposed two opinions or sets of ideas against one another, as in religious disputes and controversies, and allowed the reader to choose between them. For instance, on the subject of faith and reason:

A true believer, who has correctly understood the spirit of his religion, does not expect that it will be capable of refuting, by reason alone, the difficulties raised by reason. He knows that natural things are in no way proportional to supernatural things. . . . One must necessarily choose between philosophy and the Gospel: if you want to believe only what is clear and distinct, choose philosophy and abandon Christianity, but if you want to believe the incomprehensible mysteries of religion, choose Christianity and abandon philosophy, for to grasp both the clear and distinct and the incomprehensible at the same time is impossible.[22]

Skeptics took great pleasure in such remarks, but Bayle does not explicitly side with them; he only asserts that one must make a choice between two systems or modes of thought. He became, in fact, like other skeptics, very critical of reason, realizing that it led one into doubt. So even though he can find no necessary connection between the two systems, he acknowledges the usefulness as well as the inadequacies of both. And though he discountenanced rational proofs or arguments for God and so undermined traditional theology, he himself, according to Labrousse, was a believer. What he practiced or held was a kind of fideism, in which the truths of religion transcended reason.[23] However bitter Bayle may have been against Catholicism and rational "proofs" of God, his tone, which influenced the next two generations, is more mocking, irreverent, one might even say "gay" than indignant or confrontational. Unlike his predecessor, Pascal, his outlook is more ironic or flippant than tragic. And unlike Descartes or Malebranche, who attempted to reconcile a mechanical with a spiritual system, Bayle, though seeing the disparity between the two systems, can live without *angst* in between. But, as Labrousse says, his criticism was "an instrument so sharp that it destroyed the mental universe to which he himself still very much belonged."[24]

Nevertheless, Bayle, though a skeptical Protestant, anticipated or paralleled several of the Catholic currents of the eighteenth century. One we have seen exemplified in the rococo churches, where the religious art does not pretend to break down the barrier between the natural and the supernatural, rather it draws attention to the disparity between the two. It reminds the alert or conscious worshipper that art, like reason, falls short of expressing the divine mysteries. The system of art can but allude to what it can never by itself reach. However much the decoration of the Bavarian churches gives glory to God, none of it will ever snatch any graces beyond its reach; such can only come from God, as a gift.

The other Catholic current we see most clearly and, for rococo purposes, most perfectly in Jean Pierre de Caussade's *Abandonment to Divine Providence*, written in Nancy between 1733 and 1739. In these letters to the Nuns of the Visitation, to whom he was confessor, Father Caussade advocates the practice of giving one's self to God at every moment. As in rococo painting, which secularized and equalized time, or in Richardson, whose method of "writing to the moment" gave new significance to the minutiae of every day life, Caussade sanctifies the moments again, not in the baroque way of extraordinary epiphanies but in the rococo manner of each moment being equally alive to religious content. "*How easy it is to be holy.* . . . In reality, holiness consists of one thing only: complete loyalty to God's will. Now everyone can practice this loyalty, whether actively or passively."[25] "*God reveals himself to us through the most commonplace happenings in a way just as mysterious and just as truly and as worthy of adoration as in the great occurrences of history and the Scriptures.*"[26] If one were to try to invent religious statements couched in rococo terms, one could not do better than Caussade himself, writing during the very years during which Stanislas, Louis XV's father-in-law became King of Lorraine and commenced the building program that made Nancy, his capitol, into a rococo masterpiece.

> We can find all that is necessary in the present moment. . . . What does matter is what each moment produces by the will of God. We must strip ourselves naked, renounce all desire for created things, and retain nothing of ourselves or for ourselves, so that we can be wholly submissive to God's will and so delight him. Our only satisfaction must be to live in the present moment as if there were nothing to expect beyond it.[27]

Notice the vocabulary—abandonment, present moment, naked, satisfaction. A few letters earlier he had written, "Give your desires free reign, setting absolutely no limits, no boundaries to them."[28] One could let oneself go just because one was in the context of Providence. And throughout, Caussade makes clear that this method of attaining holiness is not one he has constructed to please cloistered females but the very one he, a Jesuit, employs amidst his worldly cares. That what he says has always been true or that much of his teaching may be found in St. Teresa of Avila does not negate the fact that he expresses these truths in a rococo manner and that these truths, among many other ways to God, would be just the ones to come to the fore during the rococo period. Sedlmayr and Bauer remark that the religious analogues to the rococo may be found in the new orders established at the end of Louis XIV's reign, the Sacred Heart and the Immaculate Heart of Mary,[29] both of which, like fideism, depend more on the joyful

experiencing of God than on either suffering or rationalistic theologies, though neither order disputed or denied the *Summa* of St. Thomas Aquinas but developed happily within the framework of orthodoxy. As Cochin complained, no lady's dressing room was prettier than a chapel, and even the confessionals had an air of gallantry.[30] But any French examples were surely outdone by the confessionals (ca. 1760) created by J. M. Feichtmayer for Ottobeuren in Bavaria.

At this point the reader may well ask, what is new about this doubleness? Does not all writing and culture proceed out of conflicting values and emotions? Does not literature depend on the reality behind the appearance and philosophy on decoding the codes? Is not a large part of the satisfaction we realize in reading literature derived from its ability to synthesize and resolve these "double structures"? To which I answer that what distinguishes the rococo among such general practices is, first, its extraordinary self-consciousness about these structures—it draws attention to them; and second, the structures have a wider gap between them, they share less in common than at any prior moment since Europe had emerged from the Dark Ages. Remember that the rococo building and the rococo room literally have a double structure, as one can see from the plans of Steinhausen and

J. M. Feichtmayer, Confessional, ca. 1760. Ottobeuren. Foto Marburg/Art Resource, New York.

Dominikus Zimmerman, ground plan, Steinhausen, 1729. Foto Marburg/Art Resource, New York.

Balthazar Neumann, ground plan (preparatory design), Vierzehnheiligen, 1744. Foto Marburg/Art Resource, New York.

Vierzehnheiligen, and that inner and outer walls have virtually no similarities. As the first recorded critic of the rococo, the Abbé le Blanc, put it, the artists "couple together beings of different natures."[31] These differences are not a matter of the roadster replacing the horse and buggy or movies replacing vaudeville, or musket and cannon replacing the broadsword and crossbow. Rather they represent two completely discordant views of life itself: the one religious, the other secular; the one hierarchical, the other egalitarian; the one heroic, the other commercial. That this shift from classic to romantic, this "crisis" in

European thought, as Hazard has called it,[32] produced a Janus-like culture is not nearly so surprising as how brilliantly its artists dealt with the disparities.

Numerous commentators, pursuing their special studies, have remarked upon this doubleness, this *Zweiseitigkeit*[33] in the culture of the first half of the eighteenth century. Earl Wasserman, for instance, writing about *Rasselas*, said, "To a large sector of the eighteenth century and to Johnson in particular, everything is bipolar, not multiple." And further. "In the dichotomous but everfluctuating world there is no clear Prodician choice [the (baroque) choice of Hercules] between alternatives, no marriage of contraries, and no mean between extremes, but only an endless, directionless oscillation between opposites, neither of which is either sufficient or stable."[34] In another important work, he described how the eighteenth-century's method of thinking in analogies encouraged a "bipartite poetic pattern."[35] Bender speaks of Hogarth's search for narrative "in a society adrift between systems of authority and structures of feeling."[36] Empson was the first to point out Fielding's use of a "double irony."[37] Paulson notes the prevalence of "bifocal" series in everything from playing cards to Johnson's *Dictionary*.[38] Ketcham remarks on the essential doubleness of *The Spectator*.[39] Payne mentions the "double truth" that pervaded eighteenth-century discussions of religion.[40] Laufer speaks of *binarité* and the *exigence double* of eighteenth-century man.[41] Maynard Mack says that the "duality of the poem [*An Essay on Man*] in this respect answers to a profound duality in the age, and very probably in his [Pope's] own mind."[42] And Northrop Frye concluded, "I think there is also some symmetry of interpenetration between Augustan and counter-Augustan tendencies, especially in the relation of individual to society, and that we can almost see the beginning and end, within the century, of a kind of double-helix movement."[43] One wonders whether these double structures do not have something to do with Anne Hollander's observation that in eighteenth-century nudes the belly gave up space to the more desirable bosom or backside and that women had tops and bottoms but no apparent middles.[44]

McKeon discusses the "double reversals" characteristic of early eighteenth-century culture. His "questions of truth" and "questions of virtue,"[45] though analogous, are themselves a dou-

ble structure, and the double reversals whereby romance idealism or aristocratic ideology are challenged by naive empiricism or progressive ideology, which in turn are countered by skepticism and conservative ideology, contain at each of its dialectical stages its own double structure, for one model is always being pitted against another. The *double* reversal resulting in skeptical thought or conservative ideology serves only to draw the audience's attention to the discordance between two structures that contradict one another without producing any synthesis. Since empiricism, which overthrows idealism, leads to the conclusion that we cannot really know anything, the best thing is, as Hume said, to stick to custom and have a good lunch. Is it any wonder that so much of rococo art depends on mirrors reflecting mirrors, surface reflecting surface?

An example of such playful thinking may be seen in the writing of Bernard Mandeville, the rococo Hobbes. Hobbes constructed his grim *Leviathan*, another example of baroque gigantism, on the premise that all men are in a state of war with one another. Such a *realpolitik* vision did not accord with the Christian belief that human beings, despite the Fall, were made in the image of God. Nevertheless, though starting with such a pessimistic and in many ways antibaroque premise, Hobbes, in the manner of his age, out of natural discord built a philosophy of social harmony, made possible, like the France of Louis XIV, by submission to a strong central authority. Mandeville commenced his system on a similar premise, but he has softened it. Instead of life being everywhere nasty, brutish, and short, life, for Mandeville, is much more pleasurable, based not on warfare but on vice. Paradoxically, and here we see the play of the two structures, all the private vices, each individual (as in Leibniz) pursuing his or her own desires, produced public virtue. Thus the natural system, left to itself, creates a social system that is harmonious. Needless to say, Mandeville, like Hobbes, outraged the moralists, but his belief that freedom and unrestrained desire paradoxically resulted in a beneficent status quo gave perfect expression to rococo license and conservatism. Adam Smith's *Wealth of Nations* (1776) owes much to Mandeville, except that Smith, a postrococo thinker, has de-ironized *The Fable of the Bees* (1714)[46] and replaced its paradoxes and hedonism with sympathy and hard work.

Throughout this book I have been, as Janson would say, "inflating" and extending the rococo: not only Boucher but Chardin, not only Boffrand but Kent, not only Leibniz but Hume. To these pairs I would add, not only Pope but Swift. Many commentators have noticed a relationship between Swift and the rococo, principally for the miniaturization evident in the concept of Lilliput.[47] But Swift is a rococo artist not only for his playful treatment of size, but for his self-conscious use of reversals and double structures. The difference is that he uses them negatively. In him, more than in any writer of the period, we see the dark underside of the "idea of the rococo." Typically Swift employs what I would call a negative dialectic. In *A Tale of a Tub* (1704) he juxtaposes the ramblings of an idiot modern author, a structure, if you will of ignorance and narcissism, to an allegory of church history. Although one sees certain relationships between the two parts of his work, such as pride and enthusiasm, one sees them only by straining, and the work deconstructs, or, to use a rococo word, dissolves, into fragments and never really concludes. From out of the chaos, we receive the message that the Anglican Church is a *via media* between the excesses of Catholicism and Calvinism. But much more startling and memorable is the "Digression on Madness," in which we read that all systems (but not the Christian one?) are founded by madmen. What the work really seems to be telling us, if anything at all, is that "the sublime and refined point of felicity, called the possession of being well deceived" is "the serene peaceful state of being a fool among knaves." Not that Swift approves of it; it is just the way most people live. Were he writing today, I am sure his narrator would be an anchorman on the local or national news. Beneath all the rambling, the non sequiturs, the digressions, the digressions within digressions, one may sense the thought of a Christian and an "ancient" mocking the freethinker and the modern.[48] But the whole work is so radically disassociated, disjunctive, and disruptive that I doubt very much that it ever offered much edification to either the pious or the conservative. "The Argument Against the Abolishing of Christianity" (1708) is a calmer, more coherent piece. In its Swift pits a nominal Christian, the narrator, against the Freethinkers. Both views are absurd, again a negative dialectic, but the implication behind the work, the hidden structure, is the worth of genuine, primitive Christianity, though given Swift's exposition of

the triumph of the world, the reader wonders, like the nominal Christian, if that exploded system was ever practiced. In other words, we see two false superficial structures of thought underlaid by a third, which has no place in the scheme of things except as a norm that shows everything else to be founded on sand. One might argue that Swift could so successfully pillory the nominal Christian and the freethinker because of the certainty of his own orthodoxy, much as Mary need not be present at the Annunciation in Berg-am-Laim. But the rise of freethinking in the eighteenth century and the decay of the Anglican Church (split by Methodism, increasingly associated with an upper-class establishment alone) tells another story. Swift was disappointed he was not made a Bishop, but any religious reader, certainly any "churchman" of the eighteenth century, Samuel Johnson being a good example, would see that however prophetic Swift was about the calamity threatening Christendom, and however accurate about the true nature of modernism, his own views as expressed in his satires were anything but safe or reliable.

In *Gulliver's Travels* he continued the negative dialectic. Humans are both Lilliputians, thus too petty, *and* Brobdignagians, and thus too gross. What is worse they are Yahoos trying, like Gulliver, to be Houyhnhnms. They are either animals incapable of reason, driven only by low passions and filthy desires, or, in their European and civilized disguises, capable of reason, but only to corrupt and pervert it. No wonder Gulliver goes mad, caught as he is between an animal nature whose lusts he cannot acknowledge and his longing for a rational nature that he can never attain. And as the "soft" readers of *Gulliver* have maintained, anomalies and contradictions plague this rational nature. So Gulliver's voyages lead nowhere, and in them we see not only a profound analysis and scathing satire on human pride, but also the dissolution of all traditional human contexts or structures. *Gulliver's Travels* is the last great European work set in courts, but Swift depicts them all as absurd, insane, or destructive. The equality of the Houyhnhnms lies beyond human capacities; it is either an illusion that we cannot reach or a foil to reflect our deficiencies. And despite the presence in the work of an implied Christianity and its doctrine of original sin, and despite repeated references to a better past, (the Roman senators were demigods, the modern parliaments are

pickpockets), we are left with a vision of a Yahoo civilization where the dunces have triumphed and universal darkness covers all.

In Swift, then, in negative form, we see clearly the structures upon which the rococo depended and played, structures that seem more dichotomous than dialectical. Ancient vs. Modern; Christian vs. Freethinker; Absolute vs. Limited Rule; Court vs. Citizen; High vs. Low; Polite vs. Rude; Great vs. Good; Experience vs. Reason. Most of these pairs were inherited from the seventeenth century. But the difference between the baroque and the rococo treatment of them is that between depth and surface. Baroque artists typically commence with contrasts, light and dark, passion and duty, but convey them into some kind of unity, some overarching scheme such as *concordia discors* in which all oppositions may be reconciled. Not infrequently, however, the resulting vision is tragic, and the contrasts can only be reconciled by death or the victory of the grave. Rococo artists typically remain on the surface of things. They know all about contrast and *concordia discors;* in one sense they assume them, and in that sense the baroque is the other structure of the rococo,[49] but rather than explore these contrasts in depth—that would be too obvious, too ponderous and dull—they prefer to *play* with them and achieve their unity through surface profusion, an accumulation of minutiae, and devastatingly accurate social observation. The resulting vision is, of course, comic or satiric. In "A Digression Concerning Madness," Swift ironically praises that wisdom "which converses about the surface" as opposed to "that pretend philosophy, which enters into the depth of things, and then comes gravely back with informations and discoveries, that in the inside they are good for nothing." But such was the wisdom of his age, and indeed his own critical method consisted not in going deeply into anything, except in the manner of parody, as in *A Tale of a Tub* or *A Modest Proposal* (1729), but in juxtaposing false superficialities and patterns of behavior. One suspects that in the passage just quoted his satire cuts against the pretense of "deep" philosophy as well as against the "shallow" wisdom of the moderns, the depth itself being a form of modern shallowness, as in Descartes or Gassendi.

Wasserman has pointed out the three ways in which the eighteenth century used its double structures: "to define reality by comparison and

contrast, as in *Absalom and Achitophel* and *The Dunciad;* the transformation of those structures into new forms, as in *Tom Jones;* and the resulting deformation of the structures in collision with reality, as in *Tristram Shandy.*"[50] These usages correspond roughly to the three stages or three generations of rococo culture, but Wasserman might have added a variation on his first type, namely the method we have been looking at in Swift, where two false systems are juxtaposed to one another. Such was also the method of Gay in *The Beggar's Opera* (1728) and of Fielding the dramatist. His funniest plays, *The Tragedy of Tragedies* (1731) and *The Convent Garden Tragedy* (1732), exploit the disparity between the lofty attitudes and high language of the baroque theater and his protagonists, in the one play, the miniaturized Tom Thumb, and in the other, a modern fop trapped for the night in a brothel. Parody and mock-heroics appear in all ages, but during the first thirty years of the eighteenth century, they became, for the reasons we have been discussing, the major genre.

Musicologists have long considered the period 1600–1750 as the baroque, and they speak with less self-consciousness and more assurance about "baroque music" than art historians do about baroque art. If the concept of rococo occurs at all in this scheme of things, it does so marginally, in the mood pieces of Couperin, begun during the last gloomy years of Louis XIV and continuing into the Regency, pieces with names such as "La Volupteuse," "Les Papillons," and "La Coqueterie" (1713–30), or in the rise of the comic opera, ballad opera, and *opera buffa.* This is all well and good—the baroque gives us opera, the rococo comic opera—but it does not go far enough for a hard-line periodizer such as myself. One suspects that baroque is too gross a category for all the musical changes that took place within this century and a half, and that the two greatest musicians of the mid-eighteenth century, Handel and Bach, had rococo qualities. For instance, Paul Henry Lang can say that Handel wrote a "loose fugue," that his *"intentions are seldom clear and he is always full of surprises,"* and that while he "composed some very fine fugues according to the book, the majority of his choral fugues are free, unpredictable, and gloriously unregulated."[51] This is rococo vocabulary, and through it we see or hear Handel exercising his license within the baroque framework. In his sober but insightful account of rococo mu-sic, Luigi Ronga includes not only Couperin and Pergolesi, not only Vivaldi and Scarlatti, but also Bach and Handel. According to Ronga, there are two aspects to the musical rococo, one, a technical virtuosity associated with the *stile galante,* the other a greater development of feeling associated with the *stile sentimentale,*[52] these two musical qualities being analogous to the doubleness and the play of nature and artifice we have found elsewhere in the rococo.

Hypothetically at least, the polyphonic system of Handel and Bach would seem just as appropriate to the rococo, where the artist can use the conventional multiple structures for playfulness and novelties, as for the baroque, where they seem to correspond to the hierarchy and diversity of an ordered universe. Edward Lowinsky would disagree. To him, baroque is aristocratic, rococo middle class. "Royal entertainment demands ceremony and dignity; middle class entertainment echoes the brisk pace of everyday life." The essence of this new style is "singleness of melody," Rousseau's *"unité de mélodie."*[53] He regards the fugue as the symbol of the baroque and the classical sonata as the symbol of the "emerging rococo." But if that were true, the emerging rococo becomes what is generally known as classical. Rather than regarding Couperin as baroque and Telemann as "still rooted in the style of baroque counterpoint," as does Lowinsky, I see them as rococo artists. For Lowinsky, Johannes Mattheson (1681–1764), who in his writings championed "the leading role of melody," "is the representative of stylistic transition, Rousseau the spokesman of the stylistic revolution achieved."[54] That is, Mattheson remained baroque while Rousseau became rococo. But for me, the musical rococo *was* this transitional period, which prepared the way for Rousseau and the classical style.

The music of Mozart, which is sometimes referred to as rococo, is better described as classical just because it is basically harmonic and not polyphonic. While Mozart does exhibit some rococo qualities, one of them being his own playfulness and invention, another being the subject matter of his operas, particularly *Cosi Fan Tutti,* to me Mozart seems to be looking at the rococo from a postrococo perspective. Heroines in the rococo period would not be unfaithful; they would either be innocent or profligate, either virgins or strumpets, either Marianne or Manon. The shift in convention that allows a good

woman to be unfaithful or sexually compromised signals the beginning of romanticism, and it commenced with Rousseau's Julie.

NATURE AND ART

Whereas baroque artists articulated these conflicts between "questions of truth" and "questions of virtue" in terms of God and man, the supernatural and the natural, the rococo artist articulated them in terms of nature and art. By presuming not God to scan, and making the proper study of mankind man, Pope announces that though *An Essay on Man* (1733–34) will be more superficial than *Paradise Lost* (1665), it will also be more empirical and, possibly, useful. It will treat not the invisible, not the hidden reality, but the observable surface of things, how human beings behave and what they make. A more negative and less pious version of the same shift in perspective appears in Montesquieu's *Persian Letters* (1721).

> Nothing is more depressing than consolations based on the necessity of evil, the uselessness of remedies, the inevitability of fate, the order of Providence, or the misery of the human condition. It is ridiculous to try to alleviate misfortune by observing that we are born to be miserable. It is much better to prevent the mind indulging in such reflections, and to treat men as emotional beings, instead of treating them as rational.[55]

So the three-dimensional seen and unseen, height and depth of the baroque becomes the two-dimensional covering of the rococo, and the conflict or tension shifts from that between the divine and the human to that between two aspects of humanity itself. Nature, which meant primarily human nature, particularly the passions, the heart, or, as in Montesquieu, the emotions, usually corresponded to truth; art to morality or virtue. The one was "nature as it is"; the other was "nature as it ought to be." The novelists, for instance, should not promiscuously describe the world, as Samuel Johnson said,[56] but should exhibit only examples of struggling virtue. He admired Richardson because he "taught the passions to move at the command of virtue"[57] that is, that nature could be governed by art. Pope tells us that Homer (art) and nature are the same, and that "true wit [art] is nature to advantage dressed." Art of course is here conceived of as clothing, as a surface decoration.

Such remarks, while assuming a conflict between nature and art (or morality), ultimately rest on the notion that they may be resolved. That was the normative, simplest way of viewing the matter.

One can best appreciate this play between nature and art by considering the theater, a medium particularly suited to the rococo aesthetic, for in it, nature, the actors, present themselves as *personae*, or art, while art uses all its craft to proclaim human nature. Yet all the illusion, however ingenious, inevitably points to itself; it fools no one, except perhaps Partridge in *Tom Jones*, who mistakes Garrick for Hamlet. In 1703 in Bologna, Ferdinando Galli-Bibiena used the *scena per angolo* for the first time. As Harries says:

> Ferdinando's son Giuseppe lets the stage appear as only an accidental part of a much larger space into which we are allowed to peek from without. . . . In keeping with the intention of illusionism, baroque stage design sought to join the pictorial space created by the stage designer to the real space of the auditorium by giving the former the axis of the latter. The distance that separates pictorial from architectural reality is thereby blurred. The *scena per angolo* asserts that distance; theatrical space and real space are divorced.[58]

And their divorce draws attention to the difference between the two systems of space. How the productions within this new special arrangement differed from the baroque has been described by Margarete Baur-Heinhold.

> The rococo stage required a different style of acting and different techniques. The index finger was no longer pointed imperiously, but the little finger was crooked, with delicacy and grace, perhaps a little affectation. Sweeping gestures, self-confidence, the embodiment of dignified gravity, which lent drama even to the act of standing still, were replaced by balletic lightness. Intimacy invaded the spaciousness that was so essential to the baroque stage, the theatre reflected the general social and intellectual withdrawal from the rigid etiquette of the great royal palaces to the smaller, more relaxed world of the *salons*. Heroism gave way to gallantry, heroes became lovers, goddesses were endowed with *esprit*. The baroque superman left the stage, and wit, gaiety, ambiguity, skepticism and irony, all the nuances of human personality were seen instead.[59]

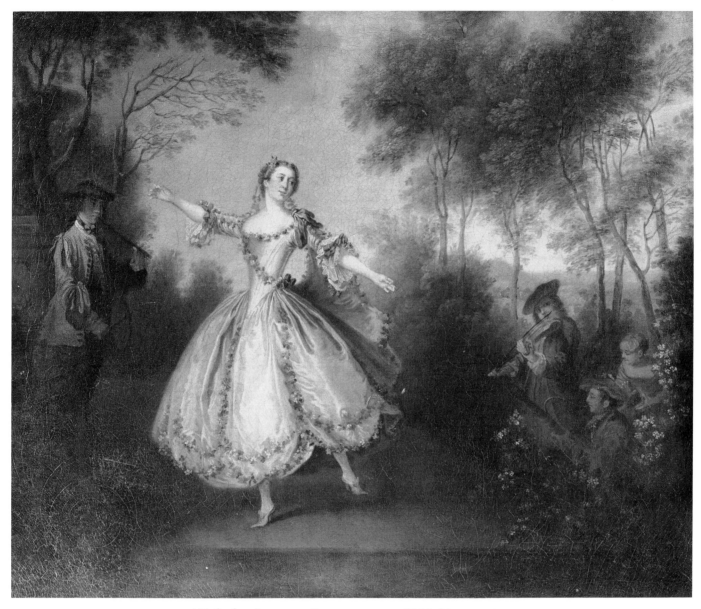

Nicholas Lancret, Camargo, *ca. 1730. Nantes, Mu-
sée des Beaux-Arts. Giraudon/Art Resource, New
York.*

She remarks on the sensation Marie Justine
Favart created in 1753 when in *Bastien et Bas-
tienne,* she appeared on the stage "with her hair
down, wearing a plain woollen dress and clogs,"
and how Favart combined "the rococo theater of
carefree aristocracy, and the theatre of senti-
ment, full of middle-class virtue and the sorrows
that beset the common people."[60] Yet this is not
unlike the earlier sensation caused by Garrick in
the late 1730s when he brought a new naturalism
to the standard repertoire of the English the-
ater.[61] Or earlier than that, the sensation caused
by Camargo, when she danced, freely, with a

shortened skirt, an event commemorated in Lan-
cret's paintings.

The increased naturalism, the softening of the
conventions of rigidity, characterized all the arts
of the rococo from acting to horseback riding,[62]
from gardening to furniture making. Even new
types of furniture were invented: "la commode,
la chiffonière, la table de toilette, le secrétaire, la
table d'ouvrage, la table de jeu, le meuble d'en-
coignure. . . . Cette spécialization des usages suf-
fit à indiquer que le sens du confort a pris le pas
sur le sens de l'appart."[63] But always the more
"natural" innovations occurred in the guise of

art. For instance, the minuet has been described as "certainly the most refined, lightest and most perfect stylization of love that dance has ever created."[64] Although it began in the mid-seventeenth century, it had by the eighteenth developed from a closed figure-8 form to a more open s- or z-shape, a dance as a line of beauty. It expresses love, but love stylized, like Pope's "nature methodized," or "True ease in writing comes from art, not chance, / As those moved easiest who have learn'd to dance." Such may be a truism, like the dialectic between art and nature, but no other period so self-consciously discussed and expressed that relationship. According to Saisselin, love itself, prior to Rousseau, was conceived of as an "aesthetic activity."[65]

The obverse of the love of naturalness was the love of things artificial. Cochin begs the goldsmiths to stop making tureens where life-sized artichokes sit beside hares the size of a finger.[66] If we may judge from the supreme example of Meissonier's silver-covered tureen with platter, we may be sure that both artichoke and hare were rendered with the greatest verisimilitude, but as usual in rococo art, the silver or gold and the juxtaposition, rather than fooling us, only draws our attention to the artifice. The sober commentators of the day, from Mr. Spectator onwards, complained continuously—it was the subject of some of their best writings—about the same kinds of extravagance and incongruity in the theater, of its spectacle, its novelty, its mindlessness and monstrosity, the phantasmagoria of it all not unlike Pope's final vision in *The Dunciad* (1743) where the curtain of false art comes down on nature itself. Clearly the audiences of the period took particular delight in the illusion that all the mechanical ingenuity of the early eighteenth century could conjure up for them: flying machines, atmospheric effects, Gods and demons, sudden appearances and disappearances, trap doors and skylights, sets that changed before their eyes. The famous theater at Drottningholm (1766) has preserved all this sort of machinery, and the equally famous one by Cuvilliès in the Residenz at Munich (1751–53) reminds us of how much the theater itself became a painted stage or artifice; in this case, even the cloths draped over the boxes are made of stucco. Such spectacle without content, at least by the criteria of "high" critics, has always pleased "the people." That the eighteenth-cen-

tury theater "fell" to this level indicates the popular nature of the enterprise and the extraordinary craftsmanship that made it possible, popularity, technique, and superficial appearances, always being bound up with the pre-Hollywood aspects of the rococo, in which art self-consciously masqueraded as nature, and nature was transformed into an artifice.

But all the theater was not trumpery and hokum. One thinks immediately of the delicacy and wit of Marivaux. In plays such as *The Double Inconstancy* (1723) or *The Game of Love and Chance* (1730), the titles of which could not be bettered by the most determined of periodizers, he reveals the metaphysics of the heart, that is nature, by mixing up and confusing the class system. Here servants pretend to be aristocrats, and aristocrats servants, a confusion made possible by the implicit understanding that their natures are not different. In a seventeenth-century play, for instance in Shakespeare, the lower classes behave in a way analogous to the upper, but their loves do not become crossed up. That would have been too much a violation of theatrical and social decorum. A master might pose as a servant in order to spy something out, but a servant could not pretend to be an aristocrat, especially to woo a lady, except as a piece of the grossest imposture, which would require exposure and punishment. Of course, in the early eighteenth century, at the end of the plays, class order has been preserved too, but more by the whim of the author and the force of convention than by anything natural.

In an age as given to reversal and playfulness as this one, not only the classes but nature and art themselves had a way of slipping into one another's costumes and changing places. One of the most thoughtful dramatic explorations of these relationships occurs in an English play, Congreve's *The Way of the World* (1700), which I consider to be the first full-fledged English example of the literary rococo. I know very well that *l'art rocaille* began in a very modest way with Pierre Lepautre in 1699, and that Congreve neither knew him nor saw his engraving, at least while he was writing *The Way of the World*. I am also aware that in the plastic arts, *l'art rocaille* did not cross the Channel into England until the 1730s. But as I have stated before, though I do not believe in a *Zeitgeist* or quasi-mystical spirit of the times, I do believe that Lepautre and Congreve lived in the same climate of opinion, a

Juste-Aurele Meissonier, Tureen with cover and platter, 1735–40, Paris. Cleveland Museum of Art, Leonard C. Hanna, Jr. Fund, CMA 77.182.

climate that favored the growth of the rococo. And I am attempting to extend the concept of rococo from a particular artistic form to the idea or ideas behind that form, ideas debated and shared by all the countries of western Europe in the first half of the eighteenth century. Thus the rococo interior design and sculpture could begin in France; rococo painting could begin in Italy and France; rococo porcelain in Saxony; rococo architecture in Italy, Austria, and Bavaria; and rococo literature in France *and* England and Germany.[67] When one considers (or realizes) that *The Way of the World, The Rape of the Lock,* the *Embassy Letters* of Lady Mary Wortley Montagu, *Gulliver's Travels, The Beggar's Opera, Pamela, Tom Jones,* and *Tristram Shandy,* are all examples of the rococo style, in short virtually the present-day canon of English works of the first half of the eighteenth century, then one will begin to see why rococo received its best and fullest *literary* expression not on the continent but in England, despite the achievements of Marivaux and Voltaire, the "typische Rokoko mensch."[68] And one

François Cuvilliès, Theater, 1752–53. Munich, Residenz. Foto Marburg/Art Resource, New York.

will begin to understand why in many ways rococo is in some ways a better context than Augustan for the England of this period, and at the very least its necessary complement.

Unlike *Love for Love* (1695) which deals, via astrology, with religious questions, *The Way of the World* devotes itself completely, as the title indicates, to the "world." Clearly Congreve satirizes the *beau monde* who make up his characters, yet, and this is typical of the rococo, no other group appears in the play. There is no redeeming good society that can be contrasted to the fallen or "mad" one of upper-class privilege. Sir Wilfull Witwoud represents the country—he is a stock type of Restoration humor, the country bumpkin—but he reveals himself as inadequate as his foppish cousin, Witwoud. "Natural, easy Suckling!" says Millamant. "Anan? Suckling! no such suckling neither, cousin, nor stripling: I thank Heaven, I'm no minor," replies Sir Wilfull. This is the crucial moment in the play. Sir Wilfull, the man of the country, the "natural" man, should, by our romantic standards, sweep away all the artifice of Millamant's world and rescue her from her sterile, unfeeling upper-class existence, not unlike Tarzan or Lady Chatterly's lover, Mellors, the gardener. But instead he is too tipsy, too gauche, too cliché-ridden, too unfamiliar with poetry to make love to a sophisticated woman, and after hearing how Millamant loathes the country and hates the town (two false systems), he escapes from her presence. Millamant laughs at him and continues her recital, "Like Phoebus sung the no less amorous boy." Then Mirabell enters, answering "Like Daphne she, as lovely and as coy" (act IV, scene i).

Instead of a romantic displacement then, we see the rococo paradox. Millamant and Mirabel quote Suckling, a cavalier or court poet of the previous age. The poetry, which of course is art, is a kind of nature poetry, but a very artificial sort, inhabited by conventional creatures like Phoebus and Daphne, who speak, playfully of real passions. Mirabel can "conquer" Millamant because he, like she, is so artful. He speaks naturally, through poetry. Of course they passionately love one another, but a sign of their genuineness is that they are better than the other characters in not revealing their true feelings. Rather they make love by devising a marriage contract, which indicates all the pitfalls of the matrimonial state and assumes they will be incompatible. Millamant would no more say "I love you," than she would "Gee, you're swell!" Rather she declares, "These articles subscribed, if I continue to endure you a little longer, I may by degrees dwindle into a wife." And Mirabel, in the last scene, while kissing Millamant's hand and expressing his passion, says, "Well, Heaven grant I love her not too well, that's all my fear." Likewise, though Mirabel's cause is just and natural, he wins Millamant and her fortune by being cleverer in his deceits than Fainall and Marwood. As he justifies himself, "it was an innocent device; though I confess it had a face of guiltiness,—it was at most an artifice which love contrived" (act V, scene i).

So the "play" occurs on the field of this world; there is no displacement to a higher world above, to a greener world away from London, or to a better world in the future, governed by more sincere people. The conflict between good and evil, true love and power games all takes place in terms of nature and art. Millamant curls her hair (nature) with love letters in verse (art), and Lady Wishfort, whose white varnished face has cracked, must sit to her picture. As Foible, her maid puts it: "I warrant you, madam, a little art once made your picture like you; and now a little of same art must make you like your picture. Your picture must sit for you, madam" (act III, scene i). The end of all these jokes and witticisms, of all this intrigue, is nothing less than a vision of a human nature that cannot be separated from art; indeed the paradox that the play dramatizes is that it is human nature to be artificial. No wonder that eighteenth-century people were taught to stand, walk, and gesture in S-curves![69]

Much of what I have just described may be found in earlier "Restoration" comedies: the *beau monde*, the country bumpkin, the male seducer, the coquette, the horny matron, the fop. In this regard, *The Way of the World* continues the tradition. But it also alters it in significant ways. The nature in the works of Etherege and Wycherley, and even in Congreve's contemporary, Vanbrugh, is a much more Hobbesian one of ferocious struggle, poorly masked of course under elaborate etiquette. Animal images, particularly animals of prey, abound. Congreve's nature as we have seen, is much more artful, and the struggle between protagonist and antagonist, though real, is perceived more as a game—the play opens with Mirabel and Fainall playing cards—than as tooth-and-claw survival. Earlier Restoration comedies are misogynist. They move toward

an assertion of male power and dominance; the rake hero manipulates women into publicly confessing or inadvertently revealing their "passion" for him. And the plays regard these men, these Dorimants, in a very positive way. Congreve's eye is much more on the women in his audience. Mirabel on several occasions confesses his genuine "love" for Millamant and is more open, in this regard, than she.

> *Mrs Mil.* . . . Ha! ha! ha! what would you, that you could help loving me?
> *Mir.* I would give something that you did not know I could not help it.
> *Mrs. Mil.* Come, don't look grave then. Well, what do you say to me?
> *Mir.* I say that a man may as soon make a friend by his wit, or fortune by his honesty, as win a woman by plain-dealing and sincerity.
> *Mrs. Mil.* Sententious Mirabel!—Prithee, don't look with that violent and inflexible wise face, like Solomon at the dividing of the child in an old tapestry hanging.

She is the one in control, in command, but of course she does not seek *power* over him; she genuinely loves him and only teases him, naturally, in terms of a work of art, the old tapestry with its religious, moral, and feminine themes, upon which she plays. The struggle for dominance has given way to the game of love, a game which, though refereed by women, can be won by both players.

Such shifts in tone and emphasis mark the beginning of "sentimental comedy." But that, too, should be seen in the context of the rococo. In France, the play of nature and art more often than not resolved itself in *plaisir*. That could happen in England too, an extreme instance being Cleland's *Memoirs of a Woman of Pleasure* (1745). But more often, the delicacy and fine feelings, the softness and domestic comforts, express themselves in "moral sentiments." Thus in Steele's *The Conscious Lovers* (1722), a play that centers on matrimonial arrangements in the family of the wealthy merchant, Mr. Sealand, the Prologue tells us:

> No more let ribaldry, with license writ,
> Usurp the name of eloquence or wit;
> No more let lawless farce uncensured go,
> The lewd dull gleanings of a Smithfield show.
> 'Tis yours, with breeding to refine the age,
> To chasten wit, and moralize the stage.

Art does not reside in licentious wit, but in good breeding and refinement. And good breeding and refinement, or manners and taste, will *moralize* the stage. What in ages past and ages hence would probably be seen as insincerity became for the early eighteenth century, the signs of morality. Hypocrites like Cimberton, the false suitor of the play, can manipulate these signs and feign them—he will, of course, be exposed. But despite such abuses, morality manifests itself on the surface of life. It is the true art of nature, both for Welsted, who wrote this Prologue, and for his enemy Pope, who stooped to "moralize his song."

In *The Rape of the Lock* Pope seemingly mocks Belinda and her circle for being completely artificial, yet all their artifice but serves the purposes of passion or nature. Though Belinda lives in a contrived social world, Pope repeatedly compares her with the sun, and not always ironically. As a result of his ambiguity or double perspective, the poem is not just a satire on the upper classes but, like Congreve's play, another paradoxical vision of the human condition, for when Belinda behaves most superficially and unnaturally, she is behaving most humanly. The critique of artifice cannot be separated from the critique of nature. Yet as Pope demonstrates the paradoxical relationship between artifice and nature, between trivial and mighty, he is also indicating that the resolution of all human conflict—sexual as well as political—occurs best, or only, in great poems such as the one he has just written. He is not just saying that art endures and locks turn to grey, as did Shakespeare in his sonnets; he is presenting, however facetiously and mockingly, for it is also lovingly, an aesthetic view of the human condition instead of a religious one, a view all the more startling in its secularity and "modernism" in that it was put forward by a Roman Catholic.

Pope's delight in transformations—coquettes into sylphs, locks into aesthetic stars—accords with the general love of transformation that characterized his whole era. This love may have been heightened by the loss of the transcendent, "for the rococo knew no real transcendence but only a revelation and enchantment of the earthly presence."[70] Its beauty came from the transitory.[71] Thus the love of the seasons, celebrated in music, paintings, tapestries, and in the most popular poem of the mid-eighteenth century in England, Thomson's *Seasons* (1726–30). But there is a rococo melancholy as well. It takes the form of a new fascination with time and history,

Joseph Effner, Magdalenenklause, 1725. Munich, Nymphenburg. Foto Marburg/Art Resource, New York.

of the nontranscendent mutability we find in Johnson's writings, but primarily it takes the form of a love for ruins, poetic ruins and triumphs of time, engraved ruins, as in Piranesi, and in the actual building of ruins to ornament the natural gardens of delight.[72] One of the first of these occurred in the Magdalenenklause (1725) at Nymphenburg, the city of Nymphs. It came as a shock to me to find in the exquisitely decorated chapels of Feichtmayer and the other Wessobruners the clothed and bejewelled skeletons and grinning skulls of the saints. Of course they were there, perhaps not so well attired, before the rococo chapels were constructed, but all the gaiety of the rococo never attempts to deny the reality of death, rather it holds an often unstated but dialectical relationship with it. Cochin complained that rococo artists made tombs pretty and gilded them over, but they never re-

moved them or pretended they did not exist.[73] Seen in this perspective the graveyard elegies of the 1740s are but the other side of the Anacreontics, the two strains merging hideously in the demonic parodies of the Hellfire Club.

The paradoxical sense of human nature as being artificial also occurs in three important thinkers of the early eighteenth century. For Vico, as Norman Hampson remarked:

> The historical process consisted of the developing self-knowledge of societies, which became increasingly aware of their ability to control their material environment and to influence the complex assumptions and attitudes which is misleadingly described as 'human nature'. For him, human nature was therefore a social creation, in continuous evolution.[74]

Yet as Isaiah Berlin points out, "Vico is in obvious ways a relativist, but in spite of this, and without attempting to reconcile the two, a devout Christian."[75] Once more, the double structure or double view. For Montesquieu, in *De l'esprit es lois* (1748), nature is both a moral imperative and a system of conditioning forces. Thus man, while determined by geography, climate, and culture can also shape nature in accordance with his will; for Montesquieu, "from the viewpoint of social determinism, cause and effect are reversible. . . . He was prepared to admit that laws were in part the products of an economic infra-structure, but only if granted that the economic infra-structure was in part the product of laws."[76] For Hume, although the rules of justice were "artificial," they were not "arbitrary." Rather, as they were "inseparable from the species," it was not "improper to call them *Laws of Nature.*"[77] Yet while all three expressed their awareness of this interplay of nature and art, and while all three carried their thought far into the regions of skepticism and determinism, they all assumed some sort of constancy in human nature, in terms either of its capacity for self-knowledge, or its innate morality, or its mode of arriving at nonconclusive conclusions. None of them crossed the line into complete relativism; all of them held on to some sort of "fiction" or frame of reference that allowed them to pursue their general theses.

During the rococo period, however much writers, artists, and the populace as a whole enjoyed the fluidity of nature and its ever-changing relationship with art, and however, much the two

were identified as one, or however reversible they might be, they were never really confused, even if they changed places. The people of the early eighteenth century were more like Cervantes than Don Quixote. They could dream of eternal youth and hedonism; they could make winter a season of fun and enjoy sleigh riding; they could adorn beautiful young heads with white wigs,[78] but they never thought snow a figment of the mind or mistook old age for youth. Bauer remarks that Marie Antoinette playing a shepherdess in *Le Hameau*, was not a figure of the rococo.[79] Rococo shepherdesses would be natural girls who are either artless or artful, like the ones who inhabit Boucher's paintings. Or they would be artificial creations, fantasies of girls made to appear natural, which may also apply to Boucher. Madame Pompadour's art made her all nature; her nature made her all art; but she never *pretended* anything, least of all that she was a shepherdess. Wortley Montagu and Lady Mary had themselves painted in Turkish costume, but she never thought she was a Turk nor did he construct a make-believe harem.

Her *Embassy Letters* (1717–18), certainly one of the most outstanding works of the eighteenth century, also reveals what should now be familiar as the rococo mentality. Lady Mary *observes* two worlds. First, the world of Vienna as compared to that of London. As always, she remarks on domestic arrangements and sexual mores. Her tone is one of ironic and amused detachment, although the Viennese system whereby each married woman has a husband and a lover, the two often the best of friends, disturbs her English calm, it does so only briefly. The greater contrast exists between the Christian world, which she leaves when she crosses the frontier near Belgrade, and the Ottoman one on the other side. Not unlike Montesquieu, she plays the customs of one against the other. Although in the most well-known letter, she points out how the women in the Sultan's harem are freer than English wives, on the whole her perspective is genuinely pluralistic and nonjudgmental. She does not use the one world to put down the other; instead, she describes, wittily, what she experiences and keeps her distance from both. She is too intelligent to choose between two cultures, neither of which would ever fully satisfy her, and both of which depend, in her eyes, upon morals and standards that are relative. So though she came home advocating reforms only in the area

of smallpox inoculation, her work, like so many others, of the period, implicitly subverts the pieties and norms on which the status quo had been erected. That is, what had traditionally been yoked together as natural *and* moral, for instance monogamy, male domination, even exclusively heterosexual attraction, can turn out to be, in her rational eyes, nothing more than custom, or art. Though circulated among her friends, the letters were only published posthumously in 1763.

Rococo writers wanted it both ways. They wished to criticize and mock the upper classes, custom, and traditional forms, all of which had ceased to represent a divine plan. But they had no faith in the lower classes, who were no better than they should be. Nowhere is this view of class more brilliantly asserted than in Gay's *The Beggar's Opera*. The thieves and fences speak and act like gentleman, who by implication, and at times direct allusion, are also crooks, charlatans, and womanizers. Since the nineteenth century the lower classes have been made to appear better than the upper ones, or at the very least their victims, their criminality justified as a kind of prerevolutionary revenge on bourgeois exploitation. Before the eighteenth century the lower classes would at worst be comic foils, at best comic analogues to the greatness of their superiors. But in Hogarth's painting of *The Beggar's Opera*, we see Macheath dressed like an aristocrat with red coat and embroidered waistcoat, while Peachum wears the somber black of the City merchant.[80] They are both "low" characters, but in their representation high, middle, and low have been equated,[81] In Gay's satire there is no difference in dress, language, or behavior between the upper classes and the London proletariat, any remaining distinction between high and low, the world of the beggar and the world of the opera (a baroque world), has completely disappeared. Swift called it a "Newgate Pastoral."[82] The urban prison scene signifies the pretence of the rural courtly one. That is the radical dimension of the play. But of course, it is all a joke, though at times a bitter one. Having seen that high and low are identical, except in the spheres they occupy, that there is no difference between Newgate and Hampton Court or Parliament, Gay leaves it at that. Such is the way of the world. He makes no attempt to change the structure of things, how could he, since both classes, alas, only behave naturally, by means of artifices

William Hogarth, The Beggar's Opera, *1728.
Richard Caspole, Yale Center for British Art, Paul
Mellon Collection.*

and strategems. Whether you are privileged or impoverished depends on the luck of the draw, but classes and deceptions are here to stay. That is the conservative dimension of the play. But such a solution is extremely unstable if not volatile. For once the secret is out, once people realize that class distinctions are artificial and have neither a divine nor a natural basis (except in human vice or folly), such distinctions will lose their legitimacy and authority. *The Beggar's Opera* was the most successful theatrical piece of its day, breaking all records for attendance. But it was also the harbinger of the democratic revolutions. Likewise, the first *opera buffa,* or comic opera, in Italy, Pergolesi's *La Serva Padrona* (1733), had as its subject, as the title indicates,

the reversal of a master-servant relationship, a reversal based, naturally, on amour.

CONCLUSION

In the first chapter we noticed how rococo art reversed the values of the baroque and equalized space, time, and light. And we further remarked how rococo art reversed high and low, male and female and equalized them as well. And we reasserted the claims of Hauser, Sedlmayr, and others that despite its association with the *ancien régime,* the rococo was not just a harbinger of revolution but also a kind of revolution. Soft and pigeon-footed though it may have been, it

was completely successful in laying down the foundations not only for the American and French Revolutions but for "modernism" itself. That it is seldom perceived in this radical role results not so much from the myopia of historians and critics, as it does from the rococo's own quality of double reversal. As McKeon has demonstrated, the first reversal, the critique of traditional aristocratic values by "progressive" ones, is countered by a second reversal, which mocks the progressive as well. As a consequence, the work of art becomes "conservative." Even an artist such as Swift, who is filled with a savage indignation about the injustice of the world, falls into this category, for his satire on kings and syphilitic aristocrats is countered by his mockery of masturbatory moderns. His friend Gay seems even more trivial, and more rococo. So while the traditionalist will see the rococo as subversive, the radical will see it as reactionary, and both will agree that it is decadent.

The characteristic shape of the rococo—the S-curve or serpentine line of beauty—provides the formal means for expressing this double reversal. It is full of motion, but in its twists and turns, it does not go anywhere. Instead, the rococo oscillates between one pole and another, like the lovers in Watteau's *Embarkation*, whose ambiguity of expression and motion prevents us from ever really knowing whether they are leaving for or departing from Cythera.[83]

Wylie Sypher wrote that the "essential genius of the enlightenment was its ability to erect fictions or semi-fictions,"[84] by which he meant, following Bentham and Vaihinger, "ideational constructs" such as natural right, natural law, and natural order. None of these are perceivable; they are in most respects in conflict with reality and self-contradictory. Nevertheless, "The Enlightenment was thus able to live in a world of ideas very consciously, being aware that its fictions were contrivances of the mind, a particular mode of belief. It gave rational meaning to sense data by the fictions it imposed on them."[85] Here once more, we see the concept of a double structure. As examples of this mode of thought, Sypher cites Pope's *Essay on Man*, Locke's *Civil Government*, Smith's *Wealth of Nations*, and Jefferson's *Declaration of Independence*, all of which dispensed with the mythical and magical world of the baroque. But it seems to me the rococo *vision* is more complicated than this. For

however much the *Essay on Man* partakes of this enlightened view, *The Dunciad* does not, filled as it is with all sorts of powers and spirits, most of them demonic. Likewise Swift's work, as we have seen, though critical of King and Church, usually for their deviations from an ancient ideal norm, devastates the very nature of enlightened fictions as narcissistic insanity, exemplified by Gulliver trying to be a Houyhnhnm. So that while the enlightened world contains a double structure, the anomalies of which Sterne exploited fully, this modern structure, in writers of the first half of the century, is more than likely to be juxtaposed and judged by the older mythical and magical one.

Because of all its rapid shifting or oscillating between radically different ideological perspectives, and because of the brilliant surface textures in which it clothes, or unclothes, these myths and fictions, or covers or exposes the gaps between them, the rococo appears insubstantial. It does not provide a firm ground on which to stand. Thus while it expresses what from a cultural and historic point of view may be the most interesting period since the first century, and though its painting, literature, and philosophy may have given us the most accurate portrait of man "as he is" that has ever been achieved, its vision does not offer much of a position except wit, taste, skepticism, and a good-natured hedonism. Brightness over dullness. Some may live by these lights, but not many. For this reason, the majority of students will always prefer Donne and Milton or Wordsworth and Blake to Pope and Swift. Molière and Goethe provide more substance than Marivaux or Wieland. Ironically fluctuating between God and the self, between mechanism and organism, between centers in the midst of a void, the rococo could not last. It was the shortest lived of all period styles, save perhaps mannerism, which in many respects is analogous to it. People need to believe in something. Paradox and skeptical "objectivity," conclusions in which nothing is concluded, will not, in the long run, do. Voltaire popularized critical and reformist attitudes, but modern philosophy derives from Rousseau. Only in the novel did the authors of the rococo achieve a synthesis of these double structures and of art and nature, a synthesis that provided a base strong enough to support later constructions.

4
Rococo and the Novel

Here he sees a brook whose limpid waters, like liquid crystal, ripple over fine sands and white pebbles that look like sifted gold and purest pearls. There he perceives a cunningly wrought fountain of many-colored jasper and polished marble, and here another of rustic fashion where the little mussel-shells and the spiral white and yellow mansions of the snail disposed in a studious disorder, mingled with fragments of glittering crystal and mock emerald, make up a work, of varied aspect, where art, imitating nature, seems to have outdone it. (*Don Quixote*, part I, chapter L)

OUR METHODOLOGICAL TROUBLES ARE FURther compounded by our desire to compare a style, rococo, not to a "text" such as *Tom Jones*, but to a genre, the novel. We stand on more or less firm ground when we examine a text, but that a text belongs to an order of texts called a novel would be denied by some, and others, who might accept the proposition, might disagree about the definition of that order. Ian Watt, for instance, believed *Tom Jones* only part novel, while Northrop Frye thought it central to the genre.[1] At best, the novel is not a precise category, even among literary categories, which have a way of merging with one another. Then, too, the novel has been considered from so many points of view—the rise of the bourgeoisie, the transformation of the epic and romance, Lockean psy-

chology, conduct books, empiricism, letter writing, spiritual autobiography, historiography, and journalism, to name but some primary examples—that one hesitates to put forward the rococo as still another context, especially as the rococo is a more debatable concept than the novel.

Here, too, we run into a chronological difficulty, for *Don Quixote* (1605–15), generally regarded as the first European novel, though enormously influential in the eighteenth century, is a seventeenth-century work, as are Scarron's *Roman Comique* (1651–57), and Madame de Lafayette's *The Princess of Cleves* (1678), all works that we consider novels, and there are no doubt other candidates, so that a good case may be made for the novel rising in the seventeenth century, stimulated by the new science and a more empirical view towards life and having its analogue in baroque naturalism, particularly in Dutch painting. Yet the handful of seventeenth-century prose fictions that could qualify today as novels were in their own time not perceived as being part of a new species of writing or a new genre. *Don Quixote* was considered so original and unique that it was *sui generis*, a category unto itself. Scarron gave his work a generic title, a comic romance, by which he meant that just as romances dealt with high subjects and were tragic or serious, so comic romances dealt with low subjects, in this case gentlemen and strolling

players. He no doubt wished to differentiate his book from the Spanish picaresque novels. But unlike Fielding who playfully reverses, mixes, and redefines categories, Scarron, through his title, in the best seventeenth-century French manner, clarifies. *The Princess of Cleves* would have been seen as a historic or courtly romance.

However much these authors admired their own writings, neither they nor their contemporaries saw their works as a new genre of literature. Even as late as the 1720s, Defoe, certainly by our lights a bona fide novelist, was regarded as a writer of imaginary voyages and criminal biographies, a grub-street hack, not the founder of a new province of writing. So, the novel *as a genre* did not exist before the mid-eighteenth century, and it was the works of Marivaux, Richardson, and Fielding that brought it into consciousness.[2] In this sense the novel really did "rise" in the eighteenth century, and it is from this rise in consciousness that eighteenth-century writers and all subsequent critics have been able to look back to the seventeenth century and earlier for prototypes of the new species. Both rococo and the novel, then, were the new art forms of the eighteenth century; the rise of the novel coincides exactly with the high point of rococo style, the 1730s and 1740s; and the three geniuses chiefly responsible for this rise all have associations with the plastic rococo. Marivaux's plays are generally regarded as the verbal analogues to Watteau's paintings and, like the *fêtes galantes*, seem to consist of natural feelings and artifice wrought into a confection of superficial profundities. Or, as Voltaire said, in what was at once a critique of the rococo and an expression of it, Marivaux spent his life "weighing the eggs of flies in balances of spider webs."[3] Richardson's work was illustrated by Hayman, an artist who also painted the delightful rococo panels for the dining booths at Vauxhall Gardens.[4] And Fielding, of course, had close intellectual and personal ties with Hogarth, the greatest rococo painter in England.[5]

I am not here concerned with whether the "novelization of culture," as Bakhtin calls it,[6] caused the rococo period, or whether the period caused the "rococo-ization of prose fiction." No more than Don Quixote can I untangle the cause and effect between art and life, or tell which came first, although the Bible tells us the world began with a word. What does concern me is the relationship between the style and the genre, not

because my *idée fixe* about the rococo being a period style depends upon it, but because my studies of the novel and its mid-eighteenth-century conventions led me into an appreciation of the rococo. What then can be said? Spitzer, in his article on *Marianne* pointed out a number of stylistic analogies: "de l'instantané, de la ligne interrompue, de la courbe morcelée, du saccadé, du pointillé."[7] Rousset, when discussing epistolary novels of the eighteenth century, speaks of the ruptures of tone, displacement of point of view, what he calls "le triumph de la ligne rompue" and compares such qualities to Hogarth. He sees a common character in the novelistic creations, whether epistolary or not, of the eighteenth century: "une esthétique analogue à celle qui vient de se dégager, celle qui préconcise et justifie le démarche digressive, le style coupé, les changements de plans, les ruptures de tons, l'entrelacement des fils: tous les caractères de la ligne sinueuse."[8]

In addition to such stylistic analogies, we can also see structural similarities. We have already noted that every aspect of rococo art depends on some kind of conscious reversal or double reversal of either form or expectation, which is why the word "surprise" figures largely in the aesthetics of the first half of the eighteenth-century.[9] If the reversals by which Pierre Lepautre inaugurated the rococo were too modest or delicate to alarm anyone, within thirty-five years they had developed into the full-blown rococo style, which amused, startled, and then disgusted. Designs such as S-curves and C-curves, which had formerly been marginal, became central to the compositions, and rocks and shells, which had formerly been confined to the basement or grotto, had, as Sedlmayr and Bauer put it, been defined and made acceptable on the *piano nobile*.[10] In the same manner, the novel takes downstairs subjects, a milliner's assistant, a chambermaid, or a footman and makes them the center, not of a parody, but of major works of fiction having epic significance. The result is something neither high, the knight or the courtier, nor low, the picaro or rogue, but a middle ground now for the first time opened up for artistic and moral exploration. Fielding understood this phenomenon completely, which is why he explained the new species of writing in terms of a double reversal: "a comic epic," for one expected an epic to be serious not comic: "poem in prose," for one would not ordinarily think of a work of prose

fiction as being as worthy or important as a work of poetry.[11] Consciously, Fielding attempted to raise both comedy and prose fiction, here joined into a new genre, to a higher level of significance. As he realized, Cervantes had already accomplished this, which is why he says *Joseph Andrews* (1742) is "written in imitation of the manner of Cervantes," but he wants the reader to know that his novel is not just an imitation of *Don Quixote* but a new type of book, at least in English.

It becomes clear, as Fielding continues his discussion in the first chapters of parts I and III of *Joseph Andrews*, that the comic epic poem in prose is to him a kind of golden mean that is neither too high, like the romances, nor too low, like the burlesque. Its subject is actually *Nature*, and the novelist, unlike the ideological historian or the self-puffing biographer, tells the truth. The new species of writing, then, is not just a blank space in the ideal taxonomy of the epic waiting to be filled, it becomes the new norm for prose fiction. As such it is a hybrid made up, as Fielding explains, of history, biography, romance, and comedy, all of course now transformed by truth and nature.[12] The quality of hybridization in the rise of the novel is also a major characteristic of rococo art, and the delight taken by eighteenth-century artists and audiences in mixed forms helps to explain the enthusiasm that met the works of Richardson and Fielding.

Everyone realizes that the novel was a revolutionary genre, that it diverted the literary gaze from courts to commoners, that it made the country gentleman, his lady, and his house the new social and moral norm, and that it treated members of the aristocracy negatively, M. de Climal, Lady Davers, Lady Booby, Lovelace, and Lady Bellaston being examples. As I argued in chapter 1, the rococo, too, shares this attitude, which might be described as good-natured (in the case of Fielding) or civil (as in the case of Richardson) disrespect. In such an age, the novel, with its episodic structure, its freedom from epic rules, and its looseness and mixture of forms, was bound to be appealing. Of course, a masterpiece such as *Tom Jones* (1749) has a highly unified structure, but it arises, surprisingly, from the deliberate randomness and chaos of a world seemingly controlled by Fortune and Chance. May we not also see some of the "problems" of *Moll Flanders* (1720)—its unreliable narrator, its questionable morality, its inconsistent satire, its generic wandering, now a gull's hornbook, now a romance, now a rogue's

biography—not so much in terms of Defoe's success or failure as an artist but in terms of the taste or compulsion for ambivalence and pleasing disorder typical of the other arts of the period.[13] Bender says, following Bakhtin, "the process of novelization tends to disable the established genres, to reformulate them in self-conscious, artificial ways." But it is also true that the disablement of established genres, the making of them into increasingly self-conscious and artificial forms, as in the rococo, also enables the novel to come into being.[14]

The new equalities of time, space, and light, which characterize the rococo, have several analogues in prose fiction. One direct one was what Richardson called "writing to the moment." This was not just a matter of rendering a moment in time, each moment having its own importance, as though life were not punctuated by epiphanies, but as though it were a succession of epiphanies day in and day out, from morn to night. Such rendering was indeed a novelty, but Richardson accomplished much more than this. Richardson achieved in fiction what Watteau and Chardin achieved in painting, that is, taking an ordinary common subject, whether a chambermaid or a merchant's daughter, and insisting that she is as important as a princess or a saint, and that her life may be just as moral, if not more so, than the traditional subjects with their hierarchical centers. Thus Pamela, having asserted her Virtue, may sit on *her* rococo bench in the garden of *her* Palladian home. Likewise, the soft pastel shades, the miniaturization, the delicacy, the waving line, the sweet disorder, and the eroticism that pervade all the arts of the mid-eighteenth century may be termed the emergence of a feminine principle suppressed by the severities of the traditionally masculine and "heroic" baroque. Gone, or deliberately remote, are the icons of authority and might. The Rococo vision, like that of the novel, is the domestic vision, the "good" man as opposed to the "great" one, and at the center of the domestic vision, one sees a woman.[15] Given this feminization of the other arts, one is not surprised to discover that the novel was in good part written by women, that women were the favorite subject of the new genre, and that the audience for it was predominantly female, a fact that has remained true until the present day. In this Leipzig illustration for *Sir Charles Grandison* we see a completely feminine and rococo world.

Still another characteristic of the rococo is a

its episodic narrative, its interpolated tales, and its randomness, one misses the consciousness of art or the desire of the author to make the reader conscious of it. Yet like *Don Quixote*, the greatest novels of the mid-eighteenth century, the novels other authors strove to imitate without anything but superficial success, are characterized and set apart by this very self-consciousness. We see it in the tone of Marianne's narrative; we see it in *Pamela* (1740) when her packet of letters becomes a kind of novel within the novel that determines the attitudes and actions of the characters.

Francis Hayman and Hubert Gravelot, a scene from Pamela. *6th edition, London, 1742. By permission of the British Library.*

self-consciousness about art that may be rivalled in our own times but has never been surpassed. Instead of using the vast resources of art to disguise the artifice or to subordinate the parts to the whole, as in the baroque, the rococo artist typically draws attention to the art or the deception. At first sight, the novel, unlike other rococo forms, seems more dominated by nature than by art or the play between the two. In its loose form,

J. M. Bernigeroth, A Scene from Sir Charles Grandison, *from a Leipzig edition of 1759. Beinecke Library.*

Shamela's interest in her "vartue" but echoes Mr. B's complaints in *Pamela* about the "art" of his beloved, by which he means not only her manipulation of others but her skill as a writer, which makes her such a formidable opponent. Most of all we see it in the "self-conscious narrator" and the perpetual play of nature and art, as both subject and method, which makes up *Tom Jones*. And finally we see the method carried to its extreme in *Tristram Shandy*, which is at once the most rococo of novels and the link between rococo and the romanticism that succeeded it.[16] As the rococo declines in the 1760s, so too, except for forced and only partially successful revivals or imitations, does the genius for self-conscious narration. In this regard the great decorative zone that separated the rococo fresco from the viewer may be seen as a plastic analogue to the self-conscious narrator of eighteenth-century fiction. In both cases, the artifice gives us an aesthetic distance so that we can better comprehend the subject; it acts as a foil to the reality or truth of what is depicted; and paradoxically, it links subject and method and author and spectator into one unified whole,[17] made up like civilization and history, of the play between human skill and desire and natural forces and necessities.

We justly praise the novel for its realism or naturalism, in the eighteenth century called "verisimilitude," and think of the rococo as being highly artificial. Yet as we have seen, the rococo is characterized not only by surface tension and busyness but also by surface realism, and it is in this dialectic between art and nature that we see its affinity with the novel. For typically the novel of the first half of the eighteenth century gains its effects through accuracy of dialogue and of observed action—not set descriptions. These traits are particularly noticeable in Defoe and Fielding, but they also characterize the more interior Richardson whose characters reflect on the body language, gestures, vocal tones, and inflections that he has gone to great lengths to render.

The case for the novel as rococo has been helped by Michael McKeon's argument in *The Origins of the English Novel, 1600–1740*. As we have seen, McKeon systematizes the social and the epistemological crises of the seventeenth and early eighteenth century into two analogous patterns, each of them consisting of "double reversals."[18]

The instability of generic and social categories in the period from 1600 to 1740 is symptomatic of a change in attitudes about how truth and virtue are most authentically signified. But the novel comes into existence in order to mediate this change in attitudes, and it therefore is not surprising that it should seem a contradictory amalgam of inconsistent elements.[19]

The novel, according to McKeon, internalizes these conflicts and confronts the intellectual and social conflicts simultaneously; it "emerges into public consciousness when this conflation can be made with complete confidence."[20]

From this perspective, the visual art of the rococo may be seen as the objective analogy to the literary art of the novel. Like the novel the rococo ridicules aristocratic ideas—notably hierarchy, on which all order depends—and substitutes for that certain progressive attitudes, such as femininity or domesticity, subjectivity, and an interest in the tiny or good as opposed to the great, but at the same time it depicts a world of pleasure and hedonism, associated by the bourgeoisie with the upper classes and decadence. Thus, as we have seen, it is a revolutionary art, but by this double reversal, its revolution is "pigeon-footed," implicit and subversive, not explicit, and so it becomes associated with the *ancien régime* that it undermined. Typically, rococo painting plays aristocratic and bourgeois attitudes against one another and suggests that it might be laughing at both the aristocrat pretending he is a citizen or peasant and the citizen or peasant pretending he is an aristocrat. By its double reversals it displaces nothing and leaves one, however uneasily, in the status quo, as in *The Beggar's Opera*. It reverses the order of baroque architecture, but it uses all its antibaroque techniques, as in the Bavarian churches, to assert all the more fervently the glory of the Church. So Fielding, while claiming the novelty of his achievement in *Joseph Andrews* and *Tom Jones*, carefully places them both in the familiar contexts of epic and romance. And from such a rococo cast of mind emerges his well-known "double irony," which makes fun of traditional sexual morality and then affirms it, and which satirizes the aristocracy without challenging the class system.[21]

The rococo, like the novel, exists to contain these oppositions, to arrest or capture them, to celebrate social and generic instability, and to fix them momentarily into its fluid forms. But had the mold not set at just the last moment, we

Sysang and Fritsch, a scene from Clarissa, *from a Dresden edition of 1751. Beinecke Library.*

Hubert Gravelot, a scene from Tom Jones. *ca. 1750, from a Dresden edition of 1774. Beinecke Library.*

wonder whether the whole would not have slid into formlessness altogether. The novel like the rococo, may, as McKeon says, mediate these questions of truth and questions of virtue with complete confidence,[22] but the tensions remain, and the forces behind them threaten to burst apart its formless form. One of the reasons mid-eighteenth-century novels reach such heights of excellence is that their authors are attempting to reconcile two such contrary views of the world. On the one hand, they wish to be normal and to assert eternal providence; on the other, they wish to record life *"as it is"* and be true to nature. These by the way are the actual terms by which eighteenth-century authors expressed "questions

of virtue" and "questions of truth." At no time in the Christian era had the demands of the two seemed more at odds, and as we know, in the generation that followed, the intelligentsia of Europe, on the whole, turned to a more "natural" view. But Richardson and Fielding succeeded in affirming tradition and orthodoxy as well as nature. *Clarissa* (1747–48) is not only a profound psychological drama but a serious religious work. And *Tom Jones*, while it claims to be a natural history, is a divine comedy that unmistakably reveals the hand of Providence at work in its all too human machinery. Richardson and Fielding wished to maintain this double perspective, which is why their two masterpieces

not only build upon extreme contrasts of values but also contain double structures: in *Clarissa*, Lovelace's comedy vs. Clarissa's tragedy, which of course turns out to be her otherworldly triumph and his worldly defeat; in *Tom Jones*, the structure of Fortune or Nature, which turns out to be providential. In the 1750s both works were illustrated in the rococo style. As McKeon says, the technical powers of the novel "as a literary form are augmented in proportion to the impassability of the gulfs it now undertakes to subtend."[23] No wonder such art inclines toward or revels in mock-forms, hybridizations, and double reversals and structures, structures which, like Tristram Shandy's method of narration, become increasingly problematic.

No two works better illustrate the difference between baroque and rococo than *Paradise Lost* and *Tom Jones*. Milton attempts nothing less than to explain the problem of evil. How can evil exist in a world created by an all good God? Or to put it another way, how can man be morally responsible or have free will in a world determined by an all powerful God? Undaunted by the difficulties of these conflicting ideas, Milton sets out to "assert eternal Providence and justify the ways of God to man." Fielding merely assumes Milton's argument. He alludes to it on several key occasions, notably when Tom is expelled from Paradise Hall, and he overlays the appearance of Fortune on the invisible structure of Providence.[24] But instead of exploring the problem of evil through things unattempted yet in verse or rhyme, Fielding dismisses it in his Preface by claiming that it is "easier to make good men wise than to make bad men good." Why Tom is good and Blifil is evil, or why the world seems governed by Fortune when it is really governed by Providence, Fielding never bothers to tell. Whereas Milton's daring consisted in stretching an old form to fit new subjects, Fielding's consisted in inventing a new form to hold old ideas. Milton reveals the heights and depths; Fielding displays the surface. As Johnson said, comparing Fielding unfavorably to Richardson, he was like a man who could but tell time, Richardson like a man who knew how a watch was made.[25]

The watch image is most telling. In it we see, once more, that most unlikely candidate for anything rococo, Dr. Johnson, engaging in a most rococo conceit. Instead of using a celestial (or baroque) image: Richardson is like the sun that sheds light; Fielding is like the moon that but reflects it; or a geologic (or romantic) one: Richardson is like a high precipice from which one can spy into the caverns of the deep; Fielding is like a strand from which one can but observe the breakers; Johnson confines them to an artifact, the clock. In so doing he miniaturizes them both, the superficial Fielding and the deep Richardson. How deep, after all, must one go to find the springs of the clock? And he assumes a double structure, not only the double structure of the clock, on which one sees the face but knows the springs lie just below, but also the analogous structures of the clock and the universe. Just as the universe is a vast mechanism, created by God and discovered by Newton, so man is a little mechanism or machine within it. To understand man, one need not rise to the heights of Heaven or the depths of Hell, one need only devote himself to the minute observations of his inner workings. Thus the clock is a metonymy for the miniaturized "world" of man. And of course "man" is better represented by Clarissa than Tom Jones.

If the locomotive was the favorite machine of the late-nineteenth-century artist, the clock was the favorite one for the early eighteenth, when great artistry and craftsmanship were lavished on the creation of clocks. Belinda in *The Rape of the Lock*, as she reluctantly awakes at noon, presses her repeating watch. Moll Flanders gives her son the stolen watch as an emblem of herself. The Lilliputians believe Gulliver's pocket watch must be his God, as he consults it upon all important occasions. Examples abound in the literature and art.[26] Undoubtedly this interest resulted from the widespread use of clocks and their greatly increased accuracy. When in 1744 Anson returned from his voyage around the world, his watch was still within a minute of the Greenwich time by which he had set it four years before. Rococo craftsmen excelled in making incredibly elaborate casings and stands in which to contain these now common but highly desirable and useful devices. So one would expect them to appear in the paintings and descriptive literature of the time. But as we have seen, the clock became not just an appendage to the age but a figure by which the age represented its understanding of itself. Whereas Milton placed all history in the context of God, Fielding concealed Providence in the history of the autumn of 1745. The eternity and infinity of the baroque have receded behind the tick-tock and hand move-

Terracotta model of a clock, ca. 1700, Paris. Collection of the J. Paul Getty Museum, Malibu, California.

ments of the rococo.

So far I have been comparing the rococo to the genre of the novel, and, save for Marivaux, using English examples. Another approach, favored by Brady and Poe consists of looking at the rococo as a much more limited, though useful, context.[27] To them the rococo is not a monolithic period style but a style of a period, a "current" as Poe calls it, which runs along with other currents, often in the same work.[28] They rightly complain of the "monolithic" critic who insists that everything between x and y is rococo, but Brady in particular practices a kind of reverse monolithism by denying that works are rococo unless they are completely rococo. That some novels are more rococo than others, I would agree. I have not yet discovered a critic, for instance, who does not believe *Marianne* (1731) a work central to the concept of the literary rococo.[29] But as I understand it, the concept of period style is never a monolithic abstraction

that precludes looking at works from a variety of perspectives and in a variety of contexts. Bernini is more baroque than Coysevox, Caravaggio than Vermeer, yet Coysevox's and Vermeer's works contain baroque elements, and it is useful for the art historian to recognize their similarities, as well as their national and personal differences. So *Clarissa* is a much more baroque work than *Tom Jones*. Its pathos, its tragic plot, its exploration of contrasts, such as angel and devil, high and low, male and female, its profound religious concerns, all point back to the "she tragedies" of the late seventeenth century and indicate a late baroque sensibility. But its bourgeois protagonist, its critique of the aristocracy, its multiple points of view, its writing to the moment, its domestic setting, its concern with minutiae—it is the epic of miniaturization—all reveal its rococo identity as well. Likewise, *Roderick Random* (1748) is less rococo than *Tom Jones*, but the name of the hero himself gives us a hint about randomness and loose structure, which might be fruitfully explored in the context of a rococo aesthetic.

Similarly, other masterworks of eighteenth-century prose fiction bear rococo markings. *The Persian Letters* contains a hodgepodge structure (the chain that holds the work together is "secret"), an acute detailed interest in the feminine and domestic, a humorous, oblique attack on the traditional hierarchies of church and monarchy (or the baroque), a sensual conception of man, fantasies of oriental eroticism, several examples of miniaturization, and a relativity in point of view; that is, as in other rococo works, the center is not immediately apparent. And to these one may add that generically speaking the work is a hybrid, combining within itself novel, oriental tale, philosophical tale, and travel book. *Manon* displaces or reverses baroque categories: Heaven gives way to fortune; virtue to pleasure, and tragedy to irony. Just as money and sensibility become totally mixed up (Can you imageine Phèdre or the Princess of Cleves worrying about their pocket money?) and confused in this work, so too does the class system, the Chevalier giving up his career for a common woman. Both of them live for pleasure, for the moment. As a hero, the Chevalier is a complete wimp, or a new man of feeling. At every crisis, he fails and becomes paralyzed, overwhelmed by himself or his emotions, so much so that the book, if one has a sense of the classical or the baroque, tends toward parody,

for instance when the Chevalier imagines that he is Dido rather than Aeneas.

Candide seems less rococo. It was, after all, written in 1759, twenty-five years later than the other French works, at the very moment when the springs of the rococo and baroque had run dry. But it too has a double structure, the ironic one between a world that is supposed to be the best of all possible worlds and is governed by Providence, and the series of misfortunes and unconvincing coincidences that the protagonist actually experiences. And the style depends on reversals, although they are single not double reversals, simply based on hypocritical actions and absurd ideologies. In terms of both structure and reversal, Voltaire is much more streamlined, efficient, and direct than other rococo authors and much less rococo than in an earlier work of his own, such as "Épître XXXIII."[30] Neither his style nor his point of view ever waver, and to me *Candide* links rococo and neoclassical in much the way that another work in 1759, *Tristram Shandy*, links rococo and romantic. Nevertheless, the entire work is a miniaturized romance, a fact that contributes to its wit, and a fact that suggests a pronounced affinity to the rococo aesthetic. And like so many other rococo works, for instance *The Beggar's Opera*, it mocks the established order but refrains from setting up a new and better one of its own. Its revolution is implicit, not explicit.[31]

A current becomes a period style when it is the main stream, not the only stream. If a period style exists, and usually only scholars far downstream can perceive the patterns of convergence, it has left its watermark on that which is typical, best, and innovative. Perhaps my disagreement with Brady and Poe is simply semantic, that is, about the meaning of period style, for they too believe that the rococo was in some way or other the essential style of the first half of the eighteenth century. Poe says that on the whole the rococo was the dominant style from roughly the 1720s to the 1760s,[32] and Brady says that, despite its pluralism of styles, the first half of the eighteenth century was the rococo period because "the Rococo aesthetic is the one best illustrated by the great works in that period."[33] If Brady overconfines the concept of rococo and denies its moral and satiric polarities, then Laufer overextends it. For Laufer rococo is the only style between 1660 and 1830, by which he means that rococo is that which is best, vital, and lasting in

the fiction of this era.[34] I like very much his linking of the rococo with the Enlightenment, for received opinion often sees them in opposition, but he does not distinguish between the divisions of the Enlightenment, of which more later, nor does he take into account the vehement rejection of the rococo in all the plastic arts, a rejection that has its analogues in the realm of prose fiction. *Liaisons Dangereuses* (1785), for instance, is not a rococo novel but an interpretation of the rococo from a postrococo perspective. It is the sweetness and refinement of the *ancien régime* in the coldly rational eyes of an overtly revolutionary era. It is Boucher as seen by David.

* * *

No one novel, not even *Marianne* or *Tom Jones*, is as rococo as the "rise of the novel" itself. For this extraordinary literary phenomenon, which has justly attracted so much critical attention, depended, even more than particular works, upon a reversal of structures, and a play of art and nature. Before the rise of the novel, Europeans lived in the context of a myth, Christianity, through which they evaluated the reality of their existence. Their most esteemed forms of literature, the epic and the drama, though of course containing imaginative "inventions," were stories of historic events and real people—Aeneas, King Arthur, Roland, Hamlet, Godfrey, the Cid, Phèdre, or Adam and Eve. As the novel rose, the romance, which had been a subordinate genre, in esteem if not in popularity, came more to the fore, as did allegory, in which fictions could be justified as deep Christian truths. These two then hybridized with fictional histories, more often than not rogue literature, which pretended to be or gave the appearance of being "true." And, as Watt, Beasley, Davis, McKeon, and other gifted critics have pointed out, by the 1740s, the truth of fiction itself ceased to be debated and moralists became more concerned with the contents of fiction than with its nature. None of this could have happened were it not for the scientific revolution of the seventeenth century and the new empirical mode of thought that it brought into being. For this revolution caused the great reversal of myth and reality. Now, instead of living within a myth, the European lived within reality, cold, indifferent, mechanical, scientific reality— that beautiful but merely natural sky we see in Canaletto's paintings. And as a consequence, literary artists reestablished the myth, now called

fiction, within the reality instead of without. If artists wished to assert eternal providence, they would have to show their readers Christianity within the world of their imaginations. Henceforth, literature would not be based on history but on fictions—lies, inventions, fancies—that would have the force of truth, at least as far as the emotional and moral life were concerned, for in this regard science had little to teach.

To put it another way, art and nature had changed places. In the old system, God's art had produced nature; nature was the content of art. But in the new system, nature, like Lady Wishfort, had to produce art, and art became the content, or the meaning, of nature. That is, human beings had to give meaning to nature, which at best was neutral. From this new empirical perspective, art and nature could now be seen as being on the same level, and, as we have seen, of changing places or assuming paradoxical identities. If Congreve and Pope were right, and it was human nature to be artificial, then artifice takes on, as it does in their works, the force and power of nature. And if the truth of nature appears best in artifice, then it follows that fiction can be true, more true than history, as Fielding comically asserts when he says, "Now with us Biographers the Case is different, the Facts we deliver may be relied on, tho' we often mistake the Age and Country wherein they happened."[35]

Fielding presents his startling thesis as a joke, that is, in a good-natured rococo style. Either he is completely assured, as McKeon would argue, that the reader already accepts fiction as true, or his common sense and piety restrain him from carrying out some of the radical implications of his views and asserting, like Oscar Wilde, that art imitates life. Or that the artist is the creator, not an analogue to one. Or that because society creates us, we can create society. Instead, he hangs between, with a joke, and the claim that he describes not an individual but a species. But such double perspectives, expressed so brilliantly in rococo art and architecture, were the very ones that made it possible for the mixed genre of the novel to come into prominence. The natural structure, which for Fielding was Fortune, became the norm. The mythical structure, or Providence, must be discovered within. Ironically, Tom Jones in his despair, cries "Let Fortune be my guide." And just as ironically, Candide cries, "Let Providence be my guide." Yet

both the believer, Fielding, and the skeptic, Voltaire, self-consciously play between these two great structures and convey their great truths through "histories" that are fictions. All of these developments were not only anticipated but fully realized in *Don Quixote*, which may be the most original literary work of all time. But only by creating the rococo, or passing through a period that was expressed by the rococo, could European culture accept as normative the innovations and implications of Cervantes.

Like the novel, the rococo emerges as an end product of a long historic process. The rise of the novel, as McKeon explains it, does not begin in the 1740s but concludes there, the consciousness of the novel as a genre being the result of a century and a half of experimentation in novelistic fiction.[36] In the same manner, the rococo concludes the long development of the baroque. Thus the daring and self-confidence of the great rococo artists—Tiepolo, Neumann, the Zimmermanns, J. M. Fischer, the Dietzenhofers—may be seen as analogues to the same qualities in Fielding and Richardson, all of these artists self-consciously working within a tradition that they carry to its very limits—and beyond: in the case of the novel creating something new and enduring; in the case of architecture exhausting the possibilities of the classical tradition.

Thus the novel, which came into consciousness as a genre in the 1740s, had by the 1770s not only changed into a simpler, more sentimental, less complex type of literature,[37] but to many had died, totally exhausted by the exertions of the great masters of the mid-century.[38] McKeon says, "The novel emerges into consciouness when the conflation comes to be made with such mastery that the conflict between naive empiricism and extreme skepticism, betwen progressive and conservative ideologies, can be embodied in a public controversy between writers who are understood to employ antithetical methods of writing what is nonetheless recognized as the same species of narrative."[39] Yet the particular conflicts that Richardson and Fielding embodied with such mastery have by the time of *Tristram Shandy*, that is, within one generation, dissolved or given way to radically different preoccupations. Thus the novel, like the rococo, seemed to be "exploded," but the novel was a flexible, adaptable form, and its surface naturalism lent itself to the more "organic" naturalism and to the sociology and aesthetics of the nineteenth century, when under

the able hands of Jane Austen and others it was reconstituted. So while the rococo was rejected as decadent, effeminate, frivolous, and reactionary, the novel, its most important literary achievement, triumphed in other contexts and in other styles. Yet the novel retains the double structure that characterized the rococo, not the double structure of "appearance vs, reality," as one used to be taught in high school, but the conservative/radical one whereby the author fundamentally accepts the world and its knaves while displaying their faults with devastating accuracy. In the hands of its greatest masters, the novel has never been far from such double perspectives, and the hybridization, self-consciousness, and bourgeois values that reveal its rococo origins.

5
After 1759

If one looks at all closely at the middle of our century, the events that occupy us, our customs, our achievements and even our topics of conversation, it is difficult not to see that a very remarkable change in our ideas is taking place, one of such rapidity that it seems to promise a greater change still to come. (D'Alembert, *Eléments de Philosophie*, 1759)[1]

Son élégance, sa mignardise, sa galanterie romanesque, sa coquetterie, son goût, sa facilité, sa variété, son éclat, ses carnations fardées, sa débauche, doivent captive les petits maîtres, les petites femmes, les jeunes genes, les gens du monde, la foule de ceux qui sont étrangers au vrai goût, à la vérite, aux idées justes, à la sévérites de l'art. (Diderot on Boucher, *Salon* of 1761).[2]

THROUGHOUT THIS BOOK, I HAVE AVOIDED, FOR fear of being thought too rigid, giving the "dates" of the rococo, but the astute reader will have noticed that almost every work I have discussed under that name was created between 1699 and 1759. Roughly then, too roughly for critics who cannot abide the messiness of periodization, the rococo period extended from 1700 to 1760. We have mentioned some of the prerococo works of the 1690s, and earlier. The rococo no more than any style sprang unannounced into the world, nor would it have spread from the 1699 engravings of Lepautre were the ground not already prepared to receive it. Levey has discussed the "intimations" of rococo in painting.[3] Singer speaks of the *"Frührokoko,"* which appeared in German literature as early as 1700.[4] I have made a case for *The Way of the World*, also 1700, as an early but fully realized rococo work. Sedlmayr, Bauer, and Harries all agree that the Bavarians had concocted an indigenous form of the rococo before 1720, as had the Austrians, all of this long before Cuvilliès arrived with his trunk full of *rocaille* engravings. The Cartuja in Granada shows how some Spanish genius invented from Churrigueresque a kind of rococo, and apart from that supreme example, we know from Kubler and Soria[5] that by 1720 a type of architecture "coeval" with French rococo existed in Spain, as it did also in Italy. In all the countries of Western Europe, rococo, or the Idea of Rococo had come into being by 1720, though of course with important regional variations.

In France, rococo, given by Meissonier its ultimate expression as *rocaille*, peaked in the 1730s, when it first became an object of criticism. In England, it was most popular in the 1740s when it joined its kinsman, neo-Palladianism. In Southern Germany, it had its longest life, and of course there it was most fully, exhaustively developed. So although no two countries exactly coincide in their invention or reception of the rococo, one may still see—if not blinded by some

J. M. Fischer, Abbey Church, 1759–63. Rott am Inn. Wolf-Christian von der Mülbe.

other critical *idée fixe*—a general pattern of "pre-rococo" in the 1690s; "early rococo" from 1700 to 1730, which includes the *Régence* style;[6] "high rococo" during the 1730s and 1740s, which Sypher calls, after a contemporary name for it, *genre pittoresque;* and "late rococo," in the 1750s and 1760s, when the style, indisputably, was on the way out, becoming more natural, like the *Erd* rocaille, in which rococo forms lose all architectural semblances and become completely organic, or more classical, like Birnau[7] and Rott am Inn (1759–63).

The rococo of course did not abruptly disappear in 1760. In France, Fragonard and Clodion carried it into the 1790s, though Madame Du Barry's rejection of the *Progress of Love* panels shows how far even the best examples of the style had fallen from favor.[8] In Spain, Goya began in the 1750s as a rococo painter and never abandoned the style, even when during and after the Napoleonic Wars he painted grotesques and monsters. In England, Gainsborough, like Goya, continued to employ his airy, light, impressionistic brush stroke—he actually grew more impressionistic as he aged, and in Italy, Guardi held to the successful rococo formulas he had learned in his youth. In Bavaria, rococo, though more restrained and classicized, was still going strong when it was banned in 1770, and it persisted in folk art well into the nineteenth century. But these are exceptions. Bauer claims that by 1745 in France, rococo had become *passé,* and in 1754, Cuvilliès, who had only in 1738 introduced *rocaille* into Germany, had himself rejected it. By 1762, according to Bauer, in the engravings of Crusius the history of *rocaille* ends.[9] On the whole, during the 1760s the style gave way before the triumphal march of neoclassicism, a progress well documented by Honour, Eriksen, Stillman, and Rosenblum.[10] Nothing shows the transformation so well as a comparison of two prints by Johann Esaias Nilson, the great rococo engraver of Augsburg. In one, *Trumeau de Glace* (ca. 1760) we see a scene of gallantry enacted before a great rococo pier glass, ornamented by putti symbolizing the four parts of human life. A decade later Nilson commemorates the decree banning the rococo in Bavaria with the more neo-classical print known as "Tearing up the Rocaille."

The shift from rococo is wonderfully illustrated by *Tristram Shandy,* which began appearing in December, 1759. We have already men-

Gottlieb Leberecht Crusius, Capriccio, *ca. 1762. Staatliche Museen Preussischer Kulturbesitz, Kunstbibliothek, Berlin.*

Johann Esaias Nilson, Trumeau de Glace, *ca. 1756. The Metropolitan Museum of Art, The Elisha Whittelsey Collection, The Elisha Whittelsey Fund, 1955. (55.503.12)*

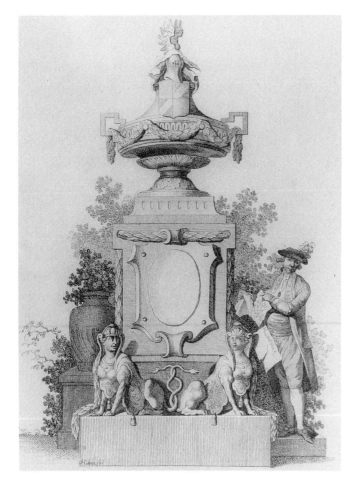

Johann Esaias Nilson, Tearing up the Rocaille, *ca. 1770. Staatliche Museen Preussischer Kulturbesitz, Kunstbibliothek, Berlin.*

tioned how it plays with both the Newtonian and the Lockean structures and shows us poor mortals absurdly trapped between the outer determinism of gravity and the inner one of the association of ideas. And we have quoted Wasserman's observation that whereas Fielding transformed an older structure, the epic, into a new one, the novel, Sterne deforms all structures, Newtonian, Lockean, and novelistic. Sterne so deforms everything that he deforms his own rococo style, for in his work the irony, the juxtaposition of structures, the play between art and nature, the comic leveling of distinctions, the good-natured and omnipresent eroticism, the intimacy and detail that characterize the rococo are carried so far that they become something new. We see in Sterne nothing less than the melting, dissolving rococo finally dissolving itself.

Gerald Tyson has written of the rococo qualities of *Tristram Shandy*,[11] but he has not noticed its romanticism. For instance, he claims that "Both Tristram and rococo have a basic antagonism to scientific enquiry and the scientific method,"[12] whereas to the degree that Sterne closely observes and renders the workings of the mind and the mechanics of time, he is being most rococo and scientific. Yet when the association of ideas produces chaos, when gravity conveys only castration or death, when conventional notions of time become a narrative impossibility—in short when the very rococo empiricism that Sterne employs begins to self-destruct, Sterne provides another system, that of feeling, sentimentality, or sympathy. The "vogue of sentiment after 1760" to which Tyson associates Sterne,[13] was not then rococo but anti-rococo, for although sensibility or the cult of feeling had their origins in the rococo period, the rococo artist was too self-conscious or ironic about feeling, too oriented toward aestheticizing it in some way or observing it in some moral or traditional context ever to let it become a thing in itself. Harley's death in *The Man of Feeling* (1771), his being overwhelmed when he discovers that his beloved returns his love, has no precedent whatsoever in the art of the first half of the eighteenth century, all the swoons and fainting notwithstanding. Sterne laughs at feeling; he is extraordinarily self-conscious and playful about his own and his characters' emotions; and in this regard he is rococo. But to the degree to which he actually approves of feeling or sympathy as the genuine way in which we may for the moment defeat sorrow and death and relate to one another, he inaugurates romanticism in England, or at least in its novels.

In *Tristram Shandy* and in other novels of the 1760s the conventions of the mid-century novel changed. The pursuit and the attempted rape of the heroine, which characterized every major novel of the 1740s and 1750s disappears. Instead of being threatened with an actual physical assault, the heroine now suffers from a "delicate" distress. The hero becomes a "man of feeling," or he behaves in a rash and melancholy way that would have earned the scorn of both Richardson and Fielding. States of mind become as important as actions. The strange mixture of individuality and allegiance to the *status quo* that had characterized the earlier protagonists, all of whom acted alone, gives way to protagonists, like Tristram himself or Matthew Bramble or Evelina, who live or travel with their families, thereby creating a greater sense of restriction

and a new tension between the self and the society. While moral and authorial points of view wavered, sensationalism, permissiveness, and relativity increased. Because the world could no longer be taken for granted, not only actions but places had to be described. Timeless settings became historical and political, and an assumed social order and modes of behavior, however arbitrary or artificial, began to look like stale custom. And as the novel changed, so did criticism of it. Nature and morality, delight and instruction, the polarities of earlier criticism parted company, and as one group of critics made more strenuous moral demands on the novel, another was more interested in sentimental pleasure for its own sake.[14] As Earl Wasserman once stated, *Tristram Shandy* can be looked upon as the link between two intellectual worlds. Prior to *Tristram Shandy* authors made use of a "public cosmos," a frame of reference shared in common by characters, authors, and readers, but in *Tristram Shandy*, because this "public cosmos" had broken down, each character has only a "private cosmos," which he himself must create.[15] *Paideia* or culture, the assumed order of things, became the oxymoron "Tristrapaideia," or the culture relative to an idiosyncratic self. Thus out of all the playfulness, disruption, and ironic dissolution of received opinion and form, emerges an entirely new kind of cosmos or mythology. Sterne did not transform a genre but a world view.

The reader will have noticed that I am using romanticism and neoclassicism somewhat interchangeably, for I agree with the view that neoclassicism in the plastic arts was the first of the romantic styles.[16] Still a third term used to characterize the second half of the eighteenth century is the Enlightenment, and it may be well to sort out the relationship among these three useful nomenclatures and the rococo. Robert Shackleton described three "phases" of the Enlightenment, a first, which "began about 1715," a second, from 1734–44, which was a period of assimilation, and then a third and triumphant one from the mid-1740s onward into the 1770s.[17] Such a scheme coincides somewhat with the phases of the rococo. At least one critic, Laufer, has insisted that rococo and Enlightenment are identical, carrying even further Ermatinger's idea that rococo is the poetic form of the Enlightenment.[18] This conflation was dismissed by Böckmann, who saw the rococo as but one among several early forms of the Enlightenment,

though an important contributor to its development.[19] But on the whole, those scholars most interested in the Enlightenment have shown little interest in the rococo and would probably, if pressed, assume that anything as earnest and radical as the Enlightenment would be anti-rococo. I doubt that the word rococo even appears in Norman Hampson's admirable study, *The Enlightenment.* Sypher wrote well about the relationship between the two, also seeing them in many ways—particularly in the construction of fictions as frameworks—as one, but his book was the last that took periodization seriously.

My own view is that the Enlightenment had two parts, each of which may be broken down, in the manner of Shakleton, into phases. The writers and artists of the first half of the Enlightenment adopted a secular view of life but were not, on the whole, willing to break with religious tradition, rather, as we have seen, they held on to some concept of God, even if he were only the remote, impersonal God of Deism. They mocked the religious and political status quo; they took delight in revealing its arbitrary and inconsistent nature; and they explicitly or implicitly forwarded the brotherhood and essential equality of all men. But they had no new ecclesiastical or political system to propose, only a more efficient or moral operation of the old one. Accepting as they did, happily or ironically, a more or less traditional framework of things, they turned their attention from ontology to epistemology, and concentrated on human behavior and thought, which more often than not they saw as some dialectic or play between nature and art. From one perspective this part of the Enlightenment was the last phase of the baroque and the Christian humanism of the Renaissance; from another it was the commencement of romanticism and modernism; looked at in its own right, it was the rococo period.

The second half of the Enlightenment, as Shackleton has noted, began to take shape in the late 1740s, became increasingly important in the 1750s, the commencement of the *Encyclopedia* being a notable sign, and gained cultural ascendancy in the 1760s. One of the many reasons Samuel Johnson is such a colossal figure is that he stands astride these two halves of the Enlightenment, often holding conservative views but attempting to justify them on new grounds. A devout believer in God, his writing is almost completely secular and empirical. A fierce supporter of social rank, or subordination as he

called it, he never attempted to justify his views according to God's plan or the wisdom of tradition. Instead he presented a paradoxical argument based on psychology. Just because rank was arbitrary (or unfair or irrational), it was better, for no one could think himself essentially inferior for being born into a lower condition, but if all high posts were open to all, the mad scramble for the few high places would turn the whole society into malcontents and failures. As Billy Boy, the three-year-old in Eudora Welty's story "The Petrified Man" put it, "If you're so smart, why ain't you rich?"[20] Paradoxical views like Johnson's, Gay's, or Mandeville's before him, based on acute social and psychological observation and always involving some play between art or morality and nature, however liberating, could not be emotionally or intellectually sustained for long.

The writers and artists of the second half of the Enlightenment became more daring or "original" in their rejection or reinterpretation of God. Hume, for instance, in the early 1740s presumed not God to scan, but in the 1770s he wrote, though he did not publish it, his notorious essay on miracles. More radical was d'Holbach, who in 1770 gave to the world his *Système de la Nature*, which denied Divine Providence and saw nature as morally indifferent. What we see as the eighteenth century progresses is the increasing importance nature takes over art, until a break occurs whereby art becomes stale custom or artificiality and nature itself, pure and simple, becomes the God by which people wished to conduct their lives. Now, instead of a double structure, in which man played on the field of God, writers, atheist or demibelievers, rejoiced in but one structure, nature. But at this moment, interestingly enough, nature itself underwent a split. On the one hand it continued to be human nature, or Humanity! (always stridently put forth) and on the other, nature as we now conceive of it, namely, the "natural world," the banks of the Wye and the Lake District and the tropical rain forests. This renting of nature and human nature further bifurcated into two major conceptions. One was materalist. It continued the scientific tradition, except that it divorced science from religion, a view completely at odds with the seventeenth-century founders of science, Bacon, Galileo, Descartes, and Newton. Just as the universe was a mechanism that could be studied "objectively," apart from God, so too,

according to La Mettrie was man a machine, a machine that resulted from chance. As depressing as this thought was to many, to others, such as Helvetius, the new determinism seemed liberating, for it opened up both the possibility of a scientific sociology and the prospect of man's creating a society more congenial to his true nature, rather than submitting to an oppressive ordering of life that could no longer be justified as deriving from God's providential supervision, as interpreted by priests and kings. The other was pantheist. It objected to the materialism of the first view and insisted that the lost unity between man and nature, formerly provided by God the Creator, could now be rediscovered in Nature itself, in the immanence of the divine in both the human psyche and in the natural world. Although at odds with one another, both the materialist and the pantheist were in agreement that the Judeo-Christian "dualism," which consisted of a Creator and a Creation, was irrational, repressive, and emotionally unsatisfying. No longer did they believe in the revealed word or the necessity for a mediator. The Bible was a book to be studied like any other, and Jesus became either "historic" or the type of the enlightened man, an enlightenment attainable through the exercise of the imagination, mountain climbing, and journeys into the wilderness.

The second half of the Enlightenment then, did not precede romanticism, but was itself an early manifestation of romanticism, and the separation of man and nature and the conflicting attitudes toward nature have characterized romantic, or enlightened, culture ever since. It gave us the two cultures: one, rational, scientific, utilitarian, and pragmatic; the other, emotional, artistic, utopian, and ideological. Appropriately, this second half of the Enlightenment manifested itself in two styles, the neoclassic and the romantic.[21] One is tempted to see the neoclassic as the rational or exterior style, the style of the plastic arts and architecture, and the romantic as the emotional or interior one, the style of poetry and Gothic novels, but in fact though the neoclassic was the dominant visual style, by the 1790s a romantic style of painting had also emerged. In artists such as Fuseli, however, the subject becomes "romantic" while the style remains neoclassical. And one could say that in David the subject becomes neoclassical but the style, by its severity, its interest in pure, primitive forms, gives expression to radical romantic longing.[22]

Often one artist worked in both styles, a superb early example being Wright of Derby, who could paint with such precision orrerys and experiments with the vacuum, and at the same time imaginary grottos and Indian maidens. One of his strange, moonlit landscapes has at its center nothing less than Arkwright's mill, the very place where the industrial revolution began. The truth is that in all the arts the neoclassical and romantic are bound up with one another. In landscaping, for instance, the rococo garden gave way to the wilder, more romantic, picturesque garden, but that garden always surrounded a neoclassical building. The Scotland that gave us Percy's *Reliques* (1765), the poetry of Ossian, and Robert Burns, also gave us Robert Adam and the perfectly neoclassical New Edinburgh. Blake, the most complete romantic poet, consistently painted in neoclassic style.

What the second half of the Enlightenment really produced, stylistically, was eclecticism. Even those who speak of the pluralism of styles in the first half of the eighteenth century must admit that classic, late baroque, and rococo are all very closely related to one another, the latter two dependent upon some sense of the first. But artists of the second half of the century could pick from a wide variety of styles, for historicism had replaced tradition. Thus Reynolds would paint intellectuals in the style of Rembrandt, heroes in the style of Titian, aristocrats in the style of Van Dyke, mothers and children in the style of Raphael, children in the style of Corregio or Murillo,[23] and Dr. Johnson as a child in the style of the rococo. His French counterpart was Houdon, who throughout his career sculpted in rococo, neoclasic, or his own unique styles. Robert Adam was consistently neoclassical, but his version of that style no longer confined itself to Vitruvius, Palladio, and Inigo Jones, but drew from Etruscan and Syrian sources, as well as Roman and Greek ones. Contemporary with Adam, one sees a new archaeologically based Greek revival and a new romantic Gothic one, as at Fonthill Abbey.[24] Ripa's *Iconologia* was abandoned, as each artist, like the Enlishman Barry, strove to invent his own personal iconology. Thus private cosmologies replaced a public one, and from this point onward, each artist attempted to paint, as Diderot said, "according to your own sun, which is not nature's sun."[25] In this regard Fragonard, the last great rococo painter, may be seen as analogous to Sterne, and to Reynolds.

Like Reynolds he could paint in several distinct manners. As Mary D. Sheriff says, "Fragonard had an absolute command of technical skills . . . was able and willing to vary his manner" and tailor "his execution to the subject, meaning, purpose, or audience at hand."[26] And like Sterne, he carried the rococo aesthetic to its very extreme, and in so doing commenced an early form of romanticism. His self-conscious explorations of "enthusiasm" and "genius," while based on a polarity between art and nature, dissolve the distinctions and tensions between them so that we are left either with a dialectic of art vs. art, that is, representation vs. expression, or the triumph of nature, that is, the triumph of feeling or imagination.[27]

Once the artist became the creator, and once the human became the "human divine," it became increasingly difficult to explain the persistence of evil in social life, except as the result of custom or, worse, reaction. Thus the philosophe/artist becomes increasingly alienated and society becomes increasingly repressive. What had been the chief rococo dialectic or tension, that between nature and art, then shifted to that between self and society, the self usually conceived of as natural, society as artificial in the sense of false, insincere, hypocritical, if not downright demonic. Only a fully realized self could bring about the needed revolution in society; only a newly constituted society could bring about the truly liberated individual, the two being reconciled through the process of mutual realization. Rousseau is the key figure in these dual developments, having in his *Social Contract* (1762) put forward the modern idea of the absolute state, and in his *Reflections of a Solitary Dreamer* (1778) the modern idea of the autonomous self.

That neither Rousseau nor his successors have succeeded in producing a public cosmology, that we are still in the Enlightened/romantic condition should be evident to all, especially after the work of Abrams and Frye. But this romantic world view, by its very essence, by the very schisms that comprise it, can never bring about reconciliation, intellectual or practical, of its own conflicted components. Instead, like Faust, it must press ever onward to newer experiences and possibilities, even if they keep circling back on themselves. As such it has been extraordinarily fertile and inventive, as well as destructive. Among other things, its objective histor-

icism and interest not only in individual but cultural autonomy have given rise to the concept of period style and have made studies like this one possible.

Though romanticism is a megaperiod extending from the mid-eighteenth century to the present, it does not readily express itself in uniform styles. Whereas the rococo subverted the cosmology upon which it depended, romanticism attempts to create a cosmology from its anti-cosmological assumptions about autonomy and individuality. As a result, romanticism has a tendency to produce either individual styles, such as Fuseli's or Turner's or Delacroix's, or movements, such as the Pre-Raphaelites, the futurists, or the surrealists. According to Sypher, romanticism never produced a period style, by which he means "conformity" to techniques adequately expressing the conciousness of an era and accepted nearly by agreement among artists who are most sensitive to their contemporary world."[28] Yet I see at least three: 1) the neoclassicism that replaced the rococo and lasted well into the nineteenth century; 2) the Victorianism or realism[29] that dominated until the 1880s, and 3) modernism, which has characterized the twentieth century. Sypher calls this last style cubism and does not see its organic relationship to romanticism.

It may be that time will unify so many various styles in which we can see so little in common, and that some Wölfflin of the future will present a just taxonomy of nineteenth and twentieth-century art. The distance of time has certainly aided in bringing the rococo into focus, a term never heard, as far as we know, between 1700 and 1760. To Pope, "Ripley with a rule" was the antithesis of Lord Burlington, but to us, both were neo-palladian architects, though with different abilities. It is hard to imagine Tiepolo seeing himself in the same aesthetic context as Watteau or Canaletto. Once more then, let me claim, despite the whole tendency of my argument, that the differences between artist and artist, school and school, nation and nation, are very real, even to me. This book has never attempted to minimize their importance but only to show that they may *also* be seen as rococo and that such a sight, rather than being reductive, will illuminate further the complexities and tensions of each work.

But I write as though period style were an honorific term, when in fact, the uniformity implied by it would be anathema to many. The desire for autonomy and liberation, which began timidly or paradoxically during the rococo period and became dominant with romanticism, has not abated. And one no more likes to have the flux of time or favorite works or artists pigeonholed than one likes to be categorized himself. But we cannot think without concepts, and better categories help us make better judgments. Hopefully, the idea of rococo presented in this book is such a category, and hopefully it will be of use to the reader.

Notes

INTRODUCTION: ROCOCO AND PERIOD STYLE

1. Heinrich Wölfflin, *Renaissance and Baroque* [1888], trans. Kathrin Simon (Ithaca, N.Y.: Cornell University Press, 1966), 16–17.

2. The reader will recognize that I am here following Northrop Frye. See particularly "Nature and Homer" and "New Directions from Old" in *Fables of Identity* (New York: Harcourt, Brace & World, 1963), 39–66, and "The Romantic Myth," in *A Study of English Romanticism* (Chicago: University of Chicago Press, 1982), 3–49. In *The Great Code: the Bible and Literature* (New York: Harcourt Brace Jovanovich, 1982), 3–30, Frye, taking a hint from Vico, discusses three historic "phases" of language, the latter two corresponding to what we think of as classic and romantic, romantic of course being an outgrowth of the scientific revolution. Meyer Abrams's *The Mirror and the Lamp* (New York: Oxford University Press, 1953) is another basic text for understanding this transformation, as are Foucault's works, all of which perceive the eighteenth century as the fulcrum of a fundamental shift in consciousness and behavior.

3. Michel Foucault, *Madness and Civilization: A History of Insanity in the Age of Reason*, trans. Richard Howard (New York: Pantheon Books, 1965), 264.

4. Fernand Braudel has called this the "Gordian knot" of history (*The Wheels of Commerce*, vol. 2 of *Civilization and Capitalism, 15th–18th Century*, trans. Siân Reynolds [New York: Harper & Row, 1982], 134). The best account of the phenomenon is William McNeill's *The Rise of the West* (Chicago: University of Chicago Press, 1963). Paul Kennedy, in *The Rise and Fall of the Great Powers* (New York: Random House, 1988), attributes Western domination to the lack of European unity and the consequent economic and military-scientific competition between powers quite strong but never strong enough to subjugate their rivals.

5. Montesquieu, *Persian Letters*, trans. C. J. Betts (Harmondsworth, Middlesex: Penguin Books Ltd., 1973), 241.

6. James S. Ackerman in "A Theory of Style" (*Journal of Aesthetics and Art Criticism* 20 [1972]: 235), suggests that Western art since the Greeks has been one megastyle. Ackerman favors a common sense, modest use of the concept of style as opposed to the overdetermined "force of some vague destiny" schools of thought.

7. Of the many contemporary works on the baroque, the three I have found most useful are Rudolf Wittkower, *Art and Architecture in Italy* (Baltimore: Penguin Books, 1958); Michael Kitson, *The Age of Baroque* (New York and London: McGraw-Hill, 1966), and Christian Norberg-Schulz, *Baroque Architecture* (New York: Harry N. Abrams Inc., 1971).

8. J. Philippe Minguet, *Esthétique du Rococo* (Paris: J. Vrin, 1966), 272. Hans Sedlmayr and Hermann Bauer call them *Sonderformen* ("Rococo," in *The Encyclopedia of World Art*, vol. 12 [New York: McGraw-Hill, 1966], col. 258).

9. Helmut Hatzfeld, "Rokoko als literarischer Epochenstil in Frankreich," *Studies in Philology* 35 (1938): 532–65; *The Rococo, Eroticism, Wit, and Elegance in European Literature* (New York: Pegasus, 1972). Patrick Brady reviewed this book in *Comparative Literature* 25 (1973): 364–66; see also his "The Present State of Studies on the Rococo," *Comparative Literature* 27 (1975): 21–33.

10. Arnold Hauser, "Style and Its Changes," in *The Philosophy of Art History* (Cleveland: World Publishing Company, 1963), 212–13.

11. C. J. Rawson in *Henry Fielding and the Augustan Ideal Under Stress* (London: Routledge & Kegan Paul, 1972), 36–66, compares Pope and Fielding. He characterizes Pope's poetry as dancelike (such as the S-curved minuet), "relaxed," and having a coherent frame behind the seeming chaos. It also consists of wit, ironic distance, assured urbanity, and "the combination of urgency and grace, the 'easy commerce' (in Eliot's phrase) between the natural rhythms of the spoken language, and the balances, interchanges and finality of social ceremony in the finest sense" (42). Rawson concerns himself with styles that show forms under stress, with "the strains of disorderly or 'unnatural' fact, of powerful or unbalancing emotions, and finally of a painful skepticism of order" (44). Except for the pain, these terms characterize the rococo as well as they do Augustan under stress. As Rawson uses the term Augustan, it is not unlike baroque or classic under stress. Margaret Anne

Doody's *The Daring Muse: Augustan Poetry Reconsidered* (Cambridge: Cambridge University Press, 1985) explodes the received opinions about Augustan poetry and points out the disorder and innovation of late seventeenth-century and early eighteenth-century English poetry. See also Donald Greene's "'Logical Structure' in Eighteenth-Century Poetry," *Philological Quarterly* 31 (1952): 315–36.

12. Willibrand Sauerländer, "From Stilus to Style: Reflections on the Fate of a Notion," *Art History* 6 (1983): 257, 266–67. Strangely, Sauerländer never mentions the work of Hauser, who saw the periods in terms of conflict and contradiction.

13. Meyer Schapiro, "Style," in *Anthropology Today*, ed. A. L. Kroeber (Chicago: University of Chicago Press, 1953), 306.

14. Fiske Kimball, *The Creation of the Rococo Decorative Style* (New York: Dover Publications, 1980), 4. First published in 1943 as *The Creation of the Rococo*.

15. C. T. Carr "Two Words in Art History: II. *Rococo*," *Forum for Modern Language Studies* 1 (1965): 267.

16. Ibid., 269.

17. Wölfflin admired some features of the baroque but on the whole believed it inferior. His more systematic account of the distinctions between the two styles appeared in *Principles of Art History*, first published in 1915. Carr gives a thorough history of the term in "Two Words in Art History: I *Baroque*," *Forum for Modern Language Studies* 1 (1965): 175–90.

18. H. W. Janson, "Criteria of Periodization in the History of European Art," *New Literary History* 1 (1970): 120–21.

19. Lawrence Lipking suggests the usefulness of seeing artists within several periods. "Periods in the Arts: Sketches and Speculations," *New Literary History* 1 (1970): 199–200.

20. Wölfflin, *Renaissance and Baroque*, 15.

21. Ibid., 16.

22. Wylie Sypher, *Four Stages of Renaissance Style* (Garden City, N. Y.: Doubleday & Company, 1955), 182–227.

23. Ibid., 252–55.

24. Kimball, *The Creation of the Rococo Decorative Style*, 5–6. Hans Tintelnot provides a history of the concept of rococo in "Zur Gewinnung unserer Barockbegriffe," in *Die Kunstformen des Barockzeitalters* (Bern: Francke Verlag, 1956), 65–69, but this should be read in conjunction with the two articles by Carr, who disputes some of Tintelnot's findings.

25. Wölfflin, *Renaissance and Baroque*, 50–64.

26. Adolf Feulner, *Bayerisches Rokoko* (Munich: Kurt Wolff Verlag, 1923).

27. Bernhard Rupprecht, *Die bayerische Rokoko-Kirche* (Kallmunz: Michael Lassleben, 1959).

28. Hans Sedlmayr, "The Synthesis of the Arts in the Rococo," in *The Age of the Rococo: Art and Culture in the Eighteenth Century* (Munich: Hermann Rinn, 1958), 25–28; "Zur Charakteristik des Rokoko," in *Manierismo, Barocco, Rococò: Concette E Termini* (Rome: Accademia Nazionale dei Lincei, 1962), 343–51.

29. Sedlmayr and Bauer, "Rococo," cols. 230–74.

30. Hermann Bauer, *Rocaille: Zum Herkunft und Zum Wesen Eines Ornament-Motivs* (Berlin: Walter de Gruyter & Co., 1962).

31. Hermann Bauer, *Rokokomalerei* (Mittenwald: Itzebeyer, 1980); Hermann and Anna Bauer, *Johann Baptist und Dominikus Zimmerman* (Regensburg: Verlag Friedrich Pustet, 1985).

32. Karsten Harries, *The Bavarian Rococo Church* (New Haven, Conn. and London: Yale University Press, 1983).

33. Kimball, *The Creation of the Rococo Decorative Style*, 68–69.

34. Marianne Roland Michel, *Lajoüe et L'art Rocaille* (Neuilly-sur-Seine: Arthena, 1984) argues that Lajoüe deserves a central role in this development.

35. J. Phillipe Minguet, *Esthétique du Rococo*.

36. Schapiro, "Style," 287–312.

37. Ibid., 305.

38. Ibid., 306.

39. Ibid., 310–11.

40. For instance, George Kubler in *The Shape of Time: Remarks on the History of Things* (New Haven, Conn.: Yale University Press, 1962) sees little or no relationship between the evolution of forms and history. See also his "A Reductive Theory of Visual Style," in *The Concept of Style*, ed. Berel Lang, revised and enlarged (Ithaca, N.Y.: Cornell University Press, 1987), 163–73.

41. John Henry Newman's *An Essay in Aid of a Grammar of Assent* [1870] (Notre Dame: Notre Dame University Press, 1979), contains the systematic working out of the idea, though it appears in almost all of Newman's thought from *Sermons Delivered Before Oxford University* (1829) onwards. Meyer Abrams relied on a similar process when he defended his concept of romanticism as a code, albeit one derived intuitively and unsystematically ("Rationality and Imagination in Cultural History: A Reply to Wayne Booth," *Critical Inquiry* 2 [1976]: 448).

42. Arnold Hauser, "Style and Its Changes, In *The Philosophy of Art History* (Cleveland: World Publishing Company, 1963), 209–14.

43. Sedlmayr and Bauer, "Rococo," cols. 237–38.

44. Hauser, "Style and Its Changes," *The Philosophy of Art History*, 213.

CHAPTER 1. ROCOCO AS REVOLUTION

1. Arnold Hauser, *The Social History of Art*, vol. 3 (New York: Vintage Books, 1958), 3.

2. Kimball, *The Creation of the Rococo Decorative Style*, 68–69.

3. Sedlmayr, "The Synthesis of the Arts in the Rococo," 26. In "Zur Charakteristik des Rokoko," 346, he says, "So sanft diese Umwälzung auch kommt, so anmutig sie sich anspielt, so total ist sie und so tief greift sie. Es ist eine der grossen europäischen Revolutionen, deren Kette jetzt nicht mehr abreissen wird." (However gently this upheaval approached and however gracefully it took place, it was [nonetheless] total and far-reaching in its impact; [Indeed] it counts among the great European revolutions whose results can now no longer be dismantled). In "Rococo," *Encyclopedia of World Art*, col. 246, speaking of ornamental prints, he and Bauer say, "Did they suspect that a revolution was in progress, a particularly dangerous one just because it came playfully on little velvet paws?"

4. Hermann and Anna Bauer, *Johann Baptist und Dominikus Zimmerman*, 204–6.

5. Sedlmayr and Bauer, "Rococo," col. 243.

6. Jean Starobinski said the rococo could be defined as "flamboyant Baroque in miniature." *The Invention of Liberty, 1700–1789*, trans. Bernard C. Swift (Geneva: Skira, 1964), 22.

7. Marianne Roland-Michel has called it a "taste without hierarchies," *Lajoüe at L'Art Rocaille* (Neuilly-sur-Seine: Arthena, 1984), 179.

8. Sedlmayr, "Zur Charakteristik des Rokoko," 345.

9. Sedlmayr and Bauer, "Rococo," col. 239.

10. Maynard Mack, "The Shadowy Cave," in *The Garden and the City* (Toronto: University of Toronto Press, 1969), 41–77.

11. Harries, *The Bavarian Rococo Church*, 235, speaks of the secularization of light.

12. Patrick Brady discusses this quality of rococo in "To-

ward Autonomy and Metonymy: The Concept of Rococo Literature from 1859 to 1976," *Yearbook of Comparative and General Literature* 25 (1976): 31–41, and in "A Sweet Disorder: Atomistic Empiricism and the Rococo Mode of Vision," *Studies in Eighteenth-Century Culture* 7 (1978): 451–62.

13. Donald Posner, on whose work I have based my comments, believes she *is* a courtesan, but that now no guilt attaches to her (*Watteau: A Lady at her Toilet* [New York: Viking Press, 1973], 75). Swift provides his own version of this subject in several notorious poems.

14. Norman Bryson, *Word and Image: French Painting of the Ancien Régime* (Cambridge: Cambridge University Press, 1981), 92.

15. Ibid., 110–21. Sedlmayr and Bauer were among the first to remark upon the relationship, "Rococo," col. 251. Patrick Brady discusses what he calls the "style Chardin" and the "style Watteau" as two aspects of the rococo in "Rococo Style in the Novel: 'La Vie de Marianne,'" *Studi Francesi* 19 (1975): 225–43.

16. Bryson, *Word and Image*, 119. Ronald Paulson says that Chardin never lets the viewer forget that he is creating an illusion (*Emblem and Expression: Meaning in English Art of the Eighteenth Century* [Cambridge, Mass.: Harvard University Press, 1975], 107).

17. Bryson, *Word and Image*, 120.

18. Hauser, *The Social History of Art*, vol. 3, 32.

19. Sedlmayr and Bauer, "Rococo," col. 239.

20. *Les Trois Cousines*, 3d Interlude (1700). Quoted in Bauer, *Rokokomaleri*, 22.

21. Arno Schönberger and Halldor Soehner remark that "Established class distinctions were obliterated in such paintings." *The Age of Rococo*, trans. Daphne Wood Ward (London: Thames and Hudson, 1960), 54.

22. Emil Ermatinger discussed this democratic aspect of the rococo, as well as its bourgeois and realistic qualities in *Krisen und Probleme der neuren deutschen Dichtung* (Zurich, Leipzig, and Vienna: Amalthea Verlag, 1928), 364–72.

23. Thomas E. Crow, *Painters and Public Life in Eighteenth-Century Paris* (New Haven, Conn., and London: Yale University Press, 1985), 43–62, sees an origin of the *fête galante* in the "parades" of Gueullette, beginning in 1707, which were theatrical representations free from rules or genre.

24. *Philip Mercier*, Catalogue of an Exhibition at the City Art Gallery, York, 1969, 7.

25. Michael Levey, *Rococo to Revolution: Major Trends in Eighteenth-Century Painting* (London: Thames and Hudson, 1966), 24–51, discusses this development, though his interpretation of the rococo and specifically Restout, 35–37, differs considerable from my own. See also John Maxon and Joseph J. Riskel, *Painting in Italy in the Eighteenth Century: Rococo to Romanticism* (Chicago: Art Institute, 1970).

26. Michael Levey, *Painting in Eighteenth-Century Venice*, rev. ed. (Ithaca, N.Y.: Cornell University Press, 1980), 48.

27. Lawrence Stone, *The Family, Sex and Marriage in England, 1500–1800* (New York: Harper & Row, 1977), 272–81.

28. Mary D. Sheriff, *Fragonard: Art and Eroticism* (Chicago and London: University of Chicago Press, 1990), 26–29, explains how this representation of feminiinity has been used against the rococo.

29. Sedlmayr and Bauer, "Rococo," col. 238.

30. Hauser, *The Social History of Art*, vol. 3, 3–4.

31. Ibid., 32.

32. Ibid., 32–33. Rémy Saisselin complains in "The Rococo muddle," *Studies in Voltaire and the Eighteenth Century*, 67 (1966): 244–45, that the people who made a revolution lived in a supposedly rococo period, by which implicit contradiction he means to dismiss rococo as a period style.

A great deal of this muddle would have been cleared up had he, like Hauser, perceived the rococo dialectically.

33. Michael McKeon, *The Origins of the English Novel, 1660–1740* (Baltimore: Johns Hopkins University Press, 1987), 21.

34. Patrick Brady, "From Traditional Fallacies to Structural Hypotheses: Old and New Conceptions in Period Style Research," *Neophilologus* 56 (1972): 7. In "A Sweet Disorder: Atomistic Empiricism and the Rococo Mode of Vision," *Studies in Eighteenth-Century Culture* 7 (1978): 451, Brady speaks of representative and transformative poles: "The Rococo mode of transformation is the sugary coating on the bitter pill of empiricism." Mary D. Sheriff says that between nature and artifice "rococo aesthetics posited an ongoing sequence of interactions" (*Fragonard: Art and Eroticism*, 82). See also Marian Hobson, *The Object of Art: The Theory of Illusion in Eighteenth-Century France* (New York and Cambridge: Cambridge University Press, 1982), 31–51.

35. A phrase Joseph Burke uses to describe Horace Walpole, *English Art 1714–1800* (Oxford: Clarendon Press, 1976), 138.

36. Alastair Laing, J. Patrice Marandel, and Pierre Rosenberg, *Francois Boucher 1703–1770* (New York: The Metropolitan Museum of Art, 1986), 216–20, 258–63.

37. William Park, "Fielding *and* Richardson," *PMLA* 81 (1966): 381–88.

38. Margaret Whinney, *Sculpture in Britain: 1530–1830* (Baltimore: Penguin Books, 1964), 102–15.

39. Ibid., 103.

40. Crow, *Painters and Public Life in Eighteenth-Century Paris*, 3. In 88–103, Crow describes the first-known critique of the Salon, the *Lettre à Monsieur Poiresson-Chamarade* (5 September 1741) as antirococo because the author satirizes the aristocrats and their "Exclusive Privilege," which Crow sees as rococo, yet he compares the letter to a *parade* and comments on its rococo style, p. 91. I would not separate style and content in this way, my point being that rococo style mixes aristocratic and anti-aristocratic elements, as in this letter, and cannot be seen as merely aristocratic.

41. Whinney, *Sculpture in Britain*, 80–81. James Gibbs, the architect of St. Martin in the Fields, made the design.

42. William Kent actually contributed to the design. Whinney, *Sculpture in Britain*, 89.

43. F. H. D., "Rococo," *Encyclopedia Universalis*, vol. 14 (Paris: Encyclopedia Universalis France, 1968), 296–300. Rococo appears in Italian sculpture too, most notably in the work of Francesco Ladatte, who in addition to his gayer pieces created the great stag (ca. 1732), which surmounts the central dome on the Stupinigi Palace. But Ladatte studied in Paris. See Luigi Mallè, "Traccia per Francesco Ladatte, scultore torinese," in *Essays in the History of Art Presented to Rudolf Wittkower* (London: Phaidon, 1967), 242–54.

44. Bauer comments upon this same quality in the paintings, which convey the model's psychological awareness of himself or herself, a mixture of smiling patience and waking self-consciousness. *Rokokomalerei*, 129.

45. Sypher, *Rococo to Cubism*, 4.

46. Ronald C. Rosbottom, "The Regency's Body: Watteau's *L'Enseigne de Gersaint*," a talk given at Western American Society for Eighteenth-Century Studies at Berkeley, 1989.

47. A point made by the *Encyclopedie Universalis*, vol. 14, 290.

48. Charles-Nicolas Cochin, "Lettre à M. L'Abbé R**. . . . ," *Mercure de France* (February, 1755), reprinted in Svend Eriksen, *Early Neo-Classicism in France*, trans. Peter Thornton (London: Faber and Faber, 1974), 250. Many commentators have mentioned this middle-class aspect of the

rococo, among them: Wilhelm Hausenstein, *Die Kunst und die Gesellschaft* (Munich: R. Piper & Co., 1916), 133, whose seeing the rococo as both feudal and bourgeois was echoed in Christine Liebold's recent study, *Das Rokoko in urspringlich mittelatererlichen des bayerischen Gebietes—ein von maurinischen Denken geprägter Stil*, Heft 98, Miscellanea Bavarica Monacensia (Munich: R. Wölfle, 1981), 10, where she discusses the feudal patrons and the bourgeois public of the rococo. Also, Bauer discusses the bourgeois genre of rocaille, *Rocaille*, 29; Michael Snodin says that rococo was probably as popular in England among the tradesmen as it was among the gentry, *Rococo: Art and Design in Hogarth's England* (London: Trefoil Books/Victoria and Albert Museum, 1984), 33. Patricia Crown discusses rococo in terms of British liberty of taste in "British Rococo as Social and Political Style," *Eighteenth Century Studies* 23 (1990): 269–82.

49. Harries, *Bavarian Rococo Church*, 122.

50. Kitson, *The Age of the Baroque*, 34.

51. Kitson, *The Age of Baroque*, 68, says that by the end of the seventeenth century, stairways were treated as ends in themselves. Sir Bannister Fletcher, *A History of Architecture*, ed. John Musgrove, 19th ed. (London: Butterworths, 1987), 915, admires Sanfelice (1675–1750) as a master of staircase design, saying "The function of ascent is expressed on the courtyard elevation."

52. Norberg-Schulz, *Late Baroque and Rococo Architecture*, 39–40.

53. Pierre Champion, *Notes critiques sur les vies anciennes d'Antoine Watteau* (Paris: E. Champion, 1921), 183–84, quoted in Margaret Morgan Grasselli and Pierre Rosenberg, *Watteau: 1684–1721* (Washington, D.C.: National Gallery of Art, 1984), 450.

54. Albert Boime, *Art in an Age of Revolution, 1750–1800* (Chicago and London: University of Chicago Press, 1987), 5.

CHAPTER 2. ROCOCO, LATE BAROQUE, AND NEO-PALLADIAN

1. Fiske Kimball, "Art Terms," Letters to the Editor, *TLS* 45 (8 June 1946): 271.

2. Hauser, *The Social History of Art*, vol. 2, 172.

3. Hans Rose, *Spätbarock* (Munich: Hugo Bruckmann Verlag, 1922), xi.3.

4. Kitson, *The Age of Baroque*, 71.

5. Hauser, *The Social History of Art*, vol. 2, 280–82.

6. Cornelius Gurlitt in *Geschichte des Barockstiles* (Stuttgart: Ebner & Seubert, 1886) began the custom of calling the Southern and Central European architecture late baroque. Rose in *Spätbarock* argued that all European art from 1660 to 1760 was late baroque. Wylie Sypher, *Four Stages of Renaissance Style* (New York: Doubleday and Company, 1955), 252–96, reverses the usual terminology and confines late baroque to the "Franco-Roman-Augustan" Northern European alone. He does not discuss German examples, which do not fit very well into his scheme.

7. Sedlmayr and Bauer, "Rococo," col. 236.

8. Ibid., col. 248.

9. Norberg-Schulz, *Late Baroque and Rococo*, 76.

10. Sedlmayr and Bauer, "Rococo," col. 237.

11. Rupprecht, *Die bayerische Rokoko-Kirche*, 55–56. I have quoted Harries's translation in *The Bavarian Rococo Church*, 4.

12. Harries, *The Bavarian Rococo Church*, 122–55.

13. Hermann and Anna Bauer, *Johann Baptist und Doiminkus Zimmermann*, present a similar argument throughout their book; see 81–93, 110–12.

14. Norberg-Schulz, *Late Baroque and Rococo*, 88. For

similar reasons S. Lane Faison in his review of Hitchcock's *Rococo Architecture in Southern Germany* and Hempel's *Baroque Architecture in Central Europe*, advocates the use of the term "Barococo" (*Journal of the Society of Architectural Historians* 29 [1970]: 195–99). The Italians use the term *Barochetto* for the late developments in baroque painting. See Robert Engass, "Visual Counterpoint in Venetian Settecento Painting," *Art Bulletin* 64 (1982): 96.

15. Emil Kaufman sees these developments as an increasing conflict of part with the whole, building with setting, interior with exterior, all of which marks the disintegration of the baroque idea. According to him the baroque moved from bodies to space and from space to chaos (*Architecture in the Age of Reason: Baroque and Post-Baroque in England, Italy, and France* [1955; reprint, New York: Dover Publications, 1968], 75–88, 106).

16. Rudolf Wittkower, *Architectural Principles in the Age of Humanism* (New York: W. W. Norton & Co., Inc., 1971), 1–32.

17. Norberg-Schulz, *Late Baroque and Rococo*, 88, 92.

18. Ibid., 93–113. Diagram on 113.

19. H. A. Meek, *Guarino Guarini and His Architecture* (New Haven, Conn. and London: Yale University Press, 1988), 171. Patrick Brady thinks the suppression of the cupola in rococo architecture symbolized the loss of transcendence. "Rococo Style in the Plastic Arts and Literature: Theory, Method, Application," *Literature and the Other Arts* (Innsbruck: International Literature Association, 9th Congress, 1979), 89. Harries remarks that the bipolar conception of the Bavarian rococo church left "little room for a strong transept, crowned by a full dome that gathers together nave and choir." *Bavarian Rococo Church*, 94.

20. Norberg-Schulz, *Late Baroque and Rococo*, 190.

21. Minguet, *Esthétique du Rococo*, 13.

22. Norberg-Schulz, *Late Baroque and Rococo*, 281.

23. In his course in seventeenth- and eighteenth-century British architecture given at Columbia University in the Spring of 1961.

24. Kaufman, *Architecture in the Age of Reason*, 19–20.

25. Sir John Summerson says, "the broad face of the tower and its narrow in-curving sides give an effect of extreme strangeness, without parallel in any church of any age." *Architecture in Britain, 1530–1830*, 4th ed. (Harmondsworth, Middlesex: Penguin Books Ltd., 1963), 180.

26. Reverand, Cedric D. II, "Review of Peter Ackroyd's *Hawksmoor*," *Eighteenth Century Life* 11, n.s. 2, (1987): 104–5.

27. The first church to display this incongruity was John James's St. George's, Hanover Square (1712). Summerson, *Architecture in Britain, 1530–1830*, 183.

28. Ibid., 209.

29. Sedlmayr and Bauer see the two styles as parallel, particularly in their use of the antique as ornament. "Rococo," col. 257. H. Grant Sampson ("Rococo in England," *The Centennial Review*, 22 [1978]: 356–73), believes neo-Palladian architecture was governed by the same structural principles as other forms of rococo art, the principles being "parentheses" and "continuity." In architecture these take the form of a clearly defined center of attention and a balancing of parts, 369. Though I agree "in principle" with Sampson, the principles he discusses would apply equally well to Renaissance buildings. His article points out the shift in all the arts away from baroque excess and magnificence.

30. I am indebted to Judith Colton's "Freemasonry and the Dissemination of Palladianism," a paper given at the North East American Society for Eighteenth-Century Studies conference at Syracuse University on 8 October 1983.

31. Rococo itself has been seen as a source for neo-

classicism. Harries, *The Bavarian Rococo Church*, 243. Joseph Burke, *English Art 1714–1800*, 335–41, discusses the rococo-classicism of Robert Adam.

32. Burke, *English Art*, 335. See also Daime Stillman, *English Neo-classical Architecture* (London: A. Zwemmer, 1988), vol. 1, no. 38, 275–76.

33. Summerson, "The Classical Country House in 18th-Century England," *Journal of the Royal Society of Arts*, 107 (1959): 564. In his *Architecture in Britain, 1530–1830*, 219, Summerson states that "Paine says he abandoned the commission owing to his heavy obligations elsewhere."

34. Gervase Jackson-Stops, "Rococo Architecture and Interiors," in *Rococo: Art and Design in Hogarth's England*, ed. Michael Snodin (London: Trefoil Books/ Victoria and Albert Museum, 1984), 190–98.

35. Hauser, *The Social History of Art*, vol. 3, 3–37. Burke, *English Art 1714–1800*, 32. Kaufman, however, claims that Palladianism survived because it better expressed the baroque system (of unity yet subordination) than the "ultra-baroque," which perverted this system, *Architecture in the Age of Reason*, 86.

36. Rudolf Wittkower, *Palladio and Palladianism* (New York: George Braziller, 1974), 182.

37. "But we may add," he continues, "this achievement only became possible by utilizing the spatial experiences of Baroque architecture," 60. That is, neo-Palladian, like rococo, though "new" also depended upon and continued baroque practices.

38. Nina A. Mallory, *Roman Rococo Architecture from Clement XI to Benedict XIV (1700–1758)* (New York: Garland Publishing, Inc., 1977), 13–18. Michel Gallet writes about a similar phenomenon in Paris, "Quelques Étapes du Rococo Dans L'Architecture Parisienne," *Gazette Des Beaux Arts* 67 (1966): 145–68.

39. Summerson, "The Classical Country House in England," 573.

40. Horace Walpole, *Anecdotes of Painting in England*, vol. 3 (London: Chatto and Windus, 1876), 55.

41. Sypher, *Rococo to Cubism*, 32–33.

42. Rudolf Wittkower, *Architectural Principles in the Age of Humanism*, 126–42.

43. Wittkower, *Architectural Principles in the Age of Humanism*, 150–54; *Palladio and Palladianism*, 131–35.

44. Mary D. Sheriff discusses how the narrative of Fragonard's *Progress of Love* is generated by the viewer and how the panels themselves, as originally planned, were related to Mme. Du Barry's real garden just beyond them. *Fragonard: Art and Eroticism*, 82–94.

45. Wittkower, *Palladio and Palladianism*, 155–56.

46. Wittkower, *Palladio and Palladianism*, 158.

47. John Summerson, *Georgian London* (Harmondsworth, Middlesex: Penguin Books Ltd., 1962), 117.

48. Summerson, *Georgian London*, 117–18.

49. Wittkower, *Palladio and Palladianism*, 161.

50. Harries, *The Bavarian Rococo Church*, 17, remarks that the "affirmation of wall or ceiling surface links the French rococo to the coming neoclassicism." Wittkower, *Palladio and Palladianism*, 174, speaks of the "decorative approach" of neo-Palladianism.

51. Bauer, *Rocaille*, 72.

52. Ibid., 72.

53. Wittkower, *Palladio and Palladianism*, 174.

54. Ibid., 141, 142, 138.

55. The relationship between rococo and modernism is discussed in Harries, *The Bavarian Rococo Church*, 243–58. Emil Kaufman, *Architecture and the Age of Reason*, 3–43, 131–57, argues that both eighteenth-century English architecture, especially the more eccentric Palladians, and the rococo were precursors of modern aesthetics.

56. Although interior and exterior differ greatly in Palladio, in Inigo Jones, and in the baroque, the rococo exhibits still greater disparity. Sedlmayr and Bauer in "Rococo," col. 237, say "in the Régence and rococo there arose a previously unknown differentiation between exterior and interior. Although through its large openings and reflections of the outside, the rococo interior communicated to a great extent with the exterior, the former is qualitatively different from the latter."

57. Mark Girouard, "Coffee at Slaughter's: English Art and the Rococo—I," *Country Life* (13 January 1966), 61. Wittkower discusses Robert Sayer's *The Modern Builder's Assistant* (1742), in which rococo and Palladian styles are mixed, *Palladio and Palladianism*, 87–88. For Ware, see *Rococo: Art and Design in Hogarth's England*, 210. Brian Allen, "Francis Hayman and the English Rococo" (Ph.D. diss., Courtauld Institute of Art, University of London, 1984), 189–238, gives a full account of the rococo artists in England, but attributes the restrained forms of the rococo to the late establishment in England of classicism and to anti-French feelings.

58. *Rococo: Art and Design in Hogarth's England*, 190. Joseph Burke, *English Art 1714–1800*, sees both styles as a reaction to the baroque and notes the parallel of plain exteriors and rich interiors, 7, 32, yet he sees the styles as opposed when he says "the rococo invaded the classical world of the English Palladians; it occupied many of its outposts and infiltrated some of its strongholds; but it never challenged the ascendancy of its grand manner," 155.

59. Ralph Edwards & L. G. G. Ramsey, eds. *The Early Georgian Period 1714–1760* (London: The Connoisseur, 1957), ix.

60. Inigo Jones was the first English architect to make a clear and intentional distinction between a simpler, dignified exterior and a decorative inner richness.

61. Nikolaus Pevsner, "The Genesis of the Picturesque," *Studies in Art, Architecture and Design*, vol. 1 (New York: Walker and Company, 1968), 91. The article first appeared in *Architectural Review*, 96 (1944). The relationship of the English garden to the rococo was also made in a review of Kimball's *Creation of the Rococo* in *TLS* 45 (23 March 1946): 134. Bauer sees the customary juxtaposition of the free garden and strict house as an example of how the rococo makes a style out of the absence of a stylistic principle, *Rocaille*, 52. Kitson, *The Age of Baroque*, 128, calls the English gardens rococo "even though they surrounded houses of classic design."

62. Pevsner, "The Genesis of the Picturesque," 101.

63. Bauer, *Rocaille*, 29, 72. Kenneth Woodbridge, "The Nomenclature of Style in Garden History," *British and American Gardens in the Eighteenth Century*, ed. Robert P. Maccubbin and Peter Martin (Williamsburg, Va.: Colonial Williamsburg Foundation, 1984), 23–24, remains skeptical of the term.

64. Although he does not call the gardens "rococo," Ronald Paulson describes them in terms that accord with Bauer's idea of the rococo, *Emblem and Expression*, 19–34. Morris R. Brownell believes that "picturesque is perhaps the most accurate term to 'characterize the unity of all the concurrent movements' of taste in the early eighteenth century." *Alexander Pope & The Arts of Georgian England* (Oxford: Clarendon Press, 1978), 263. Yet, the recent discovery of the works of Thomas Robins the Elder confirms the rococo nomenclature. According to John Harris, with but few exceptions, these paintings are the only views surviving of what the gardens actually looked like between 1739 and 1779. In them we see a distinctly rococo subject matter, both in landscape design and in the activities of the human beings, a rococo style of painting, and a rococo framework

for the painting. *Gardens of Delight: The Rococo English Landscape of Thomas Robins the Elder*, vol. 1 (London: The Basilisk Press, 1978), 10. The Prospect of Painswell House contains a rococo cartouche next to a neo-Palladian dovecote, vol. 2, 12–13.

65. Dora Wiebenson, *The Picturesque Garden in France* (Princeton: Princeton University Press, 1978), 3–43. Ingrid Dennerlein, *Die Gartenkunst der Regence und der Rokoko in Frankreich* (Worms: Werneische Verlag, 1981).

66. Wittkower, *Palladio and Palladianism*, 183.

67. John Dixon Hunt, "Pope's Twickenham Revisited," *British and American Gardens in the Eighteenth Century*, 27. Morris Brownell also sees the origins of both gardens and houses as classical. *Alexander Pope & the Arts of Georgian England*, 111.

68. Morris R. Brownell presents an excellent summary of recent criticism in "'Bursting Prospect': British Garden History Now," *British and American Gardens in the Eighteenth Century*, 5–18.

69. Kitson observed this combination of plain exterior, rich interior, and informal rococo garden, *The Age of Baroque*, 154.

70. Carole Fabricant, "Binding and Dressing Nature's Loose Tresses: The Ideology of Augustan Landscape Design," *Studies in Eighteenth-Century Culture* 8 (1979): 109–35.

71. Helene Trottman, "Die Zeichnungen Cosmas Damian Asams für den Concorso Clementino, der Accademia di San Luca von 1713," *Pantheon* 38 (1980): 158–64. I am indebted to Professor Karsten Harries for drawing this to my attention. See also Michael I. Wilson, *William Kent: Architect, Designer, Painter, Gardener, 1685–1748* (London: Routledge & Kegan Paul, 1984), 10.

72. Summerson, *Georgian London*, 117.

73. I wish to thank the editors of *Eighteenth-Century Life* for calling this to my attention. *Drawings of William Kent* (London: Victoria and Albert Museum, 1984). The dog is also reproduced as figure 20 in Wilson, 79.

74. Joseph Burke, *English Art 1714–1800*, 63, observes that the lake at Stourhead also has a rococo shape.

75. Horace Walpole, *The History of the Modern Taste in Gardening* (1771–1780), quoted in *The Genius of the Place*, ed. John Dixon Hunt and Peter Willis (New York: Harper & Row, 1975), 315.

76. "the garden is Daphne [the garden of Apollo] in little," Horace Walpole, *Correspondence*, ed. W. S. Lewis, vol. 9 (New Haven, Conn.: Yale University Press, 1941), 290.

77. This view was first fully developed by Friedrich Brie, *Englische Rokoko-Epik (1710–1730)*, (Munich: Max Heuber Verlag, 1927), 47–71, and has since been widely accepted. To my mind, the best discussion of Pope and the rococo remains Wylie Sypher's *Rococo to Cubism in Art and Literature*, 3–11, 35–47.

78. Andrea Palladio, *The Four Books of Architecture* (1738; reprint of the Isaac Ware edition, New York: Dover Publications, Inc., 1965), book III, chapter XIII, plates IX and X.

79. Daime Stillman, *English Neo-classical Architecture*, vol. 1, 217–21, provides a summary of recent scholarship on the development of these buildings.

80. Ibid., 217.

81. John Summerson discussed Wood's attempt to be Roman in *Heavenly Mansions* (New York: W. W. Norton & Co., 1963), 98–100. In *Space and the 18th-Century English Novel* (Cambridge: Cambridge University Press, 1990), 81–118, Simon Varey explains how Wood meant also to be Biblical and prehistoric, using both Hebrew models and Stonehenge. In this attempt to create a historic synthesis of architecture, Wood parallels Fischer von Erlach's *Entwurf einer historischen Architecture* (1721).

82. Wittkower, *Palladio and Palladianism*, 82–83.

83. A good color reproduction of this may be found on plate VII of Arno Schönberger and Halldor Soehner, *The Age of the Rococo* (London, 1960).

84. Ronald Paulson, *Hogarth: His Life, Art, and Times*, vol. 2 (New Haven, Conn.: Yale University Press, 1971), 4.

85. Sedlmayr and Bauer, "Rococo," col. 257.

86. George Kubler and Martin Soria, *Art and Architecture in Spain and Portugal and Their American Dominions, 1500–1800* (Harmondsworth, Middlesex: Penguin Books, 1959), 32–42.

CHAPTER 3. THE ROCOCO VISION

1. Sypher, *Rococo to Cubism*, 19–20.

2. Meyer Schapiro, "Criteria of Periodization in the History of European Art," *New Literary History* 1 (1970): 113.

3. Jacques Vanuxem, "L'Art Baroque," in *Histoire de l'Art*, vol. 3 of *Encyclopédie de la Pléiade* (Paris: Editions Gallimard, 1965), 385, 388.

4. Hans Sedlmayr, "The Synthesis of the Arts in the Rococo," in *The Age of Rococo: Art and Culture in the Eighteenth Century*, trans. Margaret D. Senft-Howie and Brian Sewell (Munich: Hermann Rinn, 1958), 28.

5. Fernand Braudel, *The Wheels of Commerce*, 169.

6. René Wellek, "The Parallelism between Literature and the Arts," in *English Institute Annual 1941* (New York: Columbia University Press, 1942), 29–63. Bernhard Fehr, "The Antagonism of Forms in the Eighteenth Century," *English Studies*, 18 (1936): 115–21, 193–205; 19 (1937): 1–13. Wellek gave his own more positive view of the worth of period concepts in "The Concept of Baroque in Literary Scholarship," *The Journal of Aesthetics and Art Criticism*, 5 (1946): 77–109.

7. Walter Binni, "Il Rococò Letterario," in *Manierismo, Barocco, Rococò: Concetti e Termini* (Rome: Accademia Nazionale Dei Lincei, 1962), 217–37. Somewhat similar conclusions were reached by Herbert Dieckmann, "Reflections on the Use of Rococo as a Period Concept," in *The Disciplines of Criticism*, eds. Peter Demetz, Thomas Greene, Lowry Nelson, Jr. (New Haven, Conn.: Yale University Press, 1968), 419–36.

8. Sypher, *Rococo to Cubism*, 3.

9. Sypher, *Rococo to Cubism*, 25.

10. Charles H. Hinnant, *Samuel Johnson: An Analysis* (New York: St. Martin's Press, 1988), 1–10. Like Johnson, Voltaire also got the point.

11. David Hume *A Treatise of Human Nature*, ed. L. A. Selby-Bigge, 2nd ed. rev. P. H. Nidditch (Oxford: Clarendon Press, 1978), [I, iv, 2], 218. This passage is quoted and discussed by John Sitter, *Literary Loneliness in Mid-Eighteenth-Century England* (Ithaca and London: Cornell University Press, 1982), 25. Sitter points out that Hume's "presentness" is analogous to Richardson's "Writing to the moment," 25–26.

12. Gottfried Wilhelm Leibniz, *Die philosphischen Schriften von Gottfried Wilhelm Leibniz*, ed. C. J. Gerhardt, vol. 3 (Berlin, 1887, reprint, Hildesheim and New York: Georg Olms Verlag, 1978), 607. I am indebted for my interpretation of Leibniz to Jacob Klein, "Leibniz: (An Introduction)," an unpublished paper.

13. James Gleick, *Chaos: Making a New Science* (New York: Viking, 1987). Between pp. 114–15 the fractal color photos of the sea horses's tail look as though they might have been composed by Cuvilliès or J. B. Zimmerman. Hans Barth, "Das Zeitalter des Barocks und die Philosophie von Leibniz," in *Die Kunstformen des Barockzeitalters* (Bern: Francke Verlag, 1956), 413–34, ascribes these same qualities

to the baroque. It is true that Leibniz was one of the great system makers, but curiously, he never published his whole system, rather he explained it or the parts of it in question to his correspondents via letters. The pluralism or doubleness of the system and this manner of "writing to the moment" seem much more rococo to me, and to most others who have considered Leibniz in period context, then baroque. Chronologically Leibniz (1646–1716) like Locke, Newton, and Bayle, was a contemporary of Louis XIV (1638–1715). Norberg-Schulz compares the rococo to Leibniz's philosophy in that Leibniz accepted general principles but introduced "dynamic pluralism." *Late Baroque and Rococo*, 13.

14. Hugh Honour, *Chinoiserie: The Vision of Cathay* (London: John Murray, 1961), 23.

15. Bertrand Russell, *A Critical Exposition of the Philosophy of Leibniz*, 2nd ed. (London: George Allen & Unwin Ltd., 1949), vi.

16. A more sympathetic view of Leibniz and his better-than-average success at reconciling the metaphysical and empirical is given by Ruth Lydia Saw, *Leibniz* (Harmondsworth, Middlesex, U.K.: Penguin Books, 1954).

17. Philip P. Weiner, "Introduction," in *Leibniz: Selections* (New York: Charles Scribner's Sons, 1951), xlv.

18. Barbara Maria Stafford, "The Eighteenth Century: Towards an Interdisciplinary Model," The State of Research, *The Art Bulletin*, 70 (March 1988): 11.

19. Paul Böckmann makes this point in *Formgeschichte Der Deutschen Dichtung*, vol. 1, (Hamburg: Hoffman und Campe, 1949), 483. In this he disagrees with Emil Ermatinger, who saw Leibniz as the source of the German Enlightenment and the rococo. *Barock und Rokoko in der deutsche Dichtung* (Leipzig, Berlin: B. G. Teubner, 1926), 103–12.

20. Manfred Kuehn, "Kant and the Refutation of Idealism in the Eighteenth Century," in *Man, God, and Nature in the Enlightenment*, ed. Donald C. Mell, Jr., Theodore E. D. Braun, and Lucia M. Palmer (East Lansing, Michigan: Colleagues Press, 1988), 27.

21. Stafford, "The Eighteenth Century," 9.

22. Bayle, *Dictionary*, Third Clarification, iv, as quoted in Elizabeth Labrousse, *Bayle*, trans. Denys Potts (Oxford, New York: Oxford University Press, 1983), 43–44. I am deeply indebted to this excellent little book for my interpretation of Bayle.

23. Labrousse, *Bayle*, 56–57.

24. Ibid., 88. In this regard Bayle, like Leibniz, was a late Baroque thinker, typical of the generation born in the 1640s who prepared the way for those born after 1680.

25. Jean Pierre de Caussade, *Abandonment to Divine Providence*, trans. John Beevers (New York: Image Books, 1975), 24. The book was not published until 1861, 110 years after Caussade's death.

26. Ibid., 42.

27. Ibid., 51.

28. Ibid., 41.

29. Sedlmayr and Bauer, "Rococo," col. 241.

30. Charles-Nicolas Cochin, "Lettre à M. l'Abbé R** . . . ," *Mercure de France* (February, 1755), quoted in Svend Eriksen, *Early Neo-Classicism in France* (London: Faber and Faber, 1974), 245.

31. Abbé le Blanc [Jean Bernard], *Lettres . . . concernant le gouvernment, la politique, et les moeurs des Anglois et des Francois*, vol. 2 (1747), 41–52, reprinted in Svend Eriksen, *Early Neo-Classicism in France*, trans. Peter Thornton (London: Faber and Faber, 1974), 231.

32. Paul Hazard, *La crise de la conscience européenne (1680–1715)* (Paris: Boivin, 1935).

33. Helmut Hatzfeld's term in "Rokoko als Literarischer Epochenstil in Frankreich," 533. Hatzfeld merges together a number of phrases taken from Gustave Lanson, "Le XVIIIe siècle et ses principaux aspects," *Revue Bimensuelle des Cours et Conférences* 24, no. 2 (1924): 97–113. "agrément frivole, *persiflage* léger, bouffonnerie *insultante*, gamineries folles, séduction de l'*esprit*, où l'*emotion* se voile de badinage, où l'ironie laisse passer un peu d'*ame*, où la *force* même et la *profondeur* peuvent s'exprimer en aisance, grâce et légèreté."

34. Earl R. Wasserman, "Johnson's *Raselas*: Implicit Contexts," *Journal of English and Germanic Philology* 74 (1975): 9, 11.

35. Earl R. Wasserman, "Nature Moralized: The Divine Analogy in the Eighteenth Century," *ELH* 20 (1953): 72.

36. John Bender, *Imagining the Penitentiary: Fiction and the Architecture of Mind in Eighteenth-Century England* (Chicago and London: University of Chicago Press, 1987), 89.

37. William Empson, "Tom Jones," *Kenyon Review* 20 (1958): 217–49.

38. Ronald Paulson, *Popular and Polite Art in the Age of Hogarth and Fielding* (Notre Dame, Ind.: University of Notre Dame Press, 1979), 98–112.

39. Michael G. Ketcham, *Transparent Designs: Reading, Performance and Form in the Spectator Papers* (Athens, Georgia: University of Georgia Press, 1985), 8, as noted in John Richetti's review in *Eighteenth-Century Studies* 20 (1987): 527–30.

40. Harry C. Payne, "Elite versus Popular Mentality in the Eighteenth Century," *Studies in Eighteenth-Century Culture* 8 (1979): 15, note 40. On p. 13 he says, "By a process whose history has not yet fully been written, the premises of Baroque elite culture—piety, honor, privilege, blood, ritual, magic, symbolic politics—gave way to an Enlightenment culture premised on gentility, moderation, leisure, secularism, toleration, and education."

41. Roger Laufer, *Style Rococo, Style des "Lumieres"* (Paris: Librarie José Corti, 1963), 30–34.

42. Maynard Mack, *Alexander Pope: A Life* (New York: W. W. Norton & Company in association with Yale University Press, New Haven, London, 1985), 741.

43. Northrop Frye, "Varieties of Eighteenth-Century Sensibility," *Eighteenth-Century Studies* 24 (Winter, 1990–91): 160.

44. Anne Hollander, *Seeing Through Clothes: (Fashioning Ourselves, an Intriguing New Look at Image-Making)* (New York: Avon Books, 1980), 116, 223.

45. McKeon, *The Origins of the English Novel*, 20–21, 118, 267.

46. Mandeville first published his idea as a poem, "The Grumbling Hive: or, Knaves Turned Honest," in 1705. The work did not arouse indignation until 1723 when he added an attack on charity schools and an essay against Shaftesbury called "A Search into the Nature of Society." In 1728 he added part II, and in 1733 he published the work in its entirety. Its progress parallels the development of the rococo.

47. Sypher, *Rococo to Cubism*, 42; Sedlmayr and Bauer, "Rococo," col. 243.

48. Jay Arnold Levine, "The Design of *A Tale of a Tub*," *ELH* 33 (1966): 214–17, reprinted in *The Writings of Jonathan Swift*, ed. Robert A. Greenberg and William Bowman Piper (New York: W. W. Norton & Co., 1973), 712–15.

49. Norberg-Schulz says, "In general, we may say that the Late Baroque conserved the belief in a great comprehensive synthesis, while the Rococo takes differentiation and individuality as its points of departure." *Late Baroque and Rococo*, 88. He thinks, however, it is not possible or necessary to make a clear distinction between them. I would

rather say there exists both distinction *and* continuity.

50. Earl Wasserman, "Johnson's *Rasselas:* Implicit Contexts," 4.

51. Paul Henry Lang, *George Frideric Handel* (New York: W. W. Norton & Co., 1966), 604.

52. Luigi Ronga, "Il Rococò Musicale," in *Manierismo, Barocco, Rococò: Concetti e Termini* (Rome: Accademia Nazionale Dei Lincei, 1962), 388–92.

53. Edward Lowinsky, "Taste, Style, and Ideology in Eighteenth-Century Music," in *Aspects of the Eighteenth Century*, ed. Earl R. Wasserman (Baltimore: The Johns Hopkins Press, 1965), 170, 190.

54. Ibid., 188–90, 204–5.

55. Montesquieu, *The Persian Letters*, trans. C. J. Betts (Harmondsworth, Middlesex, U.K.: Penguin Books, 1973), 86.

56. Samuel Johnson, *Rambler*, no. 4 (1750).

57. Ibid., no. 97 (1751).

58. Harries, *The Bavarian Rococo Church*, 151. See also Rupprecht, *Rokoko-Kirche*, 12–13.

59. Margarete Baur-Heinhold, *The Baroque Theatre: A Cultural History of the 17th and 18th Centuries*, trans. Mary Whittall (New York and Toronto: McGraw Hill Book Company, 1967), 61–62.

60. Ibid., 62, 95.

61. Alan Downer, "Nature to Advantage Dressed: eighteenth-century acting," *PMLA* 58 (1943): 1002–37.

62. Laura Carnius discusses the changes in riding from a strained and violent baroque style to the less mannered one based on English cross-country riding advocated by François Robechon de la Guériniere in *L'École de Cavaliere* (1725). *Glorious Horsemen: Equestrian Art in Europe, 1500–1800* (Springfield, Mass.: Library and Museum Association, 1981), 44.

63. "Rococo," vol. 14, *Encyclopedia Universalis*, 291. Joseph Burke has called Chippendale's *The Gentleman and Cabinet-Maker's Director* (1754) "the manifesto of the rococo in England." *English Art 1714–1800* (Oxford: Clarendon, 1976), 153.

64. Quoted from Gregor in Arno Schönberger and Halldor Soehner, *The Age of Rococo*, trans. Daphne Wood Ward (London: Thames and Hudson, 1960), 66.

65. Rémy G. Saisselin, "Room at the Top of the Eighteenth Century: From Sin to Aesthetic Pleasure," *The Journal of Aesthetics and Art Criticism* 26 (1968): 349.

66. Charles-Nicolas Cochin, "Supplication Aux Orfeæres . . . ," *Mercure de France* (December 1754), reprinted in Svend Eriksen, *Early Neo-Classicism in France* (London: Faber and Faber, 1974), 235.

67. Herbert Singer, *Der Deutsche Roman Zwischen Barock Und Rokoko* (Koln Graz: Bohlau Verlag, 1963). On pp. 41–42, Singer describes what he calls the *"FrühRokoko,"* which has already appeared in Hunold's work by 1700.

68. Fritz Neubert, "Französische Rokoko-Probleme," *Hauptfragen Der Romanistik: Festschrift für Phillip August Becker* (Heidelberg: Carl Winter's Universitätsbuchhandlung, 1922), 279. Not surprisingly, from the time of Gurlitt and Wölfflin at the end of the nineteenth century, German scholars have seen much more clearly the rococo qualities of both French and English literature than have the French and the English. That such thought was Hegelian or Spenglerian does not necessarily negate the accuracy of their particular observations. See especially Brie, *Englische Rokoko-Epik*.

69. Alicia M. Annas, "The Elegant Art of Movement," in *An Elegant Art* (Los Angeles and New York: Los Angeles County Museum and Harry N. Abrams, Inc., 1983), 40–45.

70. Sedlmayr and Bauer, "Rococo," col. 237. Patrick Brady says that the loss of vertical transcendence "gener-ated a horizontal escape in the form of a hedonistic euphemization of the here and now." As an example he cites Voltaire's *Mondain:* "Le Paradis est où je suis." "Rococo Style in the Novel: 'La Vie de Marianne'," *Studi Francesi* 19 (1975): 230.

71. Bauer, *Rocaille*, 56.

72. Georg Simmel was among the first to the write of this phenomenon. *Philosphische Kultur* (Potsdam: Gustav Kiepenleuer Verlag, 1923), 135–43.

73. Charles-Nicolas Cochin, "Lettre à M. l'Abbé R**," 245. Of course he complains ironically by pretending to defend the practice. This critique of the rococo, like the letter of 1741 discussed by Crow, is very much itself an example of rococo style.

74. Norman Hampson, *The Enlightenment* (Harmondsworth, Middlesex: Penguin Books Ltd., 1968), 235.

75. Isaiah Berlin, *Vico and Herder: Two Studies in the History of Ideas* (New York: Viking Press, 1976), 77. See also *Against the Current* (New York: Viking Press, 1980), 117–29 where Berlin states that Vico is not really a relativist.

76. Norman Hampson, *The Enlightenment*, 116–17.

77. Hume, *Treatise*, [III, ii, i], 484. Sitter, *Literary Loneliness in Mid-Eighteenth-Century England*, 46, describes Hume's concept of artificial as "in accord with human nature as manifested in society."

78. Sedlmayr and Bauer, "Rococo," col. 241.

79. Bauer, *Rokokomalerei*, 14. On p. 38 he says that in the baroque the mythical and the real world were one and the same, but in the rococo the mythical world is a fiction.

80. In the light of McKeon's dialectical theory of the origins of the novel, Gay takes a conservative view that satirizes the aristocrat Macheath and the progressive (or bourgeois) Peachum.

81. Bender sees the *Beggar's Opera* as an illustration of the "novelization of culture that Bakhtin describes," *Imagining the Penitentiary*, 95. This is no doubt true, but it also illustrates the "rococoization" of plays and novels. The process was also a style.

82. Jonathan Swift, letter to Pope of 30 August 1716, in vol. 1, *The Correspondence of Alexander Pope*, ed. George Sherburn (Oxford: Clarendon Press, 1956), 360.

83. Bauer, *Rokokomalerei*, 23–51.

84. Sypher, *Rococo to Cubism*, 19.

85. Ibid., p. 18.

CHAPTER 4. ROCOCO AND THE NOVEL

1. Ian Watt, *The Rise of the Novel* (London: Chatto & Windus, 1957), 288; Northrop Frye, *Anatomy of Criticism* (Princeton, N.J.: Princeton University Press, 1957), 306.

2. Lennard Davis, using a Foucaultian model of "discourse," reaches similar conclusions about the differences between seventeenth- and eighteenth-century novels. *Factual Fictions: The Origins of the English Novel* (New York: Columbia University Press, 1983).

3. Voltaire actually applied this phrase to himself in his letter of 27 April 1762 to Trublet, in vol. 45, *Voltaire's Correspondence*, ed. Theodore Besterman (Geneva: Institut et Musée Voltaire, 1959), 312–13.

4. David Coke, "Vauxhall Gardens," in *Rococo Art and Design in Hogarth's England*, ed. Michael Snodin (London: The Victoria and Albert Museum, 1984), 75–81, 92–93.

5. See, for instance, Martin C. Battestin's "Pictures of Fielding," *Eighteenth-Century Studies* 17 (1983): 1–13. Roger Robinson discusses Fielding's relation to the rococo in "Henry Fielding and the English Rococo," *Studies in the Eighteenth Century II*, ed. R. F. Brissenden (Toronto: University of Toronto Press, 1973), 93–111.

6. Mikhail M. Bakhtin, *The Dialogic Imagination*, ed.

and trans. Michael Holquist and Caryl Emerson (Austin: University of Texas Press, 1981), 33.

7. Leo Spitzer, "A Propos De 'La Vie de Marianne'," *Romanic Review* 44 (1953): 102–126, reprinted in *Études de Style* (Paris: Éditions Gallimard, 1970), 369.

8. Jean Rousset, *Forme et Signification: Essais sur les structures littéraires de Corneille à Claudel* (Paris: Librairie José Corti, 1962), 87, 88.

9. Marian Hobson, *The Object of Art: The Theory of Illusion in Eighteenth Century France*, 123, speaks of the "aesthetics of surprise."

10. Sedlmayr and Bauer, "Rococo," col. 237.

11. Alfred Anger recognized the rococo qualities of the "Preface" to *Joseph Andrews* in *Literarisches Rokoko* (Stuttgart: Metzlersche Verlagsbuchhandlung, 1962), 92–93.

12. Nancy Armstrong, *Desire and Domestic Fiction: a Political History of the Novel* (New York, Oxford: Oxford University Press, 1987), 109, mentions how *Pamela* contains the strategy of a book of seduction in the framework of a conduct book, and mixes up a conduct book with fiction.

13. Davis in *Factual Fictions*, 154–73, discusses this ambivalence in Defoe and relates it to a crisis in discourse in which news/novel becomes transformed into the alleged opposites fact and fiction. Bender in *Imagining the Penitentiary*, 48, says Defoe took the traditional Puritan methods of reading the world allegorically and ran them backwards. Laura A. Curtis in *The Elusive Daniel Defoe* (London: Vision Press Limited, 1984), 139, describes *Moll Flanders* as an "unstable equilibrium of picaresque, narrative, criminal biography, and spiritual autobiography."

14. John Bender, *Imagining the Penitentiary*, 105.

15. Nancy Armstrong in *Desire and Domestic Fiction* argues that the novel was revolutionary in this regard, but that this feminized new species of writing in turn created modern sexuality and its gender roles, which then became the mainstays of bourgeois capitalism.

16. R. F. Brissenden, "Sterne and Painting," in *Of Books and Humankind: Essays and Poems Presented to Bonamy Dobrée*, ed. John Butt (London: Routledge and Kegan Paul, 1964), 107 ventures that it is tempting to describe Sterne's work as rococo; he also implies that the rococo is a link between Hogarth, Fielding, Sterne, and Smollett, 107–8. Gerald P. Tyson gives a more thorough account of Sterne's relationship to the rococo in "The Rococo Style of *Tristram Shandy*," *Bucknell Review* 24 (1979): 38–55.

17. Karsten Harries, *The Bavarian Rococo Church*, 120, makes this point about the architecture.

18. McKeon, *Origins of the English Novel*, 21, 118, 267. Davis in *Factual Fictions* speaks of the new/novel discourse being built on contradictions and being marked by "an inherent doubleness or reflexivity," 70.

19. McKeon, *Origins of the English Novel*, 20–21.

20. Ibid., 22. Jerry C. Beasley has written one of the best accounts of this synthesis in *Novels of the 1740s* (Athens: The University of Georgia Press, 1982). See particularly chapter VII, 184–209.

21. William Empson, "Tom Jones," *Kenyon Review* 20 (1958): 217–49. See also William Park, "Ironist and Moralist: The Two Readers of *Tom Jones*," *Studies in Eighteenth-Century Culture*, 8 (1979): 233–42; C. J. Rawson, *Henry Fielding and the Augustan Ideal Under Stress* (London and Boston: Routledge & Kegan Paul, 1972), 3–34; and Brian McCrea, " 'Had Not Joseph Withheld Him': The Portrayal of the Social Elite in *Joseph Andrews*," in *Man, God, and Nature in the Enlightenment*, ed. Donald C. Mell Jr, Theodore E. D. Braun, and Lucia M. Palmer (East Lansing, Michigan: Colleagues Press, 1988), 123–28.

22. McKeon, *Origins of the English Novel*, 22.

23. Ibid., 420. Here he is speaking of the post-1740 novel, but few later novels in English approach the technical virtuosity of Richardson and Fielding.

24. Martin C. Battestin, *The Providence of Wit: Aspects of Form in Augustan Literature and the Arts* (Oxford: The Clarendon Press, 1974), 144–62.

25. James Boswell, *Life of Johnson*. ed. George Birkbeck Hill and L. F. Powell (Oxford: Clarendon, 1934), vol. 2, 49.

26. Important but lesser corollaries to the clock were two other "machines," the thermometer and barometer. Terry Castle, "The Female Thermometer," *Representations* 17 (1987): 1–27.

27. Patrick Brady, "Rococo Style in French Literature," *Studi Francesi* 10 (1966): 428–37; "From Traditional Fallacies to Structural Hypotheses: Old and New Concepts in Period Style Research," *Neophilologus* 56 (1972): 1–11; "The Present State of Studies on the Rococo," *Comparative Literature* 27 (1975): 21–33. George Poe, *The Rococo and Eighteenth-Century French Literature: A Study through Marivaux's Theater* (New York: Peter Lang, 1987).

28. Poe, *The Rococo and Eighteenth-Century French Literature*, 7, 52–59.

29. Patrick Brady, "Rococo Style in the Novel: 'La Vie de Marianne,' " *Studi Francesi* 19 (1975): 225–43.

30. Leo Spitzer, "Pages from Voltaire," *A Method of Interpreting Literature* (Northampton, Mass.: Smith College, 1949), 64–86.

31. Patrick Brady denies rococo status to all three of these French works: "The *Lettres persanes*: rococo or neo-classical?" *Studies on Voltaire and the Eighteenth Century* 53 (1967): 47–77; "*Manon Lescaut*: classical, romantic, or rococo?" *Studies on Voltaire and the Eighteenth Century* 53 (1967): 339–60; "Is *Candide* really 'Rococo'?" *L'Esprit Créateur* 7 (1967): 234–42.

32. Poe, *The Rococo and Eighteenth-Century French Literature*, 52.

33. Brady, "From Traditional Fallacies . . . ," 4.

34. Roger Laufer, *Style Rococo, Style des "Lumières"*, 7–22.

35. Fielding, *Joseph Andrews*, bk. III, ch. i.

36. McKeon, *Origins of the English Novel*, 19. See also, John J. Richetti, *Popular Fiction Before Richardson: Narrative Patterns 1700–1739* (Oxford: Clarendon Press, 1969).

37. William Park, "*Tristram Shandy* and the New 'Novel of Sensibility'," *Studies in the Novel*, 6 (1974): 268–79.

38. J. M. S. Tompkins, *The Popular Novel in England, 1770–1800* (London: Constable & Co., Ltd., 1932), 4–5; also John Tinnon Taylor, *Early Opposition to the English Novel* (New York: King's Crown Press, 1943), 87–105.

39. McKeon, *Origins of the English Novel*, 266. See also William Park, "What Was New about the 'New Species of Writing'?" *Studies in the Novel*, 2 (1970): 112–30.

CHAPTER 5. AFTER 1759

1. Quoted by Hugh Honour, "Neo-Classicism," in *The Age of Neo-Classicism* (London: The Arts Council of Britain, 1972), xxi.

2. Denis Diderot, *Salons*, eds. Jean Seznec and Jean Adhémar (Oxford: Clarendon Press, 1957), vol. 1, 112.

3. Michael Levey, *Rococo to Revolution*, 15–52.

4. Herbert Singer, *Der Deutsche Roman Zwischen Barock und Rokoko* (Koln Graz: Böhlau Verlag, 1963), 41–42.

5. George Kubler and Martin Soria, *Art and Architecture*, 34–42.

6. Jean Sgard has written an excellent short essay on the *Régence*, "Style Rococo Et Style Régence," in *La Régence* (Paris: Librairie Armand Colin, 1970), 11–20.

7. Henry Russell Hitchcock, *Rococo Architecture in Southern Germany* (New York: Phaidon, 1968), 165, believes

Birnau one of the best examples of rococo, but I agree with Harries's analysis of that church as "autumnal," *The Bavarian Rococo Church*, 223–25.

8. Carol Duncan, *The Pursuit of Pleasure: the Rococo Revival in French Romantic Art* (New York: Garland, 1976), argues that neoclassicism did not vanquish rococo but that it survived and was popular, 7. "The old aristocracy and newly rich struggled to maintain or to acquire the tastes and social forms of pre-Revolutionary aristocratic cultures," 1. Though no one could deny the nostalgia for the *ancien régime* and the allusions to the earlier style, much of what she discusses seems to me more eclectic or pseudorococo than a genuine continuation of the style. Bryson is very illuminating on how Greuze, for instance, while maintaining certain rococo qualities, departs from that style and belongs to a period of "sensibility" in the 1760s and 70s. According to him Greuze "is the founder of a conflict between official discursive purpose and figural actuality that will develop fully in Romanticism." *Word and Image*, 147. Crow, *Painters and Public Life in Eighteenth-Century Paris*, 130–31, remarks that the antirococo program was as much a denial of popular impulses as it was of the private tastes of the rich and the court.

9. Bauer, *Rocaille*, 38–39, 50, 55.

10. Hugh Honour, *Neo-Classicism* (London: Penguin Books, 1968); Svend Eriksen, *Early Neo-Classicism in France*, trans. Peter Thornton (London: Faber and Faber, 1974); Daime Stillman, *English Neo-Classical Architecture* (London: A. Zwemmer, 1988), 1: 27–48. Robert Rosenblum dislikes the catch all qualities of "Neo-Classicism" but does not deny the phenomenon so much as he illustrates its complexity. *Transformations in Late Eighteenth Century Art* (Princeton, N.J.: Princeton University Press, 1967).

11. Gerald P. Tyson, "The Rococo Style of *Tristram Shandy*," 38–55.

12. Ibid., 50.

13. Ibid., 50.

14. William Park, "Change in the Criticism of the Novel after 1760," *Philological Quarterly* 46 (1967): 34–41.

15. Wasserman, "From Public to Private Cosmos: The Context of Ideas in the Later Eighteenth Century," (Paper read at the Seventy-third Annual Meeting of the Modern Language Association, New York, 28 December 1958).

16. Fiske Kimball, "Romantic Classicism in Architecture," *Gazette des Beaux Arts* 25 (1944): 95.

17. Robert Shackleton, "The Enlightenment: Free Inquiry and the World of Ideas," in *The Eighteenth Century: Europe in the Age of Enlightenment*, ed. Alfred Cobban (New York: McGraw-Hill, 1969), 259–78.

18. Roger Laufer, *Style Rococo, Style des "Lumières"*. Emil Ermatinger, *Barock und Rokoko in des deutschen Dichtung*, 119–24, 164–65, 175–79.

19. Paul Böckmann, *Formgeschichte der Deutschen Dichtung*, vol. 1, 528–29. Brady repeatedly attacks Laufer's concept. He concludes his collection of essays, *Rococo Style Versus Enlightenment Novel* (Geneva: Slatkine, 1984), with the sentence "Such is the world of the Rococo—so distant from that of the Enlightenment," 225. Yet he says that the Enlightenment could not have come about without the rococo. "Demography, Modernism, and Cultural Senescence: The Rococo and the Roots of Revolution," *Mélanges à la mémoire de Franco Simone, IV, Tradition et originalité dans la création littéraire* (Geneva: Editions Slatkine, 1983), 308.

20. Eudora Welty, *The Collected Stories of Eudora Welty* (New York and London: Harcourt Brace Jovanovich, 1980), 28.

21. In England, according to Daime Stillman, the neoclassical style in architecture, in the strictest sense, began to change in the 1790s, after which a "Romantic Classicism" replaced it. *English Neo-Classical Architecture*, 2: 521–23.

22. Crow, *Painters and Public Life*, 240–41 explains how the dissonances and calculated "errors" of the *Oath of the Horatii* (1785) link the picture "to the order of nature itself."

23. Ronald Paulson, *Emblem and Expression*, 82.

24. Gothic architecture appeared in England throughout the baroque and rococo periods. On the whole the Gothic of Wren, Vanbrugh, and Hawksmoor continued a long-existing tradition of building, conservatively resistant to Mediterranean norms, but in some of Hawksmoor's work (All Soul's, Oxford) and at Strawberry Hill and in garden buildings, it became, like Chinoiserie, a version of rococo.

25. Denis Diderot, *Pensées détachées sur la peinture* (1777) in vol. 12 of *Oeuvres complètes*, ed. Roger Lewinter (Paris: Club Francais du Livre, 1971), 346, quoted in Jean Starobinski, *The Invention of Liberty*, 146.

26. Sheriff, *Fragonard*, 118.

27. Sheriff, *Fragonard*, 137–84, brilliantly uncovers the principles of Fragonard's practice, but she does not discuss Fragonard as being between rococo and romanticism. Crow, *Painters and Public Life*, 65, sees Fragonard returning to the original rococo ironies and perversity lost in Boucher.

28. Sypher, *Rococo to Cubism*, 63.

29. See Linda Nochlin, *Realism* (Harmondsworth: Penguin, 1971).

Bibliography

Abrams, Meyer. "Rationality and Imagination in Cultural History: A Reply to Wayne Booth." *Critical Inquiry* 2 (1976): 447–64.

———. *The Mirror and the Lamp.* New York: Oxford University Press, 1953.

Ackerman, James S. "A Theory of Style." *Journal of Aesthetics and Art Criticism* 20 (1972): 227–37.

Allen, Brian. "Francis Hayman and the English Rococo." Ph.D. diss., Courtauld Institute of Art, University of London, 1984.

Anger, Alfred. *Literarisches Rokoko.* Stuttgart: Metzlersche Verlagsbuchhandlung, 1962.

Annas, Alicia M. "The Elegant Art of Movement." In *An Elegant Art,* 35–58. Los Angeles and New York: Los Angeles County Museum and Harry N. Abrams, Inc., 1983.

Armstrong, Nancy. *Desire and Domestic Fiction: a Political History of the Novel.* New York, Oxford: Oxford University Press, 1987.

Bakhtin, Mikhail M. *The Dialogic Imagination.* Edited and translated by Michael Holquist and Caryl Emerson. Austin, Tex.: University of Texas Press, 1981.

Barth, Hans. "Das Zeitalter des Barocks und die Philosophie von Leibniz." In *Die Kunstformen des Barockzeitalters,* 413–34. Bern: Francke Verlag, 1956.

Battestin, Martin C. "Pictures of Fielding." *Eighteenth-Century Studies* 17 (1983): 1–13.

———. *The Providence of Wit: Aspects of Form in Augustan Literature and the Arts.* Oxford: The Clarendon Press, 1974.

Bauer, Hermann, and Anna Bauer. *Johann Baptist und Dominikus Zimmerman.* Regensburg: Verlag Friedrich Pustet, 1985.

Bauer, Hermann. *Rocaille: Zum Herkunft und Zum Wesen Eines Ornament-Motivs.* Berlin: Walter de Gruyter & Co., 1962.

———. *Rokokomalerei.* Mittenwald: Itzebeyer, 1980.

Baur-Heinhold, Margarete. *The Baroque Theatre: A Cultural History of the 17th and 18th Centuries.* Translated by Mary Whittall. New York and Toronto: McGraw Hill Book Company, 1967.

Beasley, Jerry C. *Novels of the 1740s.* Athens, Georgia: The University of Georgia Press, 1982.

Bender, John. *Imagining the Penitentiary: Fiction and the Architecture of Mind in Eighteenth-Century England.* Chicago and London: University of Chicago Press, 1987.

Berlin, Isaiah. *Against the Current.* New York: Viking Press, 1980.

———. *Vico and Herder: Two Studies in the History of Ideas.* New York: Viking Press, 1976.

Besterman, Theodore, ed. *Voltaire's Correspondence.* Vol. 45. Geneva: Institut et Musée Voltaire, 1959.

Binni, Walter. "Il Rococò Letterario." In *Manierismo, Barocco, Rococò: Concetti E Termini,* 217–37. Rome: Accademia Nazionale Dei Lincei, 1962.

Böckmann, Paul. *Formgeschichte Der Deutschen Dichtung.* Vol. 1. Hamburg: Hoffman and Campe, 1949.

Boime, Albert. *Art in an Age of Revolution, 1750–1800.* Chicago and London: University of Chicago Press, 1987.

Boswell, James. *Life of Johnson.* Edited by George Birkbeck Hill and L. F. Powell. Vol. 2. Oxford: Clarendon Press, 1934.

Brady, Patrick. "A Sweet Disorder: Atomistic Empiricism and the Rococo Mode of Vision." *Studies in Eighteenth-Century Culture* 7 (1978): 451–62.

———. "Demography, Modernism, and Cultural Senescence: The Rococo and the Roots of Revolution." In *Mélanges à la mémoire de Franco Simone, IV, Tradition et originalité dans la création littéraire.* Geneva, 301–11: Editions Slatkine, 1983.

————. "From Traditional Fallacies to Structural Hypotheses: Old and New Conceptions in Period Style Research." *Neophilologus* 56 (1972): 1–11.

————. "Is *Candide* really 'Rococo'?" *L'Esprit Créateur* 7 (1967): 234–42.

————. "*Manon Lescaut: classical romantic, or rococo?*" *Studies on Voltaire and the Eighteenth Century* 53 (1967): 339–60.

————. "Rococo Style in French Literature." *Studi Francesi* 10 (1966): 428–37.

————. "Rococo Style in the Novel: 'La Vie de Marianne'." *Studi Francesi* 19 (1975): 225–43.

————. "Rococo Style in the Plastic Arts and Literature: Theory, Method, Application." In *Literature and the Other Arts*, 87–91. Innsbruck: International Literature Association. 9th Congress, 1979.

————. "The *Lettres persanes:* rococo or neo-classical?" *Studies on Voltaire and the Eighteenth Century* 53 (1967): 47–77.

————. "The Present State of Studies on the Rococo." *Comparative Literature* 27 (1975): 21–33.

————. "Toward Autonomy and Metonymy: The Concept of Rococo Literature from 1859 to 1976." *Yearbook of Comparative and General Literature* 25 (1976): 31–41.

————. Review of *The Rococo, Eroticism, Wit, and Elegance in European Literature* by Helmut Hatzfeld. *Comparative Literature* 25 (1973): 364–66.

————. *Rococo Style Versus Enlightenment Novel*. Geneva: Slatkine, 1984.

Braudel, Fernand. *The Wheels of Commerce.* Vol. 2 of *Civilization and Capitalism, 15th–18th Century.* Translated by Siân Reynolds. New York: Harper & Row, 1982.

Brie, Friedrich. *Englische Rokoko-Epik (1710–1730).* Munich: Max Heuber Verlag, 1927.

Brissenden, R. F. "Sterne and Painting." In *Of Books and Humankind: Essays and Poems Presented to Bonamy Dobrée,* edited by John Butt, 93–108. London: Routledge and Kegan Paul, 1964.

Brownell, Morris R. " 'Bursting Prospect': British Garden History Now." In *British and American Gardens in the Eighteenth Century,* edited by Robert P. Maccubbin and Peter Martin, 5–18. Williamsburg: Colonial Williamsburg Foundation, 1984.

————. *Alexander Pope & The Arts of Georgian England.* Oxford: Clarendon Press, 1978.

Bryson, Norman. *Word and Image: French Painting of the Ancien Régime.* Cambridge: Cambridge University Press, 1981.

Burke, Joseph. *English Art 1714–1800.* Oxford: Clarendon Press, 1976), 335–41.

Carnius, Laura. *Glorious Horsemen: Equestrian Art in Europe, 1500–1800.* Springfield, Mass.: Library and Museum Association, 1981.

Carr, C. T. "Two Words in Art History: I *Baroque.*" *Forum for Modern Language Studies,* 1 (1965): 175–90.

————. "Two Words in Art History: II. *Rococo.*" *Forum for Modern Language Studies* 1 (1965): 266–81.

Castle, Terry. "The Female Thermometer." *Representations* 17 (1987): 1–27.

Caussade, Jean Pierre de. *Abandonment to Divine Providence.* Translated by John Beevers. New York: Image Books, 1975.

Champion, Pierre. *Notes critiques sur les vies anciennes d'Antoine Watteau.* Paris: E. Champion, 1921.

Coke, David. "Vauxhall Gardens." In *Rococo Art and Design in Hogarth's England,* edited by Michael Snodin, 75–98. London: The Victoria and Albert Museum, 1984.

Colton, Judith. "Freemasonry and the Dissemination of Palladianism." Paper given at the North East American Society for Eighteenth-Century Studies conference at Syracuse University on 8 October 1983.

Crow, Thomas E. *Painters and Public Life in Eighteenth-Century Paris.* New Haven, Conn. and London: Yale University Press, 1985.

Crown, Patricia. "British Rococo as Social and Political Style." *Eighteenth Century Studies* 23 (1990): 269–82.

Curtis, Laura A. *The Elusive Daniel Defoe.* London: Vision Press Limited, 1984.

Davis, Lennard. *Factual Fictions: The Origins of the English Novel.* New York: Columbia University Press, 1983.

Dennerlein, Ingrid. *Die Gartenkunst der Regence und der Rokoko in Frankreich.* Worms: Werneische Verlag, 1981.

Diderot, Denis. "Pensées détachées sur la peinture." In vol. 12. *Oeuvres complètes,* edited by Roger Lewinter. Paris: Club Français du Livre, 1971.

————. *Salons.* Edited by Jean Seznec and Jean Adhémar. Oxford: Clarendon Press, 1957.

Dieckmann, Herbert. "Reflections on the Use of Rococo as a Period Concept." In *The Disciplines of Criticism,* edited by Peter Demetz, Thomas Greene, and Lowry Nelson, Jr., 419–36. New Haven, Conn.: Yale University Press, 1968.

Doody, Margaret Anne. *The Daring Muse: Augustan Poetry Reconsidered.* Cambridge: Cambridge University Press, 1985.

Downer, Alan. "Nature to Advantage Dressed: eighteenth-century acting." *PMLA* 58 (1943): 1002–37.

Drawings of William Kent. London: Victoria and Albert Museum, 1984.

Duncan, Carol. *The Pursuit of Pleasure: the Rococo Revival in French Romantic Art.* New York: Garland, 1976.

Edwards, Ralph, and L. G. G. Ramsey, eds. *The Early Georgian Period 1714–1760.* London: The Connoisseur, 1957.

Empson, William. "Tom Jones." *Kenyon Review* 20 (1958): 217–49.

Engass, Robert. "Visual Counterpoint in Venetian Set-tecento Painting." *Art Bulletin* 64 (1982): 89–97.

Eriksen, Svend. *Early Neo-Classicism in France.* Translated by Peter Thornton. London: Faber and Faber, 1974.

Ermatinger, Emil. "Das Zeitalter des Rokoko." In *Krisen und Probleme der neuen deutschen Dichtung,* 364–72. Zurich-Leipzig-Vienna: Amalthea Verlag, 1928.

F. H. D. "Rococo." In *Encyclopedia Universalis.* Vol. 14. Paris: Encyclopedia Universalis France, 1968.

Fabricant, Carole. "Binding and Dressing Nature's Loose Tresses: The Ideology of Augustan Landscape Design." *Studies in Eighteenth-Century Culture* 8 (1979): 109–35.

Faison, S. Lane. Review of Henry-Russell Hitchcock's *Rococo Architecture in Southern Germany* and Eberhard Hempel's *Baroque Architecture in Central Europe. Journal of the Society of Architectural Historians* 29 (1970): 195–99.

Fehr, Bernhard. "The Antagonism of Forms in the Eighteenth Century." *English Studies* 18 (1936): 115–21, 193–205; 19 (1937): 1–13.

Feulner, Adolf. *Bayerisches Rokoko.* Munich: Kurt Wolff Verlag, 1923.

Fielding, Henry, *Joseph Andrews.* Edited by Martin C. Battestin. The Wesleyan Edition of the Works of Henry Fielding. Oxford: Clarendon Press, 1967.

Fletcher, Bannister. *A History of Architecture.* Edited by John Musgrove. 19th ed. London: Butterworths, 1987.

Foucault, Michele. *Madness and Civilization: A History of Insanity in the Age of Reason.* Translated by Richard Howard. New York: Pantheon Books, 1965.

Frye, Northrop. *A Study of English Romanticism.* Chicago: University of Chicago Press, 1982.

———. *Anatomy of Criticism.* Princeton: Princeton University Press, 1957.

———. *Fables of Identity.* New York: Harcourt, Brace & World, 1963.

———. *The Great Code: the Bible and Literature.* New York: Harcourt Brace Jovanovich, 1982.

———. "Varieties of Eighteenth-Century Sensibility." *Eighteenth-Century Studies* 24 (Winter 1990–91): 157–72.

Gallet, Michel. "Quelques Étapes du Rococo Dans L'Architecture Parisienne." *Gazette Des Beaux Arts* 67 (1966): 145–68.

Girouard, Mark. "Coffee at Slaughter's: English Art and the Rococo—I." *Country Life* (13 January 1966): 58–61.

Gleick, James. *Chaos: Making a New Science.* New York: Viking, 1987.

Graselli, Margaret Morgan, and Pierre Rosenberg. *Watteau: 1684–1721.* Washington: National Gallery of Art, 1984.

Greene, Donald. " 'Logical Structure' in Eighteenth-Century Poetry." *Philological Quarterly* 31 (1952): 315–36.

Gurlitt, Cornelius. *Geschichte des Barockstiles.* Stuttgart: Ebner & Seubert, 1886.

Hampson, Norman. *The Enlightenment.* Harmondsworth, Middlesex: Penguin Books, Ltd., 1968.

Harries, Karsten. *The Bavarian Rococo Church.* New Haven, Conn. and London: Yale University Press, 1983.

Harris, John. *Gardens of Delight: The Rococo English Landscape of Thomas Robins the Elder.* Vol. 1. London: The Basilisk Press, 1978.

Hatzfeld, Helmut. "Rokoko als literarischer Epochen-stil in Frankreich." *Studies in Philology* 35 (1938): 532–65.

———. *The Rococo, Eroticism, Wit, and Elegance in European Literature.* New York: Pegasus, 1972.

Hausenstein, Wilhelm. *Die Kunst und die Gesellschaft.* Munich: R. Piper & Co., 1916.

Hauser, Arnold. *The Philosophy of Art History.* Cleveland: World Publishing Company, 1963.

———. *The Social History of Art.* 4 vols. New York: Vintage Books, 1958.

Hazard, Paul. *La crise de la conscience européenne (1680–1715).* Paris: Boivin, 1935.

Hinnant, Charles H. *Samuel Johnson: An Analysis.* New York: St. Martin's Press, 1988.

Hitchcock, Henry-Russell. *Rococo Architecture in Southern Germany.* New York: Phaidon, 1968.

Hobson, Marian. *The Object of Art: The Theory of Illusion in Eighteenth-Century France.* New York and Cambridge: Cambridge University Press, 1982.

Hollander, Anne. *Seeing Through Clothes: (Fashioning Ourselves, an Intriguing New Look at Image-Making).* New York: Avon Books, 1980.

Honour, Hugh. *Chinoiserie: The Vision of Cathay.* London: John Murray, 1961.

———. *Neo-Classicism.* London: Penguin Books, 1968.

———. *The Age of Neo-Classicism.* London: The Arts Council of Britain, 1972.

Hume, David. *A Treatise of Human Nature.* Edited by A. Selby-Bigge, 2nd ed. revised by P. H. Nidditch. Oxford: Clarendon Press, 1978.

Hunt, John Dixon, and Peter Willis. *The Genius of the Place.* New York: Harper & Row, 1975.

Hunt, John Dixon. "Pope's Twickenham Revisited." In *British and American Gardens in the Eighteenth Century,* edited by Robert P. Maccubbin and Peter Martin, 26–33. Williamsburg: Colonial Williamsburg Foundation, 1984.

Jackson-Stops, Gervase. "Rococo Architecture and Interiors." In *Rococo: Art and Design in Hogarth's England,* edited by Michael Snodin, 190–98. London: Trefoil Books/ Victoria and Albert Museum, 1984.

Janson, H. W. "Criteria of Periodization in the History of European Art." *New Literary History* 1 (1970): 115–22.

Johnson, Samuel. *The Rambler.* The Yale Edition of the Works of Samuel Johnson. Vol. 3. Edited by W. J. Bate and Albrecht B. Strauss, New Haven, Conn.

and London: Yale University Press, 1969.

Kaufman, Emil. *Architecture in the Age of Reason: Baroque and Post-Baroque in England, Italy, and France.* 1955. Reprint. New York: Dover Publications, 1968.

Kennedy, Paul. *The Rise and Fall of the Great Powers.* New York: Random House, 1988.

Ketcham, Michael G. *Transparent Designs: Reading, Performance and Form in the Spectator Papers.* Athens, Georgia: University of Georgia Press, 1985.

Kimball, Fiske. "Art Terms." Letters to the Editor. *TLS* 45 (8 June 1946): 271.

———. "Romantic Classicism in Architecture," *Gazette des Beaux Arts.* 25 (1944): 95–112.

———. *The Creation of the Rococo Decorative Style.* Reprint of *The Creation of the Rococo.* 1943. New York: Dover Publications, 1980.

Kitson, Michael. *The Age of Baroque.* New York and London: McGraw Hill, 1966.

Klein, Jacob. "Leibniz: (An Introduction)." An unpublished paper.

Kubler, George, and Martin Soria. *Art and Architecture in Spain and Portugal and Their American Dominions, 1500–1800.* Harmondsworth, Middlesex: Penguin Books, 1959.

Kubler, George. "A Reductive Theory of Visual Style." In *The Concept of Style,* edited by Berel Lang, rev. and enl., 163–73. Ithaca, N.Y.: Cornell University Press, 1987.

———. *The Shape of Time: Remarks on the History of Things.* New Haven, Conn.: Yale University Press, 1962.

Kuehn, Manfred. "Kant and the Refutation of Idealism in the Eighteenth Century." In *Man, God, and Nature in the Enlightenment,* edited by Donald C. Mell, Jr., Theodore E. D. Braun, and Lucia M. Palmer, 25–35. East Lansing, Michigan: Colleagues Press, 1988.

Labrousse, Elizabeth. *Bayle.* Translated by Denys Potts. Oxford, New York: Oxford University Press, 1983.

Laing, Alastair, J. Patrice Marandel, and Pierre Rosenberg. *Francois Boucher 1703–1770.* New York: The Metropolitan Museum of Art, 1986.

Lang, Paul Henry. *George Frideric Handel.* New York: W. W. Norton & Co., 1966.

Lanson, Gustave. "Le XVIIIe siècle et ses principaux aspects." *Revue Bimensuelle des Cours et Conférences* 24, no. 2 (1924): 97–113.

Laufer, Roger. *Style Rococo, Style des "Lumières."* Paris: Librarie José Corti, 1963.

Leibniz, Gottfried Wilhelm. *Die philosophischen Schriften von Gottfried Wilhelm Leibniz.* Edited by C. J. Gerhardt. Vol. 3. Berlin, 1887. Reprint. Hildesheim and New York: Georg Olms Verlag, 1978.

Levey, Michael. *Painting in Eighteenth-Century Venice.* Rev. ed. Ithaca, N.Y.: Cornell University Press, 1980.

———. *Rococo to Revolution: Major Trends in Eighteenth-Century Painting.* London: Thames and Hudson, 1966.

Levine, Jay Arnold Levine. "The Design of *A Tale of a Tub.*" *ELH* 33 (1966): 214–17. Reprinted in *The Writings of Jonathan Swift,* edited by Robert A. Greenberg and William Bowman Piper. New York: W. W. Norton & Co., 1973.

Liebold, Christine. *Das Rokoko in ursprünglich mittelaltererlichen des bayerischen Gebietes—ein von maurinischen Denken geprägter Stil.* Miscellanea Bavarica Monacensia. Heft 98. Munich: R. Wölfle, 1981.

Lipking, Lawrence. "Periods in the Arts: Sketches and Speculations." *New Literary History* 1 (1970): 181–200.

Lowinsky, Edward. "Taste, Style, and Ideology in Eighteenth-Century Music." In *Aspects of the Eighteenth Century,* edited by Earl R. Wasserman, 163–205. Baltimore: The Johns Hopkins Press, 1965.

Mack, Maynard. *Alexander Pope: A Life.* New York: W. W. Norton & Co. in association with Yale University Press, New Haven, London, 1985.

———. *The Garden and the City.* Toronto: University of Toronto Press, 1969.

Mallè, Luigi. "Traccia per Francesco Ladatte, scultore torinese." In *Essays in the History of Art Presented to Rudolf Wittkower.* London: Phaidon, 1967.

Mallory, Nina A. *Roman Rococo Architecture from Clement XI to Benedict XIV (1700–1758).* New York: Garland Publishing, Inc., 1977.

Maxon, John, and Joseph J. Riskel. *Painting in Italy in the Eighteenth Century: Rococo to Romanticism.* Chicago: Art Institute, 1970.

McCrea, Brian. " 'Had Not Joseph Withheld Him': The Portrayal of the Social Elite in *Joseph Andrews.*" In *Man, God, and Nature in the Enlightenment,* edited by Donald C. Mell Jr., Theodore E. D. Braun, and Lucia M. Palmer, 123–28. East Lansing, Michigan: Colleagues Press, 1988.

McKeon, Michael. *The Origins of the Novel, 1660–1740.* Baltimore: Johns Hopkins University Press, 1987.

McNeill, William. *The Rise of the West.* Chicago: University of Chicago Press, 1963.

Meek, H. A. *Guarino Guarini and His Architecture.* New Haven, Conn. and London: Yale University Press, 1988.

Minguet, J. Philippe. *Esthétique du Rococo.* Paris: J. Vrin, 1966.

Montesquieu. *The Persian Letters.* Translated by C. J. Betts. Harmondsworth, Middlesex, U.K.: Penguin Books, 1973.

Neubert, Fritz. "Französische Rokoko-Probleme." In *Hauptfragen Der Romanistik: Festschrift für Phillip August Becker,* 256–79. Heidelberg: Carl Winter's Universitätsbuchhandlung, 1922.

Newman, John Henry. *An Essay in Aid of a Grammar*

of Assent. 1870. Notre Dame: Notre Dame University Press, 1979.

Nochlin, Linda. *Realism.* Harmondsworth: Penguin, 1971.

Norberg-Schulz, Christian. *Baroque Architecture.* New York: Harry N. Abrams Inc., 1971.

———. *Late Baroque and Rococo Architecture.* New York: Harry N. Abrams, Inc., 1974.

Palladio, Andrea. *The Four Books of Architecture.* 1738. Reprint of the Isaac Ware edition. New York: Dover Publications, Inc., 1965.

Park, William. "Change in the Criticism of the Novel after 1760." *Philological Quarterly* 46 (1967): 34–41.

———. "Fielding *and* Richardson." *PMLA* 81 (1966): 381–88.

———. "Ironist and Moralist: The Two Readers of *Tom Jones.*" *Studies in Eighteenth-Century Culture* 8 (1979): 233–42.

———. "*Tristram Shandy* and the New 'Novel of Sensibility'." *Studies in the Novel* 6 (1974): 268–79.

———. "What Was New about the 'New Species of Writing'?" *Studies in the Novel* 2 (1970): 112–30.

Paulson, Ronald. *Hogarth: His Life, Art, and Times.* 2 vols. New Haven, Conn.: Yale University Press, 1971.

———. *Emblem and Expression: Meaning in English Art of the Eighteenth Century.* Cambridge, Mass.: Harvard University Press, 1975.

———. *Popular and Polite Art in the Age of Hogarth and Fielding.* Notre Dame, Inc.: University of Notre Dame Press, 1979.

Payne, Harry C. "Elite versus Popular Mentality in the Eighteenth Century." *Studies in Eighteenth-Century Culture* 8 (1979): 3–32.

Pevsner, Nikolaus. "The Genesis of the Picturesque." *Studies in Art, Architecture and Design.* Vol. 1. New York: Walker and Company, 1968).

Philip Mercier. Catalogue of an Exhibition at the City Art Gallery, York, 1969.

Poe, George. *The Rococo and Eighteenth-Century French Literature: A Study through Marivaux's Theater.* New York: Peter Lang, 1987.

Posner, Donald. *Watteau: A Lady at Her Toilet.* New York: Viking Press, 1973.

Rawson, C. J. *Henry Fielding and the Augustan Ideal Under Stress.* London: Routledge & Kegan Paul, 1972.

Reverand, Cedric D., II. Review of Peter Ackroyd's *Hawksmoor. Eighteenth Century Life* 11, n.s. 2, (1987): 102–9.

Review of Fiske Kimball's *Creation of the Rococo. TLS* 45 (23 March 1946): 134.

Richetti, John J. *Popular Fiction Before Richardson: Narrative Patterns 1700–1739.* Oxford: Clarendon Press, 1969.

———. Review of Michael G. Ketcham's *Transparent*

Designs: Reading, Performance and Form in the Spectator Papers. Eighteenth-Century Studies 20 (1987): 527–30.

Robinson, Roger. "Henry Fielding and the English Rococo." In *Studies in the Eighteenth Century II,* edited by R. F. Brissenden, 93–111. Toronto: University of Toronto Press, 1973.

Roland Michel, Marianne. *Lajoüe et l'Art Rocaille.* Arthena: Neuilly-sur-Seine, 1984.

Ronga, Luigi Ronga. "Il Rococò Musicale." In *Manierismo, Barocco, Rococò: Concetti E Termini,* 387–93. Rome: Accademia Nazionale Dei Lincei, 1962.

Rosbottom, Ronald C. "The Regency's Body: Watteau's *L'Enseigne de Gersaint.*" A talk given at Western American Society for Eighteenth-Century Studies at Berkeley, 1989.

Rose, Hans. *Spätbarock: Studien Zur Geschichte Des Profan-Baues in den Jahren 1660–1700.* Munich: Hugo Bruckmann Verlag, 1922.

Rosenblum, Robert. *Transformation in Late Eighteenth Century Art.* Princeton, N.J.: Princeton University Press, 1967.

Rousset, Jean. *Forme et Signification: Essais sur les structures littéraires de Corneille à Claudel.* Paris: Librairie José Corti, 1962.

Rupprecht, Bernhard. *Die bayerische Rokoko-Kirche.* Kallmunz: Michael Lassleben, 1959.

Russell, Bertrand. *A Critical Exposition of the Philosophy of Leibniz.* 2nd ed. London: George Allen & Unwin Ltd., 1949.

Saisselin, Rémy G. "Room at the Top of the Eighteenth Century: From Sin to Aesthetic Pleasure." *The Journal of Aesthetics and Art Criticism* 26 (1968): 345–50.

———. "The Rococo muddle." *Studies in Voltaire and the Eighteenth Century* 67 (1966): 233–55.

Sampson, Grant. "Rococo in England." *The Centennial Review* 22 (1978): 356–73.

Sauerländer, Willibald. "From Stylus to Style: Reflections on the Fate of a Notion." *Art History* 6 (1983): 253–70.

Saw, Ruth Lydia. *Leibniz.* Harmondsworth, Middlesex, U.K.: Penguin Books, 1954.

Schapiro, Meyer. "Criteria of Periodization in the History of European Art." *New Literary History* 1 (1970): 113–14.

———. "Style." In *Anthropology Today,* edited by A. L. Kroeber, 287–312. Chicago: University of Chicago Press, 1953.

Schönberger, Arno and Halldor Soehner. *The Age of Rococo.* Translated by Daphne Wood Ward. London: Thames and Hudson, 1960.

Schuster, Marianne. *Johann Esaias Nilson: Ein Kupferstecher Des Süddeutschen Rokoko, 1721–1788.* Munich: Neuer Filser Verlag Inhaber Dr. Benno Filser, 1936.

Sedlmayr, Hans, and Hermann Bauer. "Rococo." In

The Encyclopedia of World Art. Vol. 12. Col. 230–47. New York: McGraw Hill, 1966.

———. "The Synthesis of the Arts in the Rococo." In *The Age of Rococo: Art and Culture in the Eighteenth Century,* translated by Margaret D. Senft-Howie and Brian Sewell, 25–28. Munich: Hermann Rinn, 1958.

———. "Zur Charakteristik des Rokoko." In *Manierismo, Barocco, Rococò: Concette e Termini,* 343–51. Rome: Accademia Nazionale Dei Lincei, 1962.

Sgard, Jean. "Style Rococo et Style Régence." In *La Régence,* 11–20. Paris: Librairie Armand Colin, 1970.

Shackleton, Robert. "The Enlightenment: Free Inquiry and the World of Ideas." In *The Eighteenth Century: Europe in the Age of Enlightenment,* edited by Alfred Cobban, 259–78. New York: McGraw-Hill, 1969.

Sheriff, Mary D. *Fragonard: Art and Eroticism.* Chicago and London: University of Chicago Press, 1990.

Simmel, Georg. *Philosophische Kultur.* Potsdam: Gustav Kiepenleuer Verlag, 1923.

Singer, Herbert. *Der Deutsche Roman Zwischen Barock und Rokoko.* Koln Graz: Böhlau Verlag, 1963.

Sitter, John. *Literary Loneliness in Mid-Eighteenth-Century England.* Ithaca, N.Y., and London: Cornell University Press, 1982.

Snodin, Michael. *Rococo: Art and Design in Hogarth's England.* London: Trefoil Books/Victoria and Albert Museum, 1984.

Spitzer, Leo. "A Propos De 'La Vie de Marianne'." *Romanic Review* 44 (1953): 102–26. Reprinted in *Études de Style.* Paris: Éditions Gallimard, 1970.

———. *A Method of Interpreting Literature.* Northampton, Mass.: Smith College, 1949.

Stafford, Barbara Maria. "The Eighteenth Century: Towards an Interdisciplinary Model." The State of Research. *The Art Bulletin* 70 (March, 1988): 6–24.

Starobinski, Jean. *The Invention of Liberty, 1700–1789.* Translated by Bernard C. Swift. Geneva: Skira, 1964.

Stillman, Daime. *English Neo-classical Architecture.* 2 vols. London: A. Zwemmer, 1988.

Stone, Lawrence. *The Family, Sex and Marriage in England, 1500–1800.* New York: Harper & Row, 1977.

Summerson, John. "The Classical Country House in 18th-Century England." *Journal of the Royal Society of Arts.* 107 (1959): 539–87.

———. *Architecture in Britain, 1530–1830.* 4th ed. Harmondsworth, Middlesex, U.K.: Penguin Books Ltd, 1963.

———. *Georgian London.* Harmondsworth, Middlesex: Penguin Books Ltd., 1962.

———. *Heavenly Mansions.* New York: W. W. Norton & Co., 1963.

Swift, Jonathan. Letter to Pope of 30 August 1716. In *The Correspondence of Alexander Pope.* Vol. 1. Edited by George Sherburn. Oxford: Clarendon Press, 1956.

Sypher, Wylie. *Four Stages of Renaissance Style.* Garden City, New York: Doubleday & Company, 1955.

———. *Four Stages of Renaissance Style.* New York: Doubleday and Company, 1955.

Taylor, John Tinnon. *Early Opposition to the English Novel.* New York: King's Crown Press, 1943.

Tintelnot, Hans. "Zur Gewinnung unserer Barockbegriffe." In *Die Kunstformen des Barockzeitalters,* 13–91. Bern: Francke Verlag, 1956.

Tompkins, J. M. S. *The Popular Novel in England, 1770–1800.* London: Constable & Co., Ltd., 1932.

Trottman, Helene. "Die Zeichungen Cosmas Damian Asmas für den Concorso Clementino, der Accademia di San Luca von 1713." *Pantheon* 38 (1980): 158–64.

Tyson, Gerald P. "The Rococo Style of *Tristram Shandy.*" *Bucknell Review* 24 (1979): 38–55.

Vanuxem, Jacques. "L'Art Baroque." In *Histoire de l'Art,* 361–656. Vol. 3. *Encyclopédie De La Pléiade.* Paris: Editions Gallimard, 1965.

Varey, Simon. *Space and the 18th-Century English Novel.* Cambridge: Cambridge University Press, 1990.

Walpole, Horace. *Anecdotes of Painting in England.* Vol. 3. London: Chatto and Windus, 1876.

———. *Correspondence.* Vol. 9. Edited by W. S. Lewis, New Haven, Conn.: Yale University Press, 1941.

Wasserman, Earl R. "From Public to Private Cosmos: The Context of Ideas in the Later Eighteenth Century." Paper read at the Seventy-third Annual Meeting of the Modern Language Association, New York, 28 December 1958.

———. "Johnson's *Rasselas:* Implicit Contexts." *Journal of English and Germanic Philology* 74 (1975): 1–25.

———. "Nature Moralized: The Divine Analogy in the Eighteenth Century." *ELH* 20 (1953): 39–76.

Watt, Ian. *The Rise of the Novel.* London: Chatto & Windus, 1957.

Weiner, Philip P. *Leibniz: Selections.* New York: Charles Scribner's Sons, 1951.

Wellek, René. "The Concept of Baroque in Literary Scholarship." *The Journal of Aesthetics and Art Criticism* 5 (1946): 77–109.

———. "The Parallelism between Literature and the Arts." In *English Institute Annual 1941.* New York: Columbia University Press, 1942.

Welty, Eudora. *The Collected Stories of Eudora Welty.* New York and London: Harcourt Brace Jovanovich, 1980.

Whinney, Margaret. *Sculpture in Britain: 1530–1830.* Baltimore: Penguin Books, 1964.

Wiebenson, Dora. *The Picturesque Garden in France.* Princeton, N.J.: Princeton University Press, 1978.

Wilson, Michael I. *William Kent: Architect, Designer, Painter, Gardener, 1685–1748*. London: Routledge & Kegan Paul, 1984.

Wittkower, Rudolf. *Art and Architecture in Italy*. Baltimore: Penguin Books, 1958.

———. *Architectural Principles in the Age of Humanism*. New York: W. W. Norton & Co., Inc., 1971.

———. *Palladio and Palladianism*. New York: George Braziller, 1974.

Wölfflin, Heinrich. *Principles of Art History*. 1915. Translated by M. D. Hottinger. 7th ed. New York: Dover Publications, Inc., 1932.

———. *Renaissance and Baroque*. 1888. Translated by Kathrin Simon. Ithaca, N.Y.: Cornell University Press, 1966.

Woodbridge, Kenneth. "The Nomenclature of Style in Garden History." In *British and American Gardens in the Eighteenth Century*, edited by Robert P. Maccubbin and Peter Martin, 19–25. Williamsburg, Va.: Colonial Williamsburg Foundation, 1984.

Index